The Decline of Modernism

The Decline of Modernism

Peter Bürger

Translated by Nicholas Walker

The Pennsylvania State University Press
University Park, Pennsylvania

Chapter 1 © Elsevier Science Publishers B.V. (North-Holland) 1983; also published in German as *Institution Literatur und Modernisierungsprozess*, © Suhrkamp Verlag 1983; chapter 6 © Suhrkamp Verlag 1977; chapters 2 & 7 © Suhrkamp 1979; chapter 9 © Suhrkamp 1983; chapters 4 & 10 © Suhrkamp 1987; chapter 3 © Telos Press Ltd 1984, first published in German as *Benjamins 'rettende Kritik': Vorüberlegungen zum Entwurf einer kritischen Hermeneutik*, © Suhrkamp 1979; chapter 5 © Peter Bürger 1991; first published in German as *Überlegungen zur historisch-soziologischen Eklärung der Genie-Ästhetik im 18. Jahrhundert* © Carl Winter Verlag 1984; chapter 8 © Peter Bürger 1991.

First published in 1992 in the United States and Canada by The Pennsylvania State University Press, Barbara Building, Suite C, University Park, PA 16802

ISBN 0-271-00889-X (cloth)
ISBN 0-271-00890-3 (paper)

A CIP catalogue record for this book is available from the Library of Congress.

Typeset in 10½ on 12 pt Times
by TecSet Ltd, Wallington, Surrey
Printed in Great Britain by TJ Press (Padstow) Ltd, Padstow, Cornwall.

It is the policy of The Pennsylvania State University Press to use acid-free paper for the first printing of all clothbound books. Publications on uncoated stock satisfy the minimum requirements of American National Standard for Information Sciences—Permanence of Paper for Printed Library Materials, ANSI 239.48-1984.

Contents

Part I

Part 1

1

Literary Institution and Modernization

Rationality and irrationality of art as a sociological problem
(Max Weber/Jürgen Habermas)

The title needs an explanation. I intend to refer not to the theories of modernity developed in the United States,[1] but to the German sociological tradition represented by Max Weber and Jürgen Habermas. For Max Weber, the distinctive mark of capitalist societies lies in the fact that in these societies the process he calls rationalization comes to full development. This process concerns, on the one hand, the faculty to dominate things by calculation, on the other, the systematization of world-views and, finally, the elaboration of a systematic way of life.[2] The principle of rationalization shapes all areas of human activity. It determines not only scientific and technical processes, but also moral decisions and the organization of everyday life. The very fact that the critical social theories of the twentieth century refer to Max Weber makes obvious that his concept of rationalism is indispensable for the analysis of capitalist society. This can be seen as well in the famous chapter on reification in Lukács's *History and Class Consciousness*, as in the *Dialectics of Enlightenment* by Horkheimer and Adorno, and finally in Habermas's recent *Theory of Communicative Action*. Besides, we can observe that a certain type of anticapitalist opposition from Rousseau

Translated by the author in collaboration with a native speaker of English, this chapter is a revised version of a lecture given in April 1981 in the course 'Theories of modernity' organized by the Inter-University-Centre of Doubrovnik and January 1982 at the Universities of Stockholm, Göteborg and Oslo.

to the ecological movements of our day can be characterized by its attitude towards rationalism in the Weberian sense. If this holds true, a cultural theory concerned with the social function of art or literature must study the relationship between art or literature and rationalization. Let us briefly examine the solutions to this problem proposed by Habermas and Weber.

In his Adorno Prize Lecture, Jürgen Habermas thus defines the relation between art and modernization (thereby recalling an idea of Max Weber):

As the [religious and metaphysical] world-views dissolved and the problems inherited from these – now arranged in terms of truth, normative correctness, authenticity or beauty – could be treated as questions of knowledge, justice or taste, so a clear categorization of areas of values arose between science, morals and art [. . .]. The idea of the modern world projected in the 18th century by the philosophers of the Enlightenment consists of their efforts to develop objective science, universal morality and law, and autonomous art, each according to its own inner logic. At the same time, this project intended to release the cognitive potentials of each of these domains to set them free from their esoteric forms. The Enlightenment philosophers wanted to utilize this accumulation of specialized culture for the enrichment of everyday life, that is to say, for the rational organization of everyday social life.[3]

This construction, continuing as it does the Kantian tradition, is fascinating in two respects: (1) The inner logic of the development of art and that of modernization are congruent. The differentiation of art as an autonomous sphere of value corresponds to that of the spheres of science and morality; (2) Habermas reconciles the autonomous development of art with the utilization of its potentials in everyday social life. But this elegant construction is not without problems. Habermas does not take into account the historical changes in the status of art, the analysis of which seems to me necessary for a complete comprehension of its actual crisis. What is more important, Habermas's harmonistic view risks concealing the contradiction between art (institutionalized as an autonomous sphere) and rationality (as the dominant principle of bourgeois society).

As to Max Weber, he gives different interpretations of the relation between art and Western rationality. In one of his sketches of universal history, he understands art (like science and capitalist economy) as a sphere of social praxis equally defined by occidental rationalism.[4] In this context, Weber cites the rational use of the arch in Gothic architecture, the organization of the tonic system in harmonic music and the linear perspective in painting. Weber

apparently views as rational the development of an architectural, musical or visual system, coherent in itself, which constitutes an optimal solution to given technical problems. According to this, rationality would be set at the level of what might be called artistic material, to use the term introduced by Th. W. Adorno and Hanns Eisler. In this essay of Weber's, art does not occupy any special position within occidental societies, but is mentioned among other spheres as an example of rationalism.

It is very interesting that Weber characterizes the position of art within modern society differently in a paragraph in *Economy and Society*. Above all, he now lays the stress on the opposition between the spheres of art and religion (especially the Christian spirit of fraternity). Weber discovers this opposition on the following levels: (1) the secular salvation which art claims to provide is opposed to religious salvation; (2) the application of aesthetic judgement (strictly confined to the subjectivity of the individual) to human relations contests the validity of religious norms; (3) it is just this rationalization of religion ('the devaluation of magical, orgiastic, ecstatic and ritual elements of religion') that brings about a devaluation of art by religion.[5]

On all three levels, the opposition of religion and art is interpreted as one of irrationality and rationality. Any rational religious ethic has to oppose secular irrational salvation by means of art.[6] Individual aesthetic judgement applied to human behaviour calls the rationality of moral norms into question, just as, conversely, religion denounces the survival of irrational practices within the context of art, practices which religion had got rid of a long time ago. Because of its irrational character, art here opposes Christian religion. For Weber there is no doubt about the fact that 'the systematic condemnation of any devotion to the proper values of art [. . .] must help to develop an intellectual and rational organization of everyday life'.[7] In this perspective, art is not part of occidental rationalism but is radically opposed to it.

At first glance, Max Weber seems to get mixed up in an insoluble contradiction, if art is to be considered as both rational and irrational. This contradiction can probably be solved when we become aware of what precisely the two texts are about. The first text is concerned with the artistic material (and it is no coincidence here that lyric poetry has been left out); the second text, by contrast, deals with art as an institution which comes into conflict with another institution, that is to say religion. According to Weber, in this conflict religion reproaches art with its irrationality. Thus, there

need not be a contradiction between the rationality of the development of artistic material and techniques and their application within the scope of an irrational institution.

This solution of the contradiction between the two Weber texts must not veil the underlying problems mentioned above: (1) during the formation of bourgeois society the status of art undergoes important changes; (2) the present crisis of art is one of its status. I want to elucidate this current problem by a historical approach. I suppose that the autonomization of art is not a unilinear process of emancipation ending in the institutionalization of a value-sphere coexisting with other spheres, but a highly contradictory process characterized not only by the acquisition of new potentials but also by the loss of others.

Before we come to the historical analysis of the changes the status of literature has undergone since the era of absolutism, we must bear in mind that we are not concerned here with individual works, but with the status of literature, that is to say with the literary institution.[8] The concept of literary institution does not signify the totality of literary practices of a given period, but only the practice characterized by the following distinctive features: the literary institution serves special purposes in the social system as a whole; it develops an aesthetic code functioning as a boundary against other literary practices; it claims an unlimited validity (it is the institution which determines what in a given period is regarded as literature). The normative level is at the centre of a thus defined concept of institution, because it determines the patterns of behaviour both of the producers and the recipients. Sub-institutions of literary distribution, like theatres, publishers, *cabinets de lecture* or book co-operatives and so on will lose in this conception the appearance of autonomy. And they will be perceived as instances where the claim of validity imposed by the institution turns out to be accepted or refused. Thus literary debates are of great importance; they may be regarded as struggles to establish the norms of the literary institution. These debates can also represent an attempt to set up a counter-institution. We may interpret these struggles as the often contradictory expression of social conflicts.

The institutionalization of the *doctrine classique* in French absolutism

The debate on the validity of the *doctrine classique* opened by the first performance of Corneille's *Le Cid* (1637) marks an important

step towards the establishment of the feudal–absolutist literary institution.[9] The rules which constitute the yardstick of the critics of Corneille's tragicomedy *Le Cid* were not yet acknowledged, neither by the majority of the playwrights nor by the public. Only because of the intervention of Richelieu and of the Académie Française, who both sided with Corneille's critics, did the rules obtain the status of an officially recognized literary doctrine, the validity of which remained almost undisputed until the nineteenth century. In the debate on *Le Cid* there is, on the one hand, a socially mixed public interested in strong emotional effects, and on the other, the representatives of the *doctrine classique* who attempt to submit the theatre to new normative tendencies. For the public the aesthetic value of a drama is identical with the pleasure it provides and therefore cannot be rationally explained. The supporters of the classical doctrine, by contrast, have at their disposal an instrument which enables them to formulate rational judgements on the aesthetic value of a play. On the one hand, social norms function as aesthetic rules and enforce a conformity between the plot of the play and a set of social norms, which in this period were not even accepted by the aristocratic elite. The introduction of the *doctrine classique* thus furthers the affect-control which, according to Norbert Elias, is one of the important features of modernization.[10] On the other hand, the well-known unities of action, place and time submit the plot of the plays to rationally controllable criteria. These criteria may be called rational because they can be applied to all objects of the same genre (principle of universality) and because an intersubjective consensus on their fulfilment or violation can be reached without any problems in the individual case. It is significant that the opponents of the *doctrine classique* are forced to agree with the judgements deduced from the rules.

The main social force promoting the new literary institution is the absolutist state. Intending to overcome the rivalry of the seigneurs, absolutism not only sets up a standing army and a centralized administration, but also tries to establish a cultural monopoly. The regulation of literary (artistic) production is supposed to provide the political system with a culture of high rank which can serve as a means of representation. Absolutism delegates the formulation and implementation of its cultural programme to the members of the bourgeoisie versed in jurisprudence. It is part of the peculiarities of the institutionalization of the *doctrine classique* that in its beginnings – in spite of its moments of bourgeois rationality – it is not carried on by the strata of the public which may be called bourgeois. During this period, this public maintains an attitude of reception

only aimed at the immediate pleasure of the performance. The absolutist state, submitting literature to political ends, fosters bourgeois rationality against the very interest of the contemporary bourgeoisie. Here, we must take note of the contradictoriness in absolutism where bourgeois and feudal moments fuse in a rather particular way. At first glance the question of whether the feudal absolutist literary institution may be called autonomous seems vain, because its dependence on the political system of absolutism, that is to say its heteronomy, cannot be ignored. But things are not as simple as they may seem. The incontestable dependence on the political system offers to the literary institution a certain (but strictly limited) scope *vis-à-vis* that institution with which literature has been in competition since the beginning of the process of bourgeois emancipation during the Renaissance: the church. Even as late as 1619, i.e. shortly before the coming to power of Richelieu, Vanini was publicly burned as a libertine in Toulouse, and some years later Théophile de Viau was sent to prison because of some allegedly atheistic verses. The rivalry between the literary institution and the church lasted for the whole century; it manifested itself above all in the attack of the church against the morally pernicious influence of the theatre. This attack was by no means primarily directed against the folk theatre (*théâtre de la foire*) and the popular genres like tragicomedy, but against high literature which, institutionally secured, claimed a cultural superiority. The more the theatre is submitted to the rules of decency – this is the argument of Nicole and Bossuet – the more it becomes tempting and thus pernicious. The conflict about the public performance of Molière's *Tartuffe* may be considered the climax of the struggle between the literary institution and the church during the seventeenth century. In the same measure as the theatre goes beyond its mere function of entertainment in order to discuss moral problems, it rivals the dominance of the church. The result of this conflict is of importance for the problem of autonomy. Molière could only push through the public performance of *Tartuffe* with the massive support of the King. Political dependence, at least in this case, is a precondition for the possibility of literature to cope with the church as a rival institution. Indeed, the conflict is continued in the eighteenth century with undiminished violence: Voltaire takes the offensive by proclaiming 'écrasez l'infâme'.

We can summarize as follows: the loss of validity of religious world-views is not only a process of erosion but also a result of conflicts, in which literature is fighting for its institutional autonomy.

In so far as literature encourages the loss of validity of religious world-views, its evolution during the feudal absolutist era is in harmony with modernization. This can also be applied to the *doctrine classique*, which can be seen as the normative core of the feudal absolutist literary institution. It is characterized by the effort to submit literary production to a process of social standardization and thus literature is put under the central principle of modernity: the principle of rationality. Obviously that does not mean that emotional effects are abandoned, but their uncontrolled implementation is restricted and their calculability postulated. We must take into account the fact that rationality still remains within the framework of the feudal absolutist state, whose requirements of representation classical French literature serves. Nevertheless, we can only explain the relatively stable validity of the *doctrine classique* during the ascent of the bourgeoisie during the eighteenth century if we recognize the modern element of rationality in it.

The success and crisis of the Enlightenment concept of literature

The changes in the literary institution during the eighteenth century can be schematized as follows: the institutionalized genres – epic, tragedy, comedy and lyric poetry – are still under the control of the *doctrine classique*. Even Voltaire becomes famous as a writer of classical tragedies. But those genres which do not fall under the jurisdiction of the doctrine – aphorism, portrait, letter, dialogue, essay and, finally, the novel – become more and more important for the alternative literary practice we usually call the literature of the Enlightenment. There are at least two features which differentiate this new practice from the feudal–absolutist one: the prose form and the fusion of a didactic intention with the principle of rational critique. It is true that the *doctrine classique* had also submitted literature to social norms, but the rule of decency (*bienséance*) required only the conformity of the conduct of the persons on stage with the aristocratic norms; there were only verbal references to the *prodesse* in the formula of Horace. This completely changes with the Enlightenment: now, literature has not only to be in agreement with social norms, but is to infuse norms into the patterns of behaviour of the individual. As Jochen Schulte-Sasse pointed out in his studies on the early German Enlightenment, the rising manufacture and trade bourgeoisie was interested in a very elementary way in the validity of

moral norms: they are an essential precondition for the functioning of the market economy.[11] Thus an alternative literary practice turns into a new institution of literature: in this institution works of art serve as instruments of moral education.

No doubt it is inadmissible to reduce the literary practice of the Enlightenment to moral education only. The principles and norms conveyed to the individual by literature are first discussed in public. Literature is at the same time an instrument of moral education and a medium of political and moral discussion. The two literary institutions coexist without major friction as long as the claim to validity of the classical doctrine is not contested. This is indirectly the case when the novel claims recognition as a literary genre and directly with Diderot's bourgeois drama. Inasmuch as they attempt a critique of the central categories of the *doctrine classique*, Diderot's programmatical statements reach another level and may be interpreted as an attempt to impose the hegemony of the new literary institution. This attempt to put an end to the coexistence of poetry submitted to the *doctrine classique* on the one hand with Enlightenment prose submitted to the new literary institution on the other, by establishing a cultural monopoly of the rising bourgeoisie, failed.[12]

The literary institution of Enlightenment occupies a central position in the process of modernization. In the same measure as the norms of human interaction are no longer legitimized by the traditional authority of systems of belief, they must be worked out in discussions. And in so far as the internalization of norms is no longer exclusively assured by religious education, other modes of integration of individuals into the normative framework must be developed. Both tasks now fall to literature in the wider sense. As philosophical critique, literature examines the claim to validity of norms; as *belles lettres* it promotes the internalization of norms. The emotional qualities of literature, its ability to affect and to move the recipient deeply, is incorporated into a rational project to organize the achievement of a humane society. In the Enlightenment the modern capitalist bourgeoisie (in contrast to the *bourgeoisie d'Ancien Régime*, which remained attached to traditional patterns of behaviour) constitutes itself as the subject of history. The process of modernization thus obtains a new quality: the character of a conscious project. In so far as this occurs in literature, literature becomes a central institution of social life.

The crisis of the Enlightenment and of the corresponding concept of literature was in former times often explained as an effect of the French Revolution. This view is not totally wrong, but it traces the

changes in the literary institution directly back to the political events. The critique of the dominating principle of utility is first formulated by Rousseau and taken up by K. Ph. Moritz and the authors of the *Sturm und Drang*. It was to become an essential basis of idealistic aesthetics and indicates that – even before the French Revolution – modernization gives rise to a certain kind of fundamental critique of bourgeois society. Though this critique is orientated at traditional ways of life (Herder and the young Goethe, for example, take up impulses from the traditionalist Justus Möser), we cannot simply classify it as traditionalist. The ardent desire for a life experienced in its totality is opposed to the principle of utility, to the submission of all spheres of life to mechanization and to the fragmentation of activities. This desire is based on experiences in traditional contexts of life, but was only to be formulated under the impact of modernization. This fundamental critique of the rationalization of social life could not be inserted into religion, because religion – as Weber and Groethuysen have proved – is involved in the process of rationalization. In addition to this, it has lost for the privileged classes its importance as an institution guaranteeing an aim in life. The literary institution of the Enlightenment does not grant any space to this kind of radical critique either; since the critique of rationality leads to a questioning of the literary institution as such. There is no doubt about the fact that critique is part of the Enlightenment, but it is based upon the very confidence in reason and in the agreement of reason with humanity. Whoever renounced this foundation, attacked the literary institution of the Enlightenment. The aesthetics of autonomy locating art in a sphere no longer submitted to theoretical or moral criteria, claims for the work of art a free space within society. In this view it constitutes a consistent answer to the crisis of the literary institution of the Enlightenment. But the autonomization of literature as art is charged with problems right from the start. This can be seen in the aesthetics of genius, which prepares the way for the new concept of autonomy.[13]

The aesthetics of genius and the discovery of barbarism in art

From the point of view of the early Enlightenment, including Voltaire, the process of civilization is a straight development (although often threatened by regression) from barbarism to civilization. Voltaire considers the literature of the 'siècle de Louis XIV' as an indication of the cultural level reached in his day; he does not

take into account the representative function of this literature for the absolutist state, but lays the stress on the importance of a national tradition and on the rationality of the *doctrine classique*. It is worth noting that the rationalism of the early Enlightenment does not harmonize to such a degree with the *doctrine classique* as Voltaire wants us to believe. This can be seen in his controversy with La Motte, who had turned the principle of rationality *against* the rules, questioning the rationality of the unities of place and time and attacking in the name of probability (*vraisemblance*), the use of verse in tragedy. The weakness of the arguments put forward by Voltaire in his answer reveals his position as a traditional one: attack against the unities and verse is an attack against poetry in general; this is Voltaire's argument when he claims for the classical doctrine a status beyond critique and discussion. The importance of the controversy consists in the fact that poetry and reason, which form a unity in the *doctrine classique*, begin to develop in different directions. There is no better witness for this process than d'Alembert's vain attempt to reconcile them again. *Dialogue entre la poésie et la philosophie pour servir de préliminaire et de base à un traité de paix et d'amitié perpétuelle entre l'une et l'autre* (dialogue between poetry and philosophy in order to provide an introduction and a base to a mutual treaty of peace and eternal friendship) is the title of one of his essays where he unwittingly admits the gap between artistic sensitivity and reason. D'Alembert cannot help recognizing that there is a connection between the increase of rationality and the loss of intensity of pleasure ('nos lumières sont presque toujours aux dépens de nos plaisirs').[14]

From here it is but a step to transform into a positive quality what Voltaire abhors: barbarism. This happens in France around Diderot, in Germany in the *Sturm und Drang*. A comparison of Voltaire's statements on enthusiasm and imagination in the *Philosophical Dictionary* with the corresponding passages of Saint-Lambert's Encyclopedia-article *Génie*, makes clear the consequences of the self-critique of the Enlightenment for the literary institution. While Voltaire ridicules poetic enthusiasm and attributes only little importance to imagination for artistic creation, these two faculties constitute the core of the new concept of the poet as a genius. The rules, devaluated now as conventions, are opposed to irregularity and savageness as aesthetic qualities. Finally, the concept of genius is linked to a type of authentic perception, in opposition to the restricted sensibility of all those pursuing precisely defined aims.

Here we can notice the beginning of the critique of alienation developed by Moritz and Schiller.

Appeal for an unrestricted sensibility, plea for the spontaneity of the artist, pleasure taken in works alien to the classical ideal of beauty: in the aesthetics of genius worked out in the second half of the eighteenth century, we can see the rise of an art opposed to modernization. The categories of the aesthetics of genius contain in a more or less explicit manner a critique of the principles of rationality and calculated labour. This critique is formulated in the name of a partially new revaluation of barbarism, which in Voltaire's cultural theory was definitely attributed to the past. 'La poésie veut quelque chose d'énorme, de barbare et de sauvage', says Diderot.[15] And more than this, he thinks that great epic and dramatic poetry can only develop in an archaic society. Poetry (the term already designates what we now call art) is brought into radical opposition to modernity (in the sociological meaning).

When we inquire about social conditions which made this new conception of poetry possible, we must remember that at least in the eighteenth century in France the aesthetics of genius is far from being dominant. Even in Diderot's and Mercier's writings we only find it in dispersed utterances and often mingled with other conceptions (like the didactic one). The aesthetics of genius, which separates art from rationality and prevailing moral thinking, can be regarded as corresponding to Rousseau's critique of civilization. Thus the aesthetics of genius is part of the self-critique of the Enlightenment. The more scientific and technical development progresses, the more it reveals its contradictory character. The bourgeois subject, claiming personal autonomy, and being itself a result of modernization, opposes society as an alien object. The critique which has been concerned with traditional residues, such as dogmatic system of belief, can now turn against modernization itself. Rousseau's thesis in his *Discours sur l'inégalité* says: historical progress is at the same time a process of regression; the technical and scientific progress is accompanied by a regression in human relations. The revaluation of nature (to put it more precisely: of an early state of civilization ignoring competition) is the theoretical response to an experience of suffering, resulting from the loss of traditional patterns of behaviour.[16] According to Rousseau, nature is a category allowing a critique of civilization. He never believed a return to nature could be possible. The aesthetics of genius starts from Rousseau's critique of civilization, but does not find satisfaction in

its results. It intends to introduce 'nature' into the given society. This is only possible if one claims an exceptional status for the subject of such a natural experience. For the radicalism of its critique of modernization the aesthetics of genius has to pay a high price: binding the critique of alienation to the great individual, it abandons one of the essentials of the Enlightenment, the principle of universality. Fascinated by barbarism, it runs the risk of succumbing to legitimization of inhuman action.

Some analogies between the *doctrine classique* and the aesthetics of autonomy

It is obvious that the aesthetics of genius, as it was developed in France in the second half of the eighteenth century, contains important elements which the aesthetics of autonomy, worked out by Moritz, Kant and Schiller, could adopt. Nevertheless there is no formulation in France, between 1780 and 1815, of a coherent idealistic aesthetics. Considering the rapid success of the aesthetics of autonomy – the latter dominates the aesthetic discussions from the beginning of the nineteenth century – we need an explanation for the different development in France, above all because of the fact that the concept of autonomy was generally accepted there in the long run.

Like the aesthetics of genius, the aesthetics of autonomy sets the artist as a producer up against society. Concerning the type of making experiences, presupposed in this case, we have to take into consideration the fact that the preconditions were missing in pre-revolutionary France. In spite of the violence of the social conflicts the philosophers of the Enlightenment could justly think that they were participating in the process of social progress. And so there was no need for them to adapt and further develop the model of a radical opposition of artist and society, which the aesthetics of genius proposed. In this context Rousseau is an exception: determined by traumatic childhood experiences, he acquired a special sensitivity to the deformations of human relations conditioned by a society of competition, and he reacted to this at least as far as he himself was concerned with an acute opposition of individual and society.

When in France at the end of the eighteenth century practically no concepts of autonomy are formulated, this is, without any doubt,

due to the dominance of the *doctrine classique*, which is not called in question even by the philosophers of the Enlightenment. This may be understood by the fact that the genres favoured by the philosophers of the Enlightenment and which we may today call operative genres are not affected by the rules. The separation of poetry and prose helps to avoid conflicts. In addition to this, there is the importance of French classical literature which gives evidence of the validity of the *doctrine classique*. Schiller and Goethe, who do not lack self-assurance (we only need to remember their *Xenien*), can only imagine the development of a German national literature in accordance with French classicism. This suggests the question of whether the *doctrine classique* and the aesthetics of autonomy, regarded under the aspect of institutionalization of art (poetry) in bourgeois society, represent *functional equivalents*. If this could be proved, we might understand the lack of an aesthetics of autonomy in France.

Now, it is not a question of finding out correspondences between the two aesthetics but only of demonstrating their functional equivalence. We may see one principle in the separation of art and life praxis. This principle is theoretically worked out in idealistic aesthetics (autonomy of an aesthetic sphere opposed to the spheres of theoretical and practical reason, as we find it in the thinking of Kant), and has the status of an aesthetic rule (*produktionsästhetische Anweisung*), in the *doctrine classique*'s postulation of idealization.[17] When in popular aesthetics since the beginning of the nineteenth century in Germany the postulation of autonomy is interpreted as a rule of aesthetic production this seems to prove the assumption mentioned above. Notwithstanding the differences between the aesthetics of autonomy and *doctrine classique*, they serve the same function, that is to separate the work of art, as part of an ideal world, from reality.

Even with regard to the relation between art and morals, we may consider the two theories as functional equivalents. This may seem astonishing because in the *doctrine classique* moral norms work as aesthetic ones, while idealistic aesthetics separates explicitly the sphere of aesthetics from that of morals. This argumentation would ignore the fact that the autonomy of an aesthetic sphere is in most cases linked to the submission of the work of art to moral norms. This is as well especially true for the popular aesthetics which determine to a great extent the conception of art of the German educated bourgeoisie.

When, in the long run, even in France concepts of autonomy prevail, this may be due to the following reasons: within the *doctrine classique* one could not imagine any aesthetic evolution. Since it binds the aesthetic quality to the fulfilment of rules and, what is more, supposes unattainable models of aesthetic perfection, any change within the aesthetic material must be regarded as an attack on the *doctrine* itself. This is exactly what happened in the era of the romantic drama in France. When Victor Hugo timidly calls in question some rules of the *doctrine*, this appears – to himself as well as to his opponents – to be a literary revolution. At the same time he does not even dare advocate the use of prose in drama. Thus in France romanticism is brought into a fictitious opposition with classicism, unknown to such a degree in the history of literature in Germany (where Goethe is celebrated by the romantics of Jena), because idealistic aesthetics constitutes the basis for both movements.

The superiority of idealistic aesthetics *vis-à-vis* the *doctrine classique*, making it the normative framework of the literary institution in bourgeois society, may be seen in the fact that different and even opposite movements lay claim to it. To give an example: Victor Cousin, a very important propagator of idealistic aesthetics in France, to whom we owe the formulation 'l'art pour l'art', emphasizes the autonomy of art, while sticking on the other hand to moral effects ('si l'art produit le perfectionnement moral, il ne le cherche pas').[18] While Cousin interprets the conception of autonomy in art in the sense of a conformity of art and dominating morals, Théophile Gautier radicalizes the postulate of autonomy in attacking (in his *Mademoiselle de Maupin*) the dominant sexual morals of his time. We may summarize as follows: in the long run only an aesthetics giving a contradictory definition of the relation of art and morals could normatively govern the institution of art/literature.[19] This literary institution is within bourgeois society that level where its immanent contradictions are apparently solved. Not only morals and liberty but also calculation and spontaneity, rationality and its contrary are to be reconciled here. In this perspective it may be plausible to discuss three central categories of idealistic aesthetics concerning production, reception and work of art; that is to say: the artist as a genius, reception as an act of contemplation, the work of art as organic totality. I do not intend to undertake a dialectical critique of these categories; I only want to discuss the relation between this concept of art and modernity.

The literary institution as a functional equivalent of the religious institution

As we suggested above, the category of genius results from the process of modernization (that is to say it is a response to this process) and at the same time it is opposed to it (non-rational faculties and modes of behaviour as well as imagination and spontaneity are taken as positive values). It seems obvious that the two other categories are determined by the same contradiction. Contemplative immersion in the work of art means a mode of behaviour lacking rational criteria to control its success and to calculate its efficiency. This emphatic reception is more reminiscent of certain forms of appropriation of religious beliefs than of a specifically modern, rational approach. There may be something like a technique of contemplation, but there is no method which permits a verification of procedure and its success. Although the emphatic recipient can focus on every part of the object, he does not proceed systematically, with the intention of grasping all the parts in their peculiarity; his aim on the contrary is to merge in the work of art. While rational procedures of appropriation presuppose and emphasize the distance between subject and object, contemplation tends to blur it.

Studying the early formulations of the aesthetics of autonomy (especially the writings of Karl Philipp Moritz), we can see that they give an answer to experiences which have their roots in the process of modernization. The subsumption of different areas of human activity under the law of rationality and the loss of opportunities for authentic experience provoke alternative patterns of behaviour, because at the same time religious beliefs increasingly lose their credibility.[20]

Like the categories of genius and contemplation, the concept of the work of art as an organic totality is opposed to the principle of formal reason. The machine, not the organism, is the most advanced result of rational planning of production. Man is not able to create organisms. To consider the work of art as an organism, or an organic totality, means to separate it from the area of normal human production and to assign to it a quasi natural status. Here the categories of the organic work and the genius are linked. Only the genius is able to create objects totally different from those which can be produced by rationally planned human activity. The concept of

the work of art as an organic totality as well as the two other categories must be regarded as a reaction to the increasing importance of rational patterns of action. In so far as formal reason is indifferent to moral criteria and an increasing loss of validity of religious beliefs can be observed, a need for a sphere of objects arises, which enables man to experience a meaningful world. 'Art constitutes a sphere of independent values and functions as a means of profane salvation of everyday life and above all of the increasing pressure of theoretical and practical rationalism.'[21]

Our reflections suggest that the institution of art/literature in a fully developed bourgeois society may be considered as a functional equivalent of the institution of religion. The separation of this world and the other world is replaced by a corresponding separation of art and everyday life. On the basis of this opposition, the aesthetic form can be delivered from the obligation to serve certain purposes and be considered as something of independent value. It is true that works of art do not have the same status as religious texts, but as we have seen, they are not received like other products of human activity; on the contrary, they are provided with the quality of absolute originality, as products of a genius. The quasi transcendent quality of works of art demands a reception which corresponds to religious contemplation. Walter Benjamin's concept of *Aura* intends to show this, as does Adorno's critique of art-religion.[22] As in former times religion, art now offers a refuge where only the privileged classes can find shelter. Far from rationally organized everyday life, a type of subjectivity is cultivated, the problematic of which – as Herbert Marcuse pointed out – consists in this separation.[23]

We must take into account, however, that a functional equivalence does not require the identity of its agents. In other words: we must not conclude from the functional equivalence of the institutions that art in bourgeois society is 'nothing else' than a substitute for religion. This conclusion would be problematic because it presupposes that works would be totally determined by the institution. But that is not the case; art in bourgeois society is based on the tension between institution and individual work.

2

Walter Benjamin's 'Redemptive Critique': Some Preliminary Reflections on the Project of a Critical Hermeneutics

The interpretation of Benjamin in the work of Jürgen Habermas

Any attempt to define Walter Benjamin's[1] contribution to the project of critical hermeneutics today must begin by considering Habermas's important essay on Benjamin,[2] for it was Habermas who introduced into the contemporary debate the fundamental distinction between Benjamin's 'redemptive critique' and the critique of ideology and thus made an essential contribution to our understanding of the unique character of Benjamin's approach. However, it is not difficult to see that the way in which Habermas underlines the distinction between these two types of critique also decisively conflicts with the idea of trying to claim Benjamin for the cause of a critical hermeneutics. In this connection we shall have to discuss the relationship between 'redemptive critique' and the critique of ideology, as well as Habermas's attempt to characterize the former as a kind of conservative critique. Finally, we shall also have to address the question as to whether the anti-evolutionary elements in Benjamin's idea of history bring his view into conflict with hermeneutics.

Habermas begins by contrasting Herbert Marcuse's essay 'On the affirmative character of culture' as an example of analysis in the style of ideology critique with Benjamin's piece 'The work of art in the age of mechanical reproduction'. Habermas proceeds to make the following distinctions:

1 'Marcuse treats the exemplary forms of bourgeois art in line with the critique of ideology insofar as he identifies the contradiction between the ideal and the real. But in his critique the overcoming of autonomous art only appears as a consequence of reflection. Benjamin on the other hand does not address critical demands to a culture which still preserves its substance intact. Rather he recounts the actual process of disintegration which befalls the aura upon which bourgeois art grounds its appearance of autonomy. He proceeds in a descriptive manner. He observes a transformation in the function of art, which is something that Marcuse only expects from the moment in which the conditions of life are transformed by revolution.'[3]

2 Whereas Marcuse is oriented towards classical art and the concept of beauty in art, Benjamin's interest lies in the 'non-affirmative forms of art' like baroque allegory and avant-garde art.[4]

For Habermas the decisive difference between Marcuse and Benjamin lies in the fact that the latter 'understands the dissolution of autonomous art as the result of an upheaval in the techniques of reproduction'.[5]

We must endorse the way in which Habermas contrasts the two approaches here, but it still tells us little about the opposition between ideology critique and redemptive critique for the principal reason that in Benjamin's essay on the work of art the problem of redemptive critique is not the central issue. If Benjamin can discover within the distintegration of the aura of the work of art produced by the development of new techniques of reproduction a moment which spells the end of autonomous bourgeois art and thus simultaneously creates the conditions for a new art accessible to the masses, then salvation can only lie in the fact that mass culture is 'rendered dialectical' (as Adorno says),[6] i.e. that the positive aspect within the negative is emphasized. In the first place we should note that Benjamin takes as his point of departure the formalist claim that the task of all new art is to disturb automatized modes of perception through the very organization of the artistic material and thus force the recipient of the work to adopt a new way of seeing. However, Benjamin makes certain crucial changes to this position. In the first place, he provides it with a materialist foundation for it is no longer the artistic means selected by the artist which bring about changed modes of perception but rather a transformation of the techniques of reproduction themselves. The connection between the two can

clearly be seen from the fact that Benjamin interprets the dadaist techniques as an anticipation of the possibilities later realized in the medium of film.[7] In the second place, Benjamin transposes the formalist claim to a unique historical situation. Thus what the formalists regarded as a law of immanent artistic development is transformed by Benjamin into a unique event, albeit one which takes place over a very considerable period of time. Finally, Benjamin also includes the recipient of art within his analysis in a concrete way. Whereas in earlier times the bourgeois consumer of art required a solitary absorption in the object, the new mode of perception is addressed to the mass of people who in a state of collective diversion are capable of responding to the work in a rational and experimental way. There is no fundamental irreconcilability between this kind of attempt to provide a materialist version of one of the basic theses of formalist art theory and the type of critique developed by Marcuse. This is the case not merely because the opposition between them arises principally from the different subject-matter in each case (the classical idea of beautiful semblance in Marcuse and an avant-garde perspective on modern mass culture in Benjamin), but above all because both approaches can ultimately be traced back to two different types of Marxian critique. Whereas Marcuse takes the critique of ideology developed by Marx in 'On the Jewish question' and the introduction to 'A contribution to the critique of Hegel's philosophy of right' as his paradigm, Benjamin takes his bearings from Marx's claim that the development of the forces of production eventually explodes the existing relations of production. Benjamin transfers this idea to the realm of the artistic forces of production (i.e. the artistic procedures and the techniques of reproduction). Just as Marx's claim that the forces of production will shatter the relations of production represents precisely the discovery of those real forces which are capable of bringing about what ideology critique has shown to be necessary, so Benjamin's theory is an expression of the hope that within the development of the artistic forces of production there may also be forces which as such necessarily promote human emancipation and resist manipulative exploitation.

Now the argument that Benjamin's critique relates to its object in a conservative manner[8] can certainly appeal to the fact that this critique sees its purpose as lying in the redemption of the past. The task laid upon every present according to Benjamin is to redeem some part of the past. If the opportunity to do so is once missed, then it is irretrievably lost. In the context of a critique of historicism

Benjamin writes: 'To articulate the past historically does not mean to recognize it "the way it really was" (Ranke). It means to seize hold of a memory as it flashes up at a moment of danger.'[9] Although Benjamin seems to speak of this danger in a purely metaphorical fashion here, he actually understands it in a quite literal sense: 'The danger affects both the content of the tradition and its receivers. The same threat hangs over both: that of becoming a tool of the ruling classes.'[10] In so far as redemptive critique secures for us a unique experience of the past it does indeed exercise a preservative function, but this does not justify us in describing it as conservative. In fact Benjamin's philosophy of history was specifically developed in direct opposition to the conservative conception of history which was characteristic of historicist thought. For Benjamin cultural goods are the spoils borne along by the rulers in the triumphal procession of history. 'A historical materialist views them with cautious detachment.'[11] And exactly the same is true for the process of cultural transmission: 'A historical materialist therefore dissociates himself from it as far as possible.'[12] One could certainly describe as conservative the sort of critique which either attempts to preserve everything as a matter of principle, or simply locates itself within the dominant tradition or finally preserves for the sake of preserving. But none of these three characteristics applies to Benjamin's idea of redemptive critique. In the first place Benjamin in no way seeks to preserve everything. On the contrary, he sees his task as one of interrogating the dominant culture for the sake of those elements which could become parts of a counter-tradition. In the second place, the dominant tradition is suspect to Benjamin precisely because it is the tradition of those who exercise domination as rulers. He does not repudiate this tradition, for it still constitutes the framework within which culture has been able to develop, but he does dissociate himself from it 'as far as possible'.[13] In the third place, as far as redemptive critique is concerned the act of preservation is certainly not an end in itself. By assembling the shattered fragments of the past into a tradition that struggles against oppression, redemptive critique vouchsafes to the oppressed the ability to understand themselves as the avengers of past oppression. And it is from this consciousness that critique draws 'hatred and the spirit of sacrifice. For both are nourished by the image of enslaved ancestors rather than that of liberated descendants.'[14] Whatever we think about reflections of this kind, it is clear that Benjamin conceived of his redemptive critique in a thoroughly political way.

But there is another important question that still needs to be addressed. This concerns the position of Benjamin's conception of

history in relation to the evolutionary view of history. At first sight it certainly does look as though Benjamin's conception is 'profoundly anti-evolutionary' in character.[15] But it should be noted that Benjamin does not attempt to conceive historical change exclusively as a movement which proceeds by discontinuous leaps. He certainly admits historical continuity. Habermas mentions 'the continuity of disenchantment' represented by the loss of aura[16] but this is by no means the only example. The way in which Benjamin appeals to the Marxian analysis of commodities in his book on Baudelaire implicitly presupposes Marx's general analysis of the origins of bourgeois society. What Benjamin does oppose is the social-democratic identification of the historical continuum with progress itself. In the face of a triumphant fascism – and we should not forget that the 'Theses on the philosophy of history' were conceived during Benjamin's exile in Paris towards the end of the 1930s – this typical social-democratic identification of the progressive mastery of nature with progress in general has finally revealed its disastrous character. This is why Benjamin finds it necessary to insist upon the 'retrogressions of society'.[17] By freeing the concept of progress from its immediate connection with the development of productive forces, Benjamin removes from it those attributes of linear advance and historical inevitability which it had acquired in vulgar Marxist theory.[18] In order to be able to apply a concept of progress at all in the face of the fascist catastrophe, Benjamin consequently seeks to find it in the moment of rupture rather than in that of continuity. Thus he conceives of critical hermeneutics as an equivalent to revolution. 'Exploding the continuum of history' simultaneously represents the consciousness of the revolutionary classes in their moment of action as well as the proper procedure of the materialist historian.[19] But we should misunderstand this procedure if we saw it as standing in absolute opposition to the concept of continuity. In fact it is directed towards the creation of a new continuity: 'As a result of this method the life-work is preserved and transcended ('aufgehoben') in the work; in the life-work, the era; and in the era, the entire course of history.'[20]

Ideology critique and redemptive critique

Let us now return to our original question concerning the difference between these two types of critique. If we take the Marxian critique of the declaration of human rights as a representative example of ideology critique[21] – and this is surely the starting-point of Haber-

mas's approach – the following opposition emerges. The critique of ideology grasps its subject-matter as the socially necessary phenomenon of false *consciousness* or socially necessary illusion.[22] It posits the relationship between the cultural objective forms of life and the social reality to which these forms owe their emergence and to which they refer back as a conscious relationship on the one hand and as a distorted one on the other. The declaration of human rights represented an attempt to interpret and to regulate the domain of social reality. Marx now demonstrates that the revolutionaries who claimed to speak in the name of all mankind were actually expressing the interests of a single class, namely the property owners. Nevertheless this fact remained hidden from the participants themselves. Ideology critique recognizes the moment of historical progress in the ideal demand for universal human equality but it also exposes the moment of obfuscation which veils the fact of real social inequality. In relation to this sort of critique we could define redemptive critique by saying that it grasps its subject-matter as an *expression* of social relations. In this context expression would have to be defined as a relationship which is unconscious and immediate. Just as a spontaneous gesture or a slip of language can 'express' the intention of a speaker, so for redemptive critique a cultural objective form can express the epoch in which it has arisen.

This attempt to distinguish the two forms of critique from one another must, however, face one crucial objection: in the Marxian critique of religion which provides the very model of Marcuse's critique of affirmative culture, religion is specifically described as an '*expression* of real misery'.[23] By this Marx does not mean that the believers consciously formulate their misery in terms of the religion in question. On the contrary, for the believer religion and misery represent two quite different domains and it is the *critic* who first reveals the real relationship between them. In other words, in the passage from Marx we have just quoted 'expression' also designates an unconscious and immediate relationship between ideology (in this case religion) and the real position in which the bearers of ideology find themselves.

Since Marx's critique of the declaration of human rights as well as his critique of religion must be taken as fundamental in any attempt to determine the nature of ideology critique, and since furthermore redemptive critique distinguishes itself from the first of these critical approaches while displaying essential features in common with the second, we must conclude that the two types of critique are in no way mutually incompatible and that ideology critique represents the

more encompassing type of critique. But this does not imply that both types of critique simply coincide with one another.

A glance at Benjamin's book on Baudelaire will help to reveal more clearly both the differences and the affinities between the two kinds of approach. In the fragments of Baudelaire's work Benjamin discovers the signature of an age, in the theme of the promenading poet for example the phenomenon of the mass. When he confronts quotations from Baudelaire's work with fragments of social reality, he does so with the intention of redeeming the historical truth content of the work of art. The cognition of reality which is consciously achieved here is the work of the critic and not the work of the author Baudelaire. If we attempt to read off the specific character of Benjamin's redemptive critique from his book on Baudelaire, it is possible to isolate the following features:

1 The connection between the objective cultural forms and the social reality is a relation of expression in the sense defined above and the connection in question is not consciously present either to the author or to the public;
2 Redemptive critique emphasizes the historical truth content of the objective cultural forms of the past and to that extent represents a preserving rather than destructive kind of critique;
3 The achievement of knowledge belongs exclusively to the critic (and his or her public).

In all this the work has the status of material which is placed on the same level as other manifestations of reality.

Let us now compare these particular features with the practice of ideology critique. With respect to the first point, ideology critique encompasses the conscious and unconscious connections between the objective cultural forms and social reality. It discovers precisely within the rational interpretations of reality (the ideologies) a moment which is concealed from the producers and consumers of the ideologies in question and subjects this moment to explicit critique. With respect to the second point, ideology critique is also concerned with the historical truth content of the objective cultural forms of the past. But ideology critique does not seek to conjure this truth content by confronting a quotation from the work with a fragment of reality but attempts to construct the truth content from the work in its totality. Finally, with respect to the third point, ideology critique differs from redemptive critique in that it takes up the knowledge of reality which is achieved in the work in order to transcend this knowledge critically. While redemptive critique con-

ceives the author as a kind of seismograph which registers, transforms and transmits impressions, ideology critique regards the author primarily as a social subject who depicts reality from a perspective determined by his or her standpoint within society.

Benjamin succeeded in developing a kind of critique which cannot simply be equated with ideology critique. For redemptive critique lacks the concept of false consciousness and indeed lacks this concept precisely because it considers the objective cultural forms exclusively as expressive phenomena which escape the consciousness of producers and consumers alike. But it would be quite mistaken to infer from this that redemptive critique and ideology critique represent two different types of procedure which are incompatible with one another. On the contrary, it should now have become obvious that both types of critique actually supplement and complete each other, although ideology critique must be accorded priority as the more encompassing model. The task of a critical hermeneutics would therefore be to develop a form of critique which would include and transcend the two types of critique we have been discussing. Critical hermeneutics cannot restrict itself exclusively to the conscious understanding of reality achieved in the work of art and will have to include consideration of those expressive phenomena which redemptive critique strives so hard to grasp.

To facilitate clarity of exposition we initially emphasized those aspects which clearly serve to distinguish ideology critique from redemptive critique, but I would now like to take up some ideas of Benjamin which could suggest an appropriate starting-point for developing a critical hermeneutics embracing both types of critique.

Redemptive critique is dialectical critique and to this extent finds itself in agreement with ideology critique. Benjamin provided his most convincing example of this aspect of redemptive critique in his review of W. Hegemann's *Das steinerne Berlin*. Although Benjamin fully shares Hegemann's enlightened critique of the Berlin tenements, he still finds the account deficient for it 'possesses no sense of historical physiognomy'.[24] 'The chaotic crudity of the settlement, which we must certainly oppose with all our strength, still has a beauty of its own, not merely for the promenading snob from the West but for the Berliners, the barge-dwelling Berliners themselves, a beauty which is intimately related to their language and customary forms of behaviour.'[25]

Redemptive critique grasps the contradictoriness of the real and is able to discover the positive moment even in that which it is attempting to destroy. It can see 'beauty even in the most profound

deformation'.[26] Redemptive critique yokes opposite together: as critique it is directed towards the destruction of what it criticizes but precisely as redemptive critique it strives to preserve the positive moment in the object it subjects to critique. This act of preservation is not a matter of mere piety towards the past but rather the expression of practical humanity which alone can prevent the deliberately constructed house of the future from becoming uninhabitable for those who are to inhabit it.

In Nietzsche's typology of the possible relationships obtaining between history and life we find ourselves confronted with a split between an antiquarian attitude concerned solely with preserving tradition on the one hand and a critical manner of treating history which shatters the tradition on the other. Benjamin forcibly seeks to bring these two approaches back together.[27] However, in pointing this out we should certainly not overlook the fundamental differences which separate Benjamin and Nietzsche when it comes to defining these preserving and critical approaches. If antiquarian history is characterized for Nietzsche by a 'highly restricted field of vision' and by a lack of sensibility for 'differing values and for proportions',[28] for Benjamin the efforts of preservation are precisely not directed indifferently towards everything handed down by the relevant tradition. On the contrary, these efforts are directed towards that which alone has shown itself under critical scrutiny to be worth preserving and to this extent the act of preservation cannot be separated from critique. And Benjamin conceives the concept of critique quite differently from Nietzsche as well. If for the latter it is 'life alone, that dark, driving, insatiably self-seeking power'[29] which constitutes the source from which all critique derives its legitimation, it is the critic's position in the present which supplies the point of reference for Benjamin. Here it is a rational social theory which provides the basis for critique rather than a mythical appeal to the power of life. The goal of Benjamin's critique is a synthesis of preservation and critique since 'a no-saying form of historical knowledge is meaningless'.[30] The problem lies in discovering what should be preserved. Here too Benjamin takes up an idea from the beginning of Nietzsche's essay when he insists upon the necessity of forgetting[31] and emphatically opposes that 'hunt for false riches . . . for the assimilation of every past' which is so characteristic of cultural history.[32] But in so doing he frees Nietzsche's critique of historicism from its original context in the philosophy of life and interprets the attempt to compile an inventory of 'the past as a dead possession' socially in terms of the 'self-alienation of man'.[33]

However, it remains an open question as to how we are to determine the criteria which allow us to decide just what is a 'dead possession' and what is a living cultural one.

Benjamin opposed the kind of critique he developed not to ideology critique but to apologetics. In order to reveal the 'methodological relation of this work [i.e. the book on Baudelaire] to dialectical materialism', Benjamin planned to write an introduction 'in the form of a confrontation between "redemption" and current "apologetics"'.[34] Two fragments connected with the 'Passages' project allow us to grasp Benjamin's approach here at least in outline. In one of them Benjamin insists that critical theory does not attempt 'to pursue the "thing itself"'[35] since the whole idea of 'the thing itself' is an objectivist delusion. 'It is a vulgar marxist illusion to believe that it is possible to determine the social function of a product, whether it is a material or a cultural–intellectual one, independently of the circumstances and the agents of its transmission.'[36] What presents itself as an object of investigation to us is not 'the thing itself' but something which has been shaped by the process of transmission. 'That means, in other words, that it [sc. the critical method] takes its point of departure from the object permeated as it is by error, by δόξα.'[37] The critical method takes this transmission as its point of departure but it does not simply abandon itself to it. Critical method enquires into the social forces which sustain the process of transmission. In so far as it recognizes in the dominant tradition the tradition of the dominators, the critique of tradition simultaneously opens up access to what is at issue here:

The process of 'appraisal' or apology strives to conceal the revolutionary moments in the unfolding of historical events. It tries above all to fabricate an appearance of continuity. . . . It lays emphasis only upon those moments of the work which have already come to form part of its effective history. It overlooks the breaks and jagged edges which give purchase to those who wish to go beyond this history.[38]

Whereas apologetic criticism abandons itself to the effective-historical continuum, redemptive critique expressly seeks out just those moments in the work which have not found their way into its effective history. It concentrates upon the 'breaks and jagged edges' and finds precisely there the clue for a reading which conflicts with that transmitted by the tradition.[39] Whereas apologetic criticism only pays attention to the moments of the work already sanctioned by its effective history, fabricating continuity in the process, redemptive critique insists upon that which cannot be accommodated in the

tradition and thus produces a rupture with the latter. As opposed to the apologetic approach, this is a form of productive critique which itself produces meaning: not any arbitary meaning but one which manifests itself to the critic who comes afterwards on the basis of the position which he or she occupies in his or her own time. This is not a question of historical empathy, which would try to project the past into the present, but a question of the production of meaning. For the critic draws useful knowledge for the shaping of the present from out of the historical work itself. 'That which has been must be held fast . . . as an image which flashes forth in the now of its cognition.'[40] Benjamin solves the problem of identifying the categories which permit the distinction between 'dead possession' and a genuine cultural one by making contemporary relevance the criterion of this distinction: 'the innermost structures of the past only reveal themselves to any present in the light produced in the white heat of their relevance now'.[41]

The construction of a contemporary perspective

Even a historical discipline which understands itself in materialist terms is not automatically immune to the danger of conservatism. Historical research is threatened in this way whenever it simply contents itself with trying to render the work of the past intelligible on the basis of its original time. Benjamin thought he could discern the danger of such conservatism in Franz Mehring, in whose work he saw a tendency which was 'much rather conserving, in the best sense, than actually revolutionary'.[42] In opposition to this approach Benjamin emphasized the relationship with the present implied in historical–hermeneutic work. 'The task is not to expound the works of literature in the context of their time but rather in the time in which they arose to reveal the time which recognizes them – and that is our own.'[43]

We should hold on to two aspects of Benjamin's thought here: on the one hand the reciprocal illumination between past and present provoked by the critic, on the other hand the moment of application which brings the past to bear upon the present. Benjamin's concept of relevance proceeds from the idea of correspondence between different epochs. He opposes the concept of temporality fulfilled in the presence of the 'now' to the purely continuous passing of 'homogeneous and empty time' as conceived by the historicist.[44] In this connection the 'now–time' only arises from the constellation

with a particular past which is entered into by the present. The historian as Benjamin understands him, who explodes the continuum of history and frees a piece of the past from it, redeems a unique image from the past by applying it to the present. Just as Robespierre could cite ancient Rome, so the historian can cite a piece of the past as well. The moment of redemption cannot be separated from this application to the present. It is very important to recognize this since otherwise we might easily misunderstand formulas like that of the 'tiger's leap into the past'.[45] Application occurs in so far as the past enters into a constellation with the present which allows us simultaneously to illuminate the present through the analysis of the past.

Yet even this idea of the application of the past to the present does not automatically protect us from a conservative approach. For there is indeed a conservative version of historical critique oriented towards the present. Benjamin encountered just this problem in the work of the literary historian Max Kommerell, whose relationship to history Benjamin characterized critically as an 'anachronism of sectarian language'. 'It [sc. history] is never a subject of study for them [sc. sects], it is always only an object for their claims. They seek to annex the past to themselves as an original entitlement or paradigm.'[46] At first sight this passage appears rather confusing, for Benjamin seems here to be criticizing in his opponents precisely the kind of method he defends himself. Yet Benajmin does not in fact seek to retreat to a spurious objectivism which would legitimate the opposition between 'study' and our 'claims' but rather grasps the problem in all its ramifications. He opposes 'theory' to Kommerell's mystical act of vision and this implies that the critical–hermeneutic application of the past to the present is only possible on the basis of a solid analysis of the contemporary situation. 'Admittedly, our present may be barren. But whatever it is like, one must take it firmly by the horns if we wish to interrogate the past.'[47] Here Benjamin provides a decisive criterion for distinguishing between a conservative and a progressive way of dealing with the past. In both cases the past is brought into relation with the present but the conservative approach lacks any theoretically grounded analysis of the present. This latter approach easily succumbs to a distorted picture of the past because it is not based upon an understanding of present reality but upon vague fantasies about the present.

This critique of the conservative application of past to present explains why Benjamin insists so strongly upon attaining a proper standpoint in the present. For him such a standpoint is not some-

thing that is already self-evidently given (as it is for Gadamer's hermeneutics). Rather it is the result of a theoretical labour which Benjamin describes as an arresting of the present. For it is only 'the concept of a present which is not a transition, but in which time stands still and has come to a stop'[48] which makes possible that way of dealing with the past to which Benjamin aspires, one in which it is 'redeemed' in so far as it knowingly contributes to the solution of the problems of the present.[49]

3

The Decline of Modernism

There is no protection against the misuse of dialectical considerations for restorative ends. Adorno

For some time sociologists and philosophers have tended to label present-day society 'post-industrial' or 'post-modern'.[1] Understandable as the wish is to set off the present from the age of advanced capitalism, the terms selected are no less problematic. A new epoch is introduced before the question is even asked, let alone answered, as to how decisive current social changes are, and whether they require that a new epochal boundary be set. The term 'post-modern', moreover, has the additional disadvantage of only naming the new period abstractly. There is an even more drastic disadvantage. Of course, deep economic, technical and social changes can be observed when compared with the second half of the nineteenth century, but the dominant mode of production has remained the same: private appropriation of collectively produced surplus value. Social democratic governments in Western Europe have learned only too clearly that, despite the increasing significance of governmental intervention in economic matters, the maximization of profit remains the driving force of social reproduction. We should therefore be cautious about interpreting the current changes and not

Translated by David J. Parent. Originally published in J. Habermas and L. von Friedeburg, eds. *Adorno-Konferenz* (Frankfurt, 1983).

evaluate them prematurely as signs of an epoch-making transformation.

Even in art, talk of the 'post-modern' shares the defects of the sociological concept of the 'post-modern'. From a few quite accurate observations, it prematurely postulates an epochal threshold which, however, can be indicated only abstractly, since a concrete definition obviously fails. Despite this general objection to the concept of the 'post-modern', it is difficult to deny that in the last twenty years changes have taken place in the aesthetic sensitivity of those strata which were and are the carriers of high culture: a positive stance towards the architecture of the *fin de siècle* and hence an essentially more critical judgement of modern architecture;[2] the softening of the rigid dichotomy between higher and lower art, which Adorno still considered to be irreconcilably opposed;[3] a re-evaluation of the figurative painting of the 1920s (e.g. in the great Berlin exposition of 1977); a return to the traditional novel even by representatives of the experimental novel. These examples (they could be multiplied) indicate changes that must be dealt with. Is it a question of cultural phenomena that accompany political neo-conservatism and therefore should be criticized from a consistent modern standpoint? Or can so unambiguous a political classification not be ascertained, and do the aforementioned changes compel us to draw a more complex picture of artistic modernity than even Adorno did?

If, starting from the post-modern problematic, one returns to Adorno's writings on aesthetics, and especially music, one discovers, not without surprise, that he was very much preoccupied with the problem of the decline of the modern age at least since the Second World War. Adorno first encountered this problem in the early 1920s in his first composition teacher who, as an opponent of atonal music, sought to lead his pupils back to tonality by portraying the former as old-fashioned. Adorno tells of this in his *Minima Moralia*: 'The ultra-modern, so his argument went, is already no longer modern, the stimuli which I was seeking had already become dull, the expressive figures which excited me belonged to an old-fashioned sentimentality, and the new youth had more red blood corpuscles, to use his favorite phrase.'[4] The idea, which strikes us as a little absurd, that modern art was already at an end by the early 1920s, could at that time have claimed a certain plausibility. As early as 1917 Picasso had abruptly broken off his cubist phase with his portrait of his wife (*Olga in the Reclining Chair*) that smacked of Ingres. In subsequent years, he alternately painted cubist and

'realistic' pictures. In 1919, Stravinsky, who just two years earlier had written the avant-garde *Histoire du soldat*, returned to eighteenth century music with the ballet *Pulcinella*. And in 1922 Paul Valéry, with his collection of poems *Charmes*, sought to re-establish the ideal of a strict, formal classicism. Not only second-rate artists rejecting their own age oriented themselves by the classical model, but with Picasso and Stravinsky (Valéry's case is somewhat different) it came to include precisely those who had contributed decisively to the development of modern art. That makes the problem of neo-classicism a touchstone for every interpretation of artistic modernity.

Adorno did not avoid the problem but – as he so often did – he advanced two contradictory interpretations of it. The first, which could be called polemical, can be found in the above-quoted text of *Minima Moralia*: 'Neoclassicism, that type of reaction which does not admit being so but presents even the reactionary element itself as advanced, was the vanguard of a vast trend, which under fascism and in mass culture quickly learned to do without delicate consideration for the all-too-sensitive artists and to combine the spirit of Courths-Mahler with technical progress. The modern age has actually become unmodern.'[5] Sharply opposed to the modern spirit, neo-classicism is at the same time denounced as politically reactionary. Undoubtedly, this interpretation can be documented: De Chirico's turn to fascism corresponds to his rejection of so-called mythical painting.[6] But such individual cases are hardly sufficient to support so far-reaching an interpretation as Adorno's, which excludes neo-classicism as a whole from the modern.

Adorno himself could hardly have missed the problematic character of so summary a viewpoint. At any rate, in his late essay on Stravinsky, where he corrects his portrayal of the Schönberg-antipode in the *Philosophy of Modern Music*, he proposed a completely different interpretation of neo-classicism: Stravinsky's music is not the reconstruction of a binding musical language but an artist's sovereign play with pre-given forms of the past. Winckelmann's classicism was not being set up as a norm, but it 'appeared as in dreams, plaster statues on clothes-cabinets of his parents' apartment, scattered odds and ends and old paraphernalia, not a genre-concept. The scheme was shattered by this individuation of the formerly schematic into a scarecrow; it was damaged and disempowered by a patched-up arrangement of dreams.'[7] By explicitly locating Stravinsky's as well as Picasso's neo-classicism in the vicinity of surrealism, Adorno now assigns the latter a place *within* modern

art. That the two interpretations are incompatible is obvious, and so is the superiority of the latter interpretation. Whereas the polemical interpretation proceeds in a globalizing fashion, understanding neo-classicism as a unitary movement, the second interpretation seeks differentiation. It leaves open at least the possibility of seeing more in neo-classical works than a sheer relapse into a reactionary thinking of order.

As for Adorno's evaluation of neo-classicism, however, one must not be deceived by the allusion to a common ground with surrealism. He compares even the montage-procedure of *Histoire du soldat* with the 'surrealists' dream-montages made of everyday remnants',[8] without thereby at all mitigating the negative judgement of this work. With an argument which he will take up in his dispute with Hindemith, he interprets the element of protest in the *Histoire* as regressive, as the expression of the ambivalent stance of a man who remains attached to the authority against which he rebels.[9] 'Close behind the wild behavior lurks identification with that against which one is rebelling; excess itself, as it were, proclaims the necessity of moderation and order so that such a thing may at last cease.'[10] Adorno sees a connection between Stravinsky's turning to so-called neo-classicism and the previous questioning of traditional musical language by reference to trivial forms and their consistent shattering in the *Histoire du soldat*; but he devalues both as 'music about music'.[11] By taking up and disintegrating pre-given forms such as march music and ragtime, Stravinsky seizes '(literally) existing musical materials' and changes them (Stravinsky's neo-classicial music uses the very same approach). Such a procedure runs counter to the principle postulated by Adorno of a complete pervasiveness of *form*. Just as the surrealistic collage first takes up the wood-cut, with its depiction of the *fin-de-siècle* bourgeois interior as a retrospective fragment of reality, so Stravinsky's *Histoire du soldat* takes up the tango or the waltz. And as Max Ernst alienates the interior by giving his humans beast-of-prey heads, so Stravinsky alienates the forms of entertainment music. This quite avant-gardistic treatment of the pre-given, which does not settle just for the parody of these forms (as Adorno suggests in one passage),[12] but through it aims at a questioning of art, resists Adorno's concept of art. Holding firmly to the idea that artistic material reflects the state of total social development without the consciousness of the producer being able to see this connection, he can recognize only *one* material in a given epoch. Indeed he goes so far as to challenge the use of the concept of material for Stravinsky: 'The concept, central for Schönberg's

school, of a musical material innate in the work itself is, strictly speaking, hardly applicable to Stravinsky. His music is constantly looking at other music, which it consumes by overexposing its rigid and mechanistic traits.'[13] The concept of 'material' applied here, which eliminates the element of givenness from the material, absorbing it completely within the work and attaching it to the principle of the *all*-pervasiveness of form, is revealing because it stands at odds with the avant-gardist principle of montage. Here we encounter what I have called Adorno's anti-avant-gardism.[14] It is only apparently paradoxical that this anti-avant-gardism lies at the basis of his rejection not only of the (in his own term) infantile Stravinsky, but also of the neo-classical one.

Here it is not a question of saving neo-classicism as a whole; this would be just a repetition of the mistake of the polemical interpretation from *Minima Moralia* under a different valency. Whether the recourse to past formal schemata merely reproduces them or they are made into a convincing means of expression for a current expressive need cannot be decided by theory, but only by meticulous, detailed analysis of individual works.[15] Adorno's magnificent one-sidedness consists in having demanded this decision of theory. Of course, increasing historical distance is also highlighting more and more its negative consequences which restrict the field of possible artistic activity. This is true especially of the thesis of the single-strandedness of the artistic material. But it also applies to the principle of the totally constructed character of the work, which assigns an eccentric place to the concept of montage within the system of Adorno's aesthetics; for this concept can be assimilated by Adorno only by absorbing Benjaminian motifs into his own thinking.

The abandonment of Adorno's thesis (ultimately based on the history of philosophy) of the most 'advanced artistic material,' does not merely allow the juxtaposition of different stocks of material to come into view (e.g. the painting of the 'new objectivity' along with Picasso's or that of the surrealists), whereby theory no longer presumes to explain *one* material as the indicator of the historical moment. It also facilitates the insight that the later development of an artistic material can run into internal limits. This can be observed in cubism. The consistency with which Braque and Picasso draw certain conclusions from Cézanne's late work and carry them further has often been admired. Yet, it is not hard to observe in Picasso's paintings from 1914 a certain arbitrariness, whose most striking feature is the recourse to pointillistically shaped surfaces. This pointillism will then return in a few of the traditional figurative

pictures of 1917 – a technical idea whose necessity is lacking in both cases. The idea that the possibility of a consistent continuation of the cubist material could have been exhausted is not far-fetched. It could probably also be supported by including the further development of the painting of Braque and Gris. If this is admitted, then the recourse to a different material which Picasso undertakes in *Olga in the Reclining Chair* is given a consequentiality which Adorno's aesthetics does not allow us to recognize. Neither the recourse to a neo-classical material is thereby aesthetically justified (for this, the quotation-character of the recourse would have to be cogently proven, which I consider impossible), nor it is adequately interpreted historically (for this, various possibilities of interpretation would have to be weighed against one another). But the necessity to break out of one type of material would be made evident as precisely the attitude which the modern artist feels compelled to adopt.

The free disposition over various stocks of materials seems at first sight to broaden creative possibilities immeasurably. This is indeed true in a certain sense, but at the same time it no less drastically restricts the chances of success. Here lies the moment of truth in the normative restrictions which Adorno and Lukács adopt (though in opposite directions). Valéry saw this correctly: the restriction of the field of productive possibilities can increase the chances of artistic success, because it compels concentration. But – and Valéry overlooked this – the restriction must not be an arbitrarily postulated one, but must be experienced by the producer as necessary. Because Valéry's poetic activity submits to coercions that are set only externally, it comes close to craftsmanship on more than a few occasions. Only where the free availability of various stocks of materials is not simply accepted as a given wealth, but is reflected in the work itself, can the producer hope to escape the illusion of unlimited possibilities.

Adorno's first composition teacher had falsely posed the problem of the waning of the modern age, namely, in terms of the obsolescence of the modern as a result of neo-classical anti-modernism. At least in the text of *Minima Moralia*, Adorno lets the statement of the problem be prescribed to him by the opponent when he condemns neo-classicism *en bloc* as reactionary. But not even in the *Philosophy of Modern Music* does he proceed much differently; only here he includes Stravinsky in his avant-garde phase in his negative judgement. Radical avant-gardism and neo-classicism remain equally outside Adorno's concept of the modern. Only with the essay published in 1954 on the 'Decline of the new music' does he pose the

problem which we have already cited with reference to cubism: the immanent boundaries in the development of the new music. 'Decline' here does not mean the gradual process of adaptation on the part of at least certain strata of listeners to this music and the resulting dulling of the shock effect; it is rather a question of the central categories of the thing itself. What bothers Adorno could be called modernist conformism. It is first characterized by the works' loss of tension,[16] their lack of expression. The phenomenon is not limited to music. Who has not seen those abstract paintings, which are ideally suited to decorate managerial offices? All that can be said about such works is: they disturb nothing. As such, they betray the modern; as abstract, however, they also claim to belong to it.

Adorno does not blame the works' manifest loss of vigour on the subjective failure of the producers, but on an objective developmental tendency of modern art. This could be summed up in the statement that the modern primacy of artistic material turns into 'material fetishism'.[17] This goes right to the central category of Adorno's aesthetic: the artistic material, which is at the centre of his historico-philosophical interpretation of the development of art. As sedimented content, it corresponds subterraneanly to the totality of the epoch. Hence, its transformation coincides with that of society; both belong to the principle of progressive rationalization: 'The core-concept which sets recent musical history in motion is that of rationality, immediately united with that of the social domination of extra- and intra-human nature'.[18] This formulation is very radical, but precisely because of this, it casts a harsh light on a constant of Adorno's aesthetic: the refusal '(to isolate) from the process of enlightenment, art as a protected natural part of the unchangingly human and well-protected immediacy'.[19] This means an uncompromising advocacy of rationality in the artistic production process. Adorno must now recognize precisely these 'tendencies toward total rationalization', combined with the 'widespread allergy to all expression'[20] as the cause of all waning of the modern. Even 'the emancipation from the pregiven formal categories and structures',[21] which he identifies as the ineluctable accomplishment of the artistic revolution at the beginning of our century, owes its expressive content not least to the traditional material from which it distances itself. Modernism, by not admitting that it is obligated to tradition by its very negation of it, succumbs to the 'superstition of significant original elements, which in fact stem from history and whose very meaning is historical'.[22]

Adorno's judgement is hard: not only does the technicized stance of the producers, their 'infatuation with the material',[23] associate them involuntarily with the art industry, but even their rationality becomes a superstition of the direct symbolism of colours and tones. Yet, the expectation that Adorno would draw the consequences from this radical critique of modernism, more precisely from his concept of modernity, is frustrated. He even sees himself compelled to rehabilitate the categories of expression and the subject. But this by no means goes so far that he would revise his own earlier statements. In the *Philosophy of Modern Music*, he says of Webern: 'He saw the derivative, exhausted, irrelevant nature of all subjectivity, which music here and now would like to fulfill: the insufficiency of the subject itself'; and a little later: 'the subject's right to expression itself succumbed'.[24] No less categorical, however, are the statements in 'The decline of the new music': 'All aesthetic objectivity is mediated by the power of the subject, which brings a thing completely to itself'.[25] Hence, 'the symptoms of the waning of the new music' can be interpreted as symptoms 'of the disintegration of individuality'.[26] The contradiction is surely not just one of theory; rather, theory captures something of the aporetic position of the modern artisit. The artist is pledged to a subjectivity under conditions which are ever more unfavourable to the development of individuality.

The insights into the waning of the new music have, as far as I can see, evoked no thorough revision in Adorno's aesthetics. The closest to this would be the category of *mimesis* which in his *Aesthetic Theory* assumes an important position as a counterpoint to aesthetic rationality. It remains, however, unclear how mimesis becomes effective in the production process. This in turn depends on the fact that a theory of mimesis in the strict sense is impossible, since Adorno defines this as 'archaic behavior', 'a stance toward reality this side of the rigid opposition of subject and object'.[27] Indeed, some formulations of *Aesthetic Theory* go so far as to subordinate aesthetic rationality to mimesis, so that the concept of rationality hardly has anything to do with Max Weber's employment of it, but means merely the artist's intervention: 'With blindfolded eyes, aesthetic rationality must plunge itself into the process of formation, instead of steering it from the outside, as a reflection on the work of art'.[28] But even this strong relativization of the concept of aesthetic rationality (Adorno speaks in one place only of a 'quasi rational tendency of art')[29] does not call into question the construction of the

development of art in bourgeois society based on the Weberian concept of rationality. Neither the theorem of the most advanced artistic material nor what could be called Adorno's purism (his refusal to consider the possibility of a recourse to trivial material) are revised.[30] The presence of a modernist conformism is, for Adorno, no reason to permit recourse to past stocks of material: 'However, that radically abstract pictures can be displayed in exposition halls without annoyance does not justify any restoration of objectivism, which comforts a priori, even though for the sake of reconciliation one selects Che Guevara as object.'[31] One can ask whether the (unnecessary) jab at the student movement does not merely conceal a weakness of the argument. Today, at any rate, it should no longer be clear why neo-realism should be rejected simply because it uses an objective material, or Peter Weiss's *Aesthetic of Resistance* because it uses narrative techniques of the realistic novel.

If one seeks the reasons that prevent Adorno from drawing conclusions for his aesthetic theory from his insights into the decline of the modern, it makes sense to consider his belonging to the Schönberg school. In fact, in his 1960 essay 'Music and new music', he tried to solve the problem with virtuosity: here the waning of the new music is reinterpreted in the sense of the ascendancy of a new epochal style.[32] 'Its concept wanes because next to it the production of others becomes impossible, becomes *Kitsch*.'[33] The restriction of the music of the present to 'the variety which has a place in the Schönberg school'[34] must none the less not be explained just from the fact that Adorno's aesthetics is production-oriented. Such an interpretation would take too lightly Adorno's claim to have formulated *the* aesthetic theory of the modern. There is more behind this undeniable aesthetic decisionism than the dogmatism of a school. With it Adorno seeks to banish the danger of historicism, 'the chaotic juxtaposition of music-festival authors, who in the same era embody historically different positions and whose syncretic co-existence merely continues the stylistic jumble of the nineteenth century'.[35]

Now it is easy to see that aesthetic decisionism and historical juxtaposition are just two sides of the same historical situation as long as there is failure to legitimate the decision for a specific material tradition. Adorno does this by associating artistic development in bourgeois society with the modernization process (in his terminology: with enlightenment). Art should by no means become the refuge of the irrational within a rationalized world. Only when art corresponds technically to the state of development of the forces

of production can it be simultaneously an instrument of knowledge and a potential for contradiction. 'But if art really would want to revoke the mastery of nature; if it applies to a state in which men no longer exercised mastery through the mind, then it reaches this point solely by virtue of the mastery of nature.'[36] One is tempted to reproach Adorno with a mysticism of the dialectical reversal. In fact, he does not draw from the dialectic of enlightenment the consequence that it is a matter of slowing up the process of modernization. Rather, he holds firmly to the idea of the dialectical reversal: 'in a rationally organized society, together with scarcity, the necessity of repression through organization [would disappear]'[37] Such hopes (seldom expressed by Adorno) of an ultimately achieved rationalization might be difficult to share today.

Fear of regression remains the central motif for Adorno's aesthetic decisionism. It determines both his rejection of the avant-gardist Stravinsky as well as of neo-classicism. This fear, understandable because of the experience of fascism which knew how to channel and legitimize the regressive wishes of the masses, however, strips modernism of one of its essential modes of expression. Diderot had realized this when he wrote: 'Poetry wants something monstrous, barbaric and savage.'[38] The longing for regression is an eminently modern phenomenon, a reaction to the advancing rationalization process. It should not be tabooed, but worked out. Bloch's warning not to leave irrationalism to right-wingers has today reacquired an urgency which can hardly be overestimated.

Adorno's thoughts on the waning of modernism are formulated from the perspective of production; they should therefore be complemented by a remark on changes in the area of reception. Among younger persons today one can often notice a way of dealing with literary works that can only be characterized as low-brow from Adorno's standpoint. I mean the widespread renunciation of any discussion of aesthetic form in favour of a discussion of the norms and patterns of behaviour which are the basis of the actions of the characters portrayed. The questions which are asked of the work then do not read: How are the aesthetic form and content of the work communicated? but: Did this or that character act correctly in this situation? How would I have behaved in a comparable situation? Such an attitude of reception can be dismissed as inadequate to works of art and can be judged as a sign of a cultural decline. But one can also ask whether the reading of a realistic novel that is interested mainly in procedures of narrative technique does not miss precisely its specific achievement. One can even go further and ask whether

the novel does not become primarily an autonomous work of art detached from the living practice of individuals by the fact that a particular discourse marks it as such. What first seemed to be only a lack of culture could prove to be the starting-point of a new way of dealing with works of art that overcomes the one-sided fixation on form and at the same time places the work back in relation to the experiences of the recipients.

Do these observations justify the characterization of the art of the present as one of post-modernism, and what implications does this have? To answer these questions, I would like to distinguish three different readings.

1. *The anti-modern reading*: It could use Adorno's theorem that there is in every epoch just *one* advanced stock of material, and turn it against Adorno. The signs of a waning of the new music which he noted, turned, it could be argued, away from twelve-tone music and returned to tonality. Since comparable processes of decline can be seen in abstract painting and modern literature, a return to objectivity or to realistic forms of narration is suggested here too. Of course, metaphysical validity could no longer be attributed to the traditionally normative genres, but they had their place as artistic means. As Valéry repeatedly showed, artificially posed difficulties (for instance, the fulfilment of a complicated verse scheme) acted as stimulants to artistic achievement. In brief, one could formulate a theory of post-modernism as a pleading for the new academicism and in so doing appeal once again to Adorno who has regretted the loss of the 'pedagogical virtues of academicism'.[39]

That Adorno was as far from thinking of a return to academicism as he was from any call for moderation (he calls 'the ideal of moderate modernism' disgusting[40]) is not adequate to refute the above argument. Its strength consists precisely in that it – rightly, it would seem – raises the claim of drawing from Adorno's reflections the conclusions which he evaded. Also the argument drawn from Adorno's critique of Lukács that realistic forms are *as such* affirmative, has become unconvincing, since non-objective paintings have become the decor of managerial suites and are used as montages for magazine covers. If one does not want to settle for a political critique of aesthetic restoration, then one will have to try to show its weakness by way of immanent critique. It lies in an *aporia* that is otherwise typical of neo-conservatism. For it can attain its own standpoint (here: the return to tonality, to objectivity and to traditional literary forms) only by the abstract negation of modernism. But this approach contradicts its own conservative self-

understanding, which values not new beginnings, but preservation and development. Since the anti-modern version of the post-modern theorem can preserve nothing of modernism, it comes to contradict its conservative self-understanding. That unmasks it as a badly secured polemical position which has nothing to contribute to the comprehension of the possibility of art today.

2. *The pluralistic reading.* It could be formulated approximately as follows: theorists of modernism have held the objectively illegitimate thesis that only modern art has attained the heights of the epoch. They thereby devalued implicitly or explicitly all rival artistic movements. The decline of modernism shows the one-sidedness of a concept of tradition which recognizes in music only the Schönberg school, and in narrative literature only a few authors such as Proust, Kafka, Joyce and Beckett. The music and literature of the twentieth century were, however, much richer. The consequence of this position for the present reads: there is no advanced material, all historical stocks of material are equally available to the artist. What counts is the individual work.

This position has a series of arguments in its favour. There can be no doubt that a construction of tradition such as Adorno's is one-sided. We should, however, not forget that it owes to this one-sidedness its capacity for making connections recognizable. That today, however, no particular material can still be regarded as historically the most progressive is indicated not only by the motley array of different things, so confusing for the outsider, which every local fine arts exhibit documents. It is demonstrated mainly by the intensity with which some of the most conscious artists explore the use of the most varied stocks of materials. A few of Pit Morell's etchings contain reminiscences of Renaissance drawings along with the expressive directness of the paintings of children and the insane. And Werner Hilsing paints at the same time surrealist, expressionist and cubist miniatures, thus reflecting the possibility of a multiplicity of material. If one wanted to try to draw any conclusions from this, it would be that aesthetic valuation today must detach itself from any link with a particular material. Less than ever does the material guarantee in advance the success of the work. The fascination which correctly emanates from periods of consistent development of material (say, in early cubism) must not mislead one into making it the supratemporal criterion of aesthetic valuation.

The insight into the free availability of different stocks of material which exists today must neither blind us to the resulting artistic difficulties nor to the problematic of the position which is here called

pluralist. Whereas Adorno would single out almost all of current artistic production as worthless, the 'pluralist' runs the danger of recognizing everything equally and falling prey to an eclecticism which likes everything indiscriminately. Art thus threatens to become an insipid complement to everyday life, i.e. what it always was to the popularizations of idealist aesthetics.

Instead of drawing from the questioning of the theorem of the most advanced material the false conclusion that today everything is possible, one would have to insist on the difficulties which confront works today. If reliance on the correspondence between the artistic material and the epoch has vanished, a reliance which is the historico-philosophical basis of Adorno's aesthetics, then for the productive artist too the abundance of possibilities can appear as arbitrariness. He cannot counter it by surrendering to it, but only by reflecting upon it. That can be done in many different ways: by radical restriction to *one* material, but also by the attempt to use the multiplicity of possibilities. The decision is always legitimized only afterwards, in the product.

3. *Towards a contemporary aesthetic*: I would explicitly not like to place this third reading under the auspices of post-modernism, because the concept suggests an end to the modern era, which there is no reason whatever to assume. One could instead claim that all relevant art today defines itself in relation to modernism. If this is so, then a theory of contemporary aesthetics has the task of conceptualizing a dialectical continuation of modernism. It will strive to affirm essential categories of modernism, but at the same time to free them from their modernist rigidity and bring them back to life.

The category of artistic modernism *par excellence* is form. Subcategories such as artistic means, procedures and techniques converge in that category. In modernism, form is not something pre-given which the artist must fulfil and whose fulfilment the critics and the educated public could check more or less closely against a canon of fixed rules. It is always an individual result, which the work represents. And form is not something external to the content; it stands in relation to it (this is the basis of interpretation). This modern conception of artistic form, which originates in the modern age with the victory of nominalism, ought to be irreplaceable for us. Though we can imagine a work of art in which individual elements are interchangeable (from a picture of Pollock's one can cut off a part without essentially changing it, and in a paratactically constructed narrative individual parts arranged in succession can be

interchanged or even left out); but we cannot imagine a work in which the form as such would be arbitrary. Irreplaceability means that in the act of reception we apply a concept of form that grasps the form of the work as particular, necessary within certain limits, and semantically interpretable.

But irreplaceability must not be confused with unchangeability. The aesthetics of idealism grasps the work of art as a form/content unity. 'True works of art are such, precisely by the fact that their content and form prove to be completely identical,' says Hegel in his *Encyclopedia*.[41] But in this positing of a unity of subject (form) and object (content) history did not come to a stop. Rather, the development of art in bourgeois society bursts asunder the idealistically fused elements of the classical type of work. The concept of the work held by idealistic aesthetics was itself already an answer to the modern phenomenon of the alienation of individuals from themselves and the world. In the organic work of art, the really unresolved contradictions are supposed to appear as reconciled. Hence, the demand of a form–content unity that alone can generate the appearance of reconciliation. Now, to the extent that bourgeois society develops into a system that is subject to crises, but none the less closed, the individual increasingly feels impotent *vis-à-vis* the social whole. The artist reacts to this by attempting to prove, at least in his own field, the primacy of the subject over the given. This means the primacy of the subjectively set form, the primacy of material development. The result is achieved first in aestheticist poetry: the striving for purity of form, which has characterized the idealist conception of art since its earliest formulations, threatens to annihilate that which makes producing a work worthwhile, i.e. the content. The novel, which can absorb the fullness of reality, for a long time proves to be resistant to the coercion to formalization. Only with Robbe-Grillet's *nouveau roman* is the aestheticist project of a 'book about nothing' realized also in this genre. Here too the emancipation from the matter as something given and withdrawn from the control of the subject leads to emptiness.

The earliest answer – unmatched to this day despite all contradictions – to the developmental tendencies of art in bourgeois society is given by the historical avant-garde movements. The demand for a return of art to life, the abolition of the autonomy of art, marks the counterpole to that tendency which extrapolated the status of autonomy right into the work. The aestheticizing primacy of form is now replaced by the primacy of expression. The artist-subject revolts

against form, which now confronts him as something alien. What should master the facticity of the given, proves to be a coercion which the subject inflicts on himself. He rebels against it.

And where do we stand, we who are both the heirs of aestheticist formalism and of the avant-garde protest against it? The answer to the question is made more difficult by the fact that we have had to confirm both the decline of the modern (in Adorno's sense) and the failure of the avant-garde attack on the institution of art.[42] Neither anti-modernism nor historical eclecticism can be considered adequate designs for the aesthetic theory of the present. But merely clinging to the theory of aesthetic modernity, as Adorno has formulated it, also fails to see relevant phenomena of contemporary artistic production, e.g. the *Aesthetic of Resistance*, in which Peter Weiss uses the narrative techniques of the realistic novel throughout. Instead of propagating a break with modernism under the banner of the post-modern, I count on its dialectical continuity. That means that aesthetic modernism must also recognize as its own much that it has until now rejected. That is, no more tabooing of tonality, representation, and traditional literary forms; but at the same time distrust of this material and of the appearance of substantiality which emanates from it. The recourse to past stocks of material must be recognized as a modern procedure, but also as an extremely precarious one (Picasso's *Olga in the Reclining Chair* is not a successful picture). The modern is richer, more varied, more contradictory than Adorno depicts it in the parts of his work where he sets up boundaries out of fear of regression, as in the Stravinsky chapter of *Philosophy of Modern Music*. The artist can rely on what seems to him to be immediacy of expression which yet is always mediated. Since the expressive strength of the painting of children and of the insane is recognized, there can no longer be any taboo against regression. But it would be mistaken to believe that it is enough to imitate the clumsy drawings of first-formers to produce good paintings. The dialectics of form and expression must be executed as something irreducibly particular, whereby the latter no longer means individual situation but social experience refracted through the subject.

Already Hegel prognosticated the free disposition over forms and objects for art after the 'end of art'. This prospect becomes cogent at the moment when there is no longer any generally binding system of symbols. To the question of a criterion for putting a stop to the bad wealth of historical eclecticism, first a distinction would have to be made between an arbitrary toying with past forms and their necess-

ary actualization. Secondly, after the attack of the historical avant-garde movements on the autonomy of art, the reflection on this status ought to be an important trait of important art. To the extent that this reflection is translated into artistic conduct, it encounters the historico-philosophical place of art in the present. If this is plausible, then Brecht's work should have a place within the literature of our century which Adorno does not concede to it.

On the side of reception, the dialectical continuation of modernity means the striving to combine the above-mentioned reception stance oriented to living practice with sensitivity for the specific achievement of forms, which modern art has taught us since impressionism and aestheticism. With the risk of being misunderstood, what is meant can be characterized as the re-semanticization of art. This term is misleading because it does not appeal to the formal a priori of art. What Adorno criticizes as 'material fetishism' in a modernism consistent in its rational tendencies has its complement on the side of reception – the readiness to celebrate even the monochromatically painted canvas as an extraordinary artistic event. Against this, the semantic dimension of the work of art must be emphasized.

In closing, let me return to the concept of 'post-modernism'. Perhaps, the problematic of the concept can be most readily delineated if one says that it is both too broad and too narrow. Too broad, because it relegates to the past the modern concept of form, which is irreplaceable for us. Too narrow, because it restricts the question of contemporary art to the question of a material decision. But that is not permissible because the changes which are currently taking shape are also precisely changes in the way of dealing with art. If the claim formulated by avant-garde movements to abolish the separation of art and life, although it failed, continues as before to define the situation of today's art, then this is paradoxical in the strictest sense of the word: if the avant-gardist demand for abolition turns out to be realizable, that is the end of art. If it is erased, i.e. if the separation of art and life are accepted as matter of course, that is also the end of art.

4

The Return of Analogy: Aesthetics as Vanishing Point in Michel Foucault's *The Order of Things*

In all the discussion surrounding Foucault's major work *The Order of Things*, perhaps insufficient attention has been paid to the fact that the book begins with a reference to Borges and the 'laughter that shattered, as I read the passage, all the familiar landmarks of my thought – *our* thought, the thought that bears the stamp of our age and our geography'.[1] The Borges text in question tells of a Chinese encyclopedia in which animals are divided into groups which reveal no intelligible order to us: into animals '(a) belonging to the emperor, (b) embalmed, (c) tame, (d) sucking pigs, (e) sirens' etc.[2] As Foucault shows, the text does not merely allow us to take a somewhat surreal pleasure in the combination of such extremely different things – rather its monstrous quality consists in the fact that 'the common ground on which such meetings are possible has itself been destroyed'.[3] Since we cannot detect any common element among the ordering categories in question, the ground is pulled out from beneath us in our search for order. If we recognize the full significance of this reference to Borges, we can grasp Foucault's book as an attempt to re-enact the move described by Borges with reference now to modern thought and thus to show that the latter is groundless in the full sense of the word. Post-modern thought would then represent the laughter over the groundlessness of post-Kantian philosophy and the final dismissal of historical and transcendental thought. Instead of discussing the legitimacy of the claim to ground a form of thought that transcends the philosophy of the subject,[4] I would like to approach Foucault's book somewhat obliquely and

enquire into the position of aesthetics in the work. Such a decentred approach may not be so inappropriate for a philosophy which already understands itself as decentred.

At first sight it might appear that literature and aesthetics are matters of only subsidiary importance in Foucault's *The Order of Things* since the author is clearly concerned here with uncovering those rules within a given epoch which underlie the various forms of scientific practice. But this seemingly historicist interest is overlaid by another polemical intention that is directed towards a critique of modern thought since the end of the eighteenth century. For modern thought, according to Foucault's thesis, is bound to a concept of man which forces it into a series of aporetic positions. The most serious of these aporias concerns the duplication of man into an empirical being that is part of the world on the one hand and into a transcendental being that stands over against the world as a whole on the other. As an empirical being man is an object of scientific investigation, while as a transcendental being he is the guarantee and validating source of knowledge. Foucault indicates how post-Kantian thought seeks all kinds of different ways of escaping from this dual structure, only to fall victim to it again and again.[5] According to Foucault's thesis, a culture which is based upon such a self-thematization of man is fated to exhaust itself in the endless repetition of a dilemmatic structure. As a cognitive being man is pure self-relating thought which knows itself as the unconditioned, while as an empirical being on the other hand he is variously conditioned by nature and history (through life, labour and language). Man seeks to grasp what conditions him, whether as a nature hidden within himself or as a historical origin of some kind. But both these attempts elude him and must inevitably elude him. Since thought shapes his object the inner nature he discovers never represents the primordial nature he seeks but is always itself the product of thought which bears the inconceivable origin along with it like a shadow. Likewise the illuminated origin always reveals the possibility of another more remote origin lying behind it. Man is incapable of recuperating what conditions him, either in the dimension of nature or of history. He can only initiate an endless process of ever-accumulating knowledge.

Now Foucault believes that these aporias are a result of an erroneous but fundamental cultural tendency which began around the turn of the nineteenth century along with the modern self-thematization of man as a historical being. In order to overcome these aporias it is necessary for us to abandon this fundamental

orientation of thought. This is precisely what is meant by Foucault's initially enigmatic suggestion that we should ask ourselves whether man really exists ('Cette question consisterait à se demander si vraiment l'homme existe').[6] However, such a form of post-modern thought, which neither thematizes man as an object of scientific investigation nor privileges him as a cognitive subject, finds itself placed in a difficult epistemological position. For the rejection of all modern philosophies from Kant to Husserl or from Hegel to Sartre as so many expressions of the aporetic self-thematization of man is not of itself sufficient to define the contours of this new mode of thought.[7] Obviously Foucault himself sees that there is no possibility of our returning to the pre-Kantian rationalism of the seventeenth or eighteenth century, whose model of a transparent relationship between signifier and signified he employs as a foil for his critique of modern thought. Rather it is Nietzsche and above all Mallarmé who appear in Foucault's work as exponents of the kind of philosophizing which has emancipated itself from the premises of the historical–transcendental thought of modernity.

What then will take the place of the self-possessed subject? Foucault approaches this question in his 1963 essay 'A preface to transgression' and the answer he gives is 'language': 'the philosopher now perceives that he does not dwell in the totality of his language like a secret all-speaking God; he discovers that alongside himself there is a language that speaks and of which he is not the master, a language that proceeds of itself, that fails and falls silent, a language that he cannot set in motion'.[8] This language is not that of the philosophy of reflection, a language governed by the subject, nor that of rationalism, a language conceived as a transparent system of signs, but one which simultaneously enjoys the material density of a thing and the active capacity ascribed to the self-conscious subject, even though it is not a subject. Of course we may well ask what is really gained if those capacities for self-reflection and action which formerly belonged to the subject are now attributed to language.[9] However, I am concerned here with a different issue, namely the proximity of Foucault's conception of language to a specific tradition of modern aesthetic thought which is marked by the name of Mallarmé.

In fact a concept of 'littérature' expressly orientated towards Mallarmé enjoys a peculiar dual role in *The Order of Things*. Foucault explains that philology has turned language into an object of methodologically directed knowledge just like any other. This demotion of language ('ce nivellement du langage qui le ramène au

pur statut d'objet')[10] is compensated among other things by developing a concept of literature which defines it in terms of pure self-referentiality. If the literature of the classical age during the seventeenth and eighteenth centuries was pledged to the values of taste, pleasure, naturalness and truth, then the reinterpretation of literature which culminates in Mallarmé explicitly detaches it from these values and grasps it as a pure manifestation of language moving wholly within its own sphere:

[la littérature] devient pure et simple manifestation d'un langage qui n'a pour loi que d'affirmer – contre tous les autres discours – son existence escarpée; elle n'a plus alors qu'à se recourber dans un perpétuel retour sur soi, comme si son discours ne pouvait avoir pour contenu que de dire sa propre forme.
[literature] becomes merely a manifestation of language that has no other law than that of affirming – in opposition to all other forms of discourse – its own precipitous existence; and so there is nothing for it to do but to curve back in a perpetual return upon itself, as if its discourse could have no other content than the expression of its own form.[11]

We can ignore here Foucault's rather unconvincing claim that the aestheticist radicalization of the idea of aesthetic autonomy as formulated by Mallarmé represents a compensation for the (alleged) demotion of language produced by philology – all the more so in fact since elsewhere Foucault himself advances a more plausible version of his thesis and one which can be reconciled with Mallarmé's own interpretation of his work. In this context Foucault identifies the counter-discourse of literature as a compensation for the representational use of language as a system of signs:

A l'âge moderne, la littérature, c'est ce qui compense (et non ce qui confirme) le fonctionnement significatif du langage. A travers elle, l'être du langage brille à nouveau aux limites de la culture occidentale – et en son cœur – car il est, depuis le XVIe siècle, ce qui lui est le plus étranger.
In the modern age, literature is that which compensates for (and not that which confirms) the signifying function of language. Through literature, the being of language shines once more on the frontiers of western culture – and at its centre – for it is what has been most foreign to that culture since the sixteenth century.[12]

What emerges in modern literature like that of Mallarmé is the 'being of language' which had originally been utterly repressed with the successful establishment during the seventeenth century of a conception of language as a theory of signs and was only rediscovered in the nineteenth century precisely in the field of literature. What fascinates Foucault about the conception of language charac-

teristic of the Renaissance (the pre-classical age in Foucault's terminology) is the idea that nature itself is organized like a language, an unbroken tissue of words and characters ('un tissu ininterrompu de mots et de marques').[13] Taking Aldrovandi's *Historia serpentum et draconum* as an example, Foucault vividly succeeds in showing that the author makes no qualitative distinction between the exact observation of natural phenomena on the one hand and quite fantastical reports on the other, because for him and his contemporaries nature still displayed the character of writing for which the task was to provide an interpretive commentary. Whereas the introduction of a binary conception of the linguistic sign turned nature into a fixed object, over against which the sign-user now took up the position of a subject, in the 'pre-classical' conception of language according to Foucault both knowledge and the world alike were understood as linguistic in kind. Thus in place of the subject–object relation what we encounter here is a kind of speech like the ceaseless movement of the sea, 'un moutonnement à l'infini du langage'.[14] Thus the world and the infinite commentary which knowledge spins around it would represent a single network of substantial analogical relationships in which the knower is interwoven with the object.

The unique position which Mallarmé's radically self-referential conception of literature occupies in Foucault's thought derives from the fact that he sees this conception as a rediscovery of the knowledge of the 'being of language' which had been lost since the introduction of the seventeenth-century conception of the linguistic sign. Thus the task for post-modern thought now is to 'think' modern literature. In the pre-classical conception of language, just as in that of Mallarmé – and this seems to me to be the hidden point of Foucault's thought here (and one quite probably hidden from the author's mind as well) – the subject–object opposition is eliminated in favour of a homogenous network of substantial analogical relationships. That is why Foucault can make the paradoxical claim that the task of (post-modern) thought is to think (modern) literature but to do so outside the framework of a theory of signification:[15]

C'est pourquoi de plus en plus la littérature [sc. self-referential literature like that of Mallarmé] apparaît comme ce qui doit être pensé; mais aussi bien, et pour la même raison, comme ce qui ne pourra en aucun cas être pensé à partir d'une théorie de la signification.

This is why literature is appearing more and more as that which must be thought, but equally, and for the same reason, as that which can never, in any circumstance, be thought in accordance with a theory of signification.[16]

We can identify two consequences which follow from this attempted reconstruction of Foucault's argument: post-modern thought in Foucault's sense represents the privileging of the self-referential discourse of modern literature in opposition to the discourse of post-Kantian philosophy. A particular strand within the tradition of modern literature (Mallarmé) is defined as the very essence of literature and is opposed as the 'correct' philosophy to the tradition of modern philosophy from Hegel to Sartre. I leave aside the question whether this intellectual realignment, which certainly does not escape a certain dichotomy for its own part, really represents a genuine advance. It is obvious that a post-modern aesthetic cannot adequately be formulated on the basis of an approach which proclaims the self-referential discourse of modern literature as post-modern thought. The second consequence that results from our reconstruction concerns the motivating impulse which lies behind the realignment outlined above. If it is indeed correct that Mallarmé occupies a privileged position within Foucault's historical construction, because it was he who rediscovered the 'pre-classical' conception of language, and that this conception fascinates Foucault precisely because it does not oppose the knower and the object to one another but unites them in the medium of language, then Foucault's post-modern thought would simply seem to conceal behind itself the idealist yearning for the overcoming of the opposition of subject and object. The so emphatically invoked 'dividing line between those who still believe that the discontinuities of the present can be grasped in terms of the historical–transcendental tradition of the nineteenth century and those who seek to liberate themselves decisively from that tradition'[17] would crumble if the old idea of the subject–object were to be revealed as the hidden objective of a mode of thought that takes itself to be quite new.

Anyone who undertakes 'to reveal a *positive unconscious* of knowledge: a level that eludes the consciousness of the scientist and yet is part of scientific discourse', as Foucault outlines his project in the foreword to the English edition of his book,[18] must be prepared for the possibility that an interpreter might uncover the basis of this discourse which eludes the consciousness of its author. If our

approach has any plausibility, the only appropriate response to it on Foucault's part would be his laughter at the identification of a centre in such a decentred thought. Incidentally Foucault did indeed suspect Hegel might ultimately overtake him after all. At the end of *L'ordre du discours* Foucault writes: 'But in order to escape Hegel properly, we must take the measure of what it costs to renounce him; one must realize how much he has secretly haunted us, and that what is opposed to him in our thought still perhaps derives from Hegel.'[19]

Part II

Part II

5

Some Reflections upon the Historico-Sociological Explanation of the Aesthetics of Genius in the Eighteenth Century

'Those historical moments in which new ideals, new themes, new styles and new genres are born are . . . ones in which the transformations in the social base break through the existing ideological structure and the literary forms of expression associated with it and lay the foundations of a new tradition.'[1] If we consider the central role which the concept of genius has played ever since the second half of the eighteenth century in the idea of artistic creation shaped by idealist aesthetics, then we cannot fail to recognize in this concept one of those 'new ideals' which according to Erich Köhler arise in epochs of major historical change. At first sight a historico-sociological explanation of the aesthetics of genius would appear to be a relatively simple matter because the historical categories for grasping the great transition from feudal to bourgeois society are already available to us in a worked-out form. In fact we shall see that this is a misleading assumption and that there are several quite different interpretive possibilities within this general framework. In the following discussion I am less concerned to propose a single interpretation as the correct one than to increase and sharpen our awareness for certain alternative *possibilities of interpretation*.[2] It seems to me that one defect of the numerous (and in other respects

This chapter was originally given as a lecture under a different title at a number of universities in and outside Germany. The lecture form has been preserved unchanged in the printed version.

particularly productive) contributions to the sociology of literature is that while they do indeed present us with extremely plausible historical explanations, they nevertheless fail to consider alternative ways of interpreting the problem in question. This is connected with the fact that the sociology of literature is still insufficiently aware of either the variety of possible levels of explanation or the different range of particular approaches in the practice of interpretation. For example, it makes a crucial difference whether a given explanation takes its point of departure from the development of society as a whole or proceeds from a group-sociological perspective. In fact the greater range of an explanatory approach in terms of society as a whole may under certain circumstances reduce its explanatory power with respect to the particular phenomenon. On the other hand, in the case of a group-sociological approach it is quite legitimate to ask whether the results obtained have been truly mediated with the developmental tendencies of society as a whole or whether they merely possess a temporary explanatory value. Only if we succeed in accommodating questions of this kind into our interpretive practice, can we prevent a given methodology from becoming an independent discipline alongside an interpretive practice which is not properly conscious of what it is doing.

Boileau, summarizing the classical doctrine of aesthetic rules in his 'Art poétique', points out right at the beginning of his didactic poem that one is a poet from birth:

> Si son Astre en naissant ne l'a formé Poëte,
> Dans son génie étroit il est toûjours captif.
> Pour lui Phébus est sourd, et Pégaze est rétif.[3]

In this context the word 'génie' does not yet possess the meaning that it will come to have in the eighteenth century. Here it designates a capacity, 'talent naturel, disposition qu'on a à une chose plutôt qu'à une autre' (Furetière). What is at issue here is not the sudden possession of the poet by divine inspiration but a necessary gift or faculty. Within the poetics of rules there is no place for the doctrine of divine poetic inspiration. Such poetics is concerned with something quite different, namely with the unification of rhyme and reason:

> Quelque sujet qu'on traite, ou plaisant, ou sublime,
> Que toujours le Bon sens s'accorde avec la Rime . . .

Aimez donc la Raison. Que toujours vos écrits
Empruntent d'elle seule et leur lustre et leur prix.[4]

For the proponents of the *doctrine classique* the rules in question are grounded in reason itself.[5] And Voltaire still saw the matter in just the same way: 'Les principes de tous les arts qui dépendent de l'imagination sont tous aisés & simples, tous puisés dans la nature & dans la raison.'[6] In this connection the article on 'Enthousiasme' in the *Dictionnaire philosophique* is instructive. Here Voltaire pours scorn upon religious enthusiasm as exemplified by the Pythian priestess, upon the case of artistic enthusiasm exemplified by the youth whose intoxicated commitment to poetry makes him believe he is already a poet, and upon the enthusiasm of lovers as exemplified by Sappho. As we would expect, Voltaire directs his scorn principally against religious states of enthusiasm ('cette maladie devient souvent incurable').[7] It is the opposition between 'enthousiasme' and 'raison' which lies at the root of all these examples. 'Enthusiasm' in this sense appears as the contrary principle to reason and as a power which is capable of destroying it. However, Voltaire also recognizes an 'enthousiasme raisonnable' in the domain of eloquence and poetry ('dans les grands mouvements d'éloquence, et surtout dans la poésie sublime').

Comment le raisonnement peut-il gouverner l'enthousiasme? C'est qu'un poète dessine d'abord l'ordonnance de son tableau; la raison alors tient le crayon. Mais veut-il animer ses personnages et leur donner le caractère des passions, alors l'imagination s'échauffe, l'enthousiasme agit; c'est un coursier qui s'emporte dans sa carrière; mais la carrière est régulièrement tracée.

Voltaire is clearly concerned to limit the part played by enthusiasm in the process of poetic creation as much as possible. And the parameters within which enthusiasm is allowed an active role are already rationally defined by the artist's plan. The supplementary material to this article in the *Questions sur l'Encyclopédie* also shows that Voltaire evaluates the effect of poetic enthusiasm upon the quality of the work in a rather negative way: 'Ce qui est toujours fort à craindre dans l'enthousiasme, c'est de se livrer à l'ampoulé, au gigantesque, au galimatias.'[8]

It is not unwarranted to see Voltaire's article on 'Enthousiasme' as a response to the article on 'Génie' in the *Encyclopédie* (I have discussed Voltaire's piece first because although it was composed at a later date than Saint-Lambert's article on 'Génie' it nevertheless represents the older state of thought on the question).[9]

At the very beginning of his article Saint-Lambert sets up an opposition between the 'homme de génie' and the great majority of other human beings ('la plupart des hommes'). Whereas the latter are only affected in a sensuous manner by the things which stand in immediate relation to their own needs, the former is equally affected and moved by all kinds of phenomena ('frappée par les sensations de tous les êtres, intéressée à tout ce qui est dans la nature').[10] The contrast is between the limited sensibility of the man whose pursuit of clearly defined goals drives him to concentrate his perceptive faculties on these alone, and the unlimited sensibility of the genius. The second characteristic capacity of the genius is that of recollection ('le souvenir'). The manifold variety of sensuous experience enjoyed by the genius is not bound to the original moment since he is quite capable of vividly reproducing it: 'dans le silence et l'obscurité du cabinet, il jouit de cette campagne riante et féconde'.[11]

So far the text has principally been concerned to describe a particular way of relating to reality. The concept of genius serves to specify an all-embracing and intensive way of experiencing reality which is radically distinguished from the limited kind of experience characteristic of most human beings. Thus the concept also indicates the existence of a limited form of experience in the everyday life of the majority and attempts to respond to this phenomenon. The specific character of the response consists in the fact that instead of asking why experience is generally limited the way it is it begins by projecting the possibility of an unlimited form of experience in the figure of the genius. It is significant that this project remains bound to an extraordinary type of individual.

There are two further aspects of the article on genius which are worth emphasizing: the opposition between 'génie' and 'goût' on the one hand and that of 'philosophie' and 'imagination' on the other.

Le goût est souvent séparé du *génie*. Le *génie* est un pur don de la nature; ce qu'il produit est l'ouvrage d'un moment; le goût est l'ouvrage de l'étude et du temps; il tient à la connaissance d'une multitude de règles ou établies ou supposées; il fait produire des beautés qui ne sont que de convention. Pour qu'une chose soit belle selon les règles du goût, il faut qu'elle soit élégante, finie, travaillée sans le paraître: pour être de *génie*, il faut quelquefois qu'elle soit négligée; qu'elle ait l'air irrégulier, escarpé, sauvage. Le sublime et le *génie* brillent dans Shakespeare comme des éclairs dans une longue nuit, et Racine est toujours beau; Homère est plein de *génie*, et Virgile d'élégance.[12]

There had already been some criticism of the classical rules before Diderot's writings on the bourgeois drama and Saint-Lambert's

article on genius (La Motte's critique of the unities of time and place, for example). But these criticis still argued on the basis of the same presuppositions as those who advocated the rules. Both parties were concerned with formulating rational principles the results of which could be verified by reference to the enjoyment ('plaisir') of the educated theatrical public. The fact that La Motte himself attempts to formulate a new rule in terms of the unity of interest (i.e. the concentration of the spectator's interest upon *one* particular figure in the drama) shows how little he is ready to doubt the necessity of rules in general. Certain individual rules and features of *tragédie classique* are questioned (the issue of verse form, for example) but never the principle that there are rules to be observed. Nor does Du Bos fundamentally put in question the principle of rules either although he did make the 'sentiment' into the basis of legitimate aesthetic judgement and thus became one of the most important innovators in questions of aesthetic evaluation (by detaching this evaluation from its dependence upon the rule-governed 'goût' of an elite public). Such questioning is found for the first time in texts like those under discussion here. For now the work which is produced by observing the correct rules appears as something conventional, as opposed to the work of genius which succeeds in combining irregularity and sublimity. We can derive the following schema of conceptual oppositions from the passage quoted above:

	goût	génie
Exemplary figure:	Racine	Shakespeare
Type of creative production:	a work of diligence ('ouvrage de l'étude et du temps')	a work of spontaneity ('ouvrage du moment')
	Observance of rules	Violation of rules
Type of work produced:	classical perfection ('oeuvre élégante, finie')	irregularity ('l'air irrégulier, escarpé, sauvage')

It is characteristic that there is an important dimension missing in this whole oppositional schema, namely that of reception. Whereas the *doctrine classique* still unconditionally allowed the enjoyment of the public as a decisive criterion for evaluation, this is no longer the case with the emergent aesthetics of genius.[13] The elevation of the artistic creator to the status of genius simultaneously loosens the connection which binds him to the needs of the public. This emancipation from the needs of the public is not yet explicitly

formulated here and has to be read off from the omission of any discussion of the aspect of reception.

At first sight it might seem astonishing that the concept of 'goût' is so unambiguously placed on the rules side of the schema, especially since the concept of taste in the seventeenth century is often employed as a means of loosening the hold of the prevailing rule-oriented poetics. This is particularly true of Bouhours who already admitted an 'art de la nature' alongside the rule-oriented poetics: 'Si cela est ainsi, dit Eugène, on a tort de condamner le goût, et l'inclination d'autrui, quelque bizarre que soit ce goût, et quelque extravagance que cette inclination puisse être: car c'est à la nature qu'il faut s'en prendre, et non pas à nous qui ne faisons que la suivre, et qui ne pouvons lui résister en ses rencontres.'[14] Nevertheless it would be a mistake to try and interpret the concept of 'goût' as one polemically directed against rule-oriented poetics. The concept serves rather to designate a certain spontaneity in aesthetic judgement which is not opposed to the rules in question. It is only in the light of this that we can resolve the apparent contradiction in which La Rochefoucauld, for example, seems to be involved when he defines taste on the one hand as spontaneity of judgement ('une sorte d'instinct', 'lumières naturelles', etc.), while on the other hand he connects it once again to the rules ('le goût qui nous en fait connaître et discerner les qualités [sc. des choses] en s'attachant aux règles').[15] In his 'Essai sur le goût' of 1757 Montesquieu still conceives of taste as a spontaneous faculty of judgement which operates in harmony with rules: 'le goût naturel n'est pas une connaissance de théorie; c'est une application prompte et exquise des règles mêmes que l'on ne connaît pas'.[16]

Thus while in the aesthetic theories of the seventeenth century and the first half of the eighteenth century 'goût' generally designates this spontaneity of aesthetic judgement in harmony with rules, in Saint-Lambert it is situated wholly on the side of rule-oriented aesthetics and can thus be contrasted with the concept of genius. For now Saint-Lambert emphasizes only the aspect of regularity and no longer that of spontaneity in the idea of taste. Thus taste becomes for him a representative concept for everything that genius finds itself in revolt against. The opposition between 'génie' and 'goût' is taken up and further developed in terms of the opposition between 'imagination' and 'philosophie'. Saint-Lambert is not concerned here with exluding philosophical content from poetry but only with the question of the kind of presentation appropriate to poetry. The logical coherence of philosophical exposition is in contradiction with the passionate character which belongs to the imagination.

Here we should remember that the aesthetics of genius was anticipated within rule-oriented poetics through the freedoms that were conceded to the ode form.[17]

> Son style impétueux souvent marche au hasard:
> Chez elle un beau désordre est un effet de l'art.[18]

The question as to how this 'beau désordre' was properly to be understood was a subject of violent and controversial debate during the eighteenth century, as Hermann Dieckmann has shown. Rationalists like La Motte defended a restricted version of the idea, according to which the 'beau désordre' was limited to certain grammatical liberties and definitely did not extend to the freedom of arrangement of poetic ideas ('J'entends par ce beau désordre, une suite de pensées liées entr'elles par un rapport commun à la même matière, mais affranchies des liaisons grammaticales, et de ces transitions scrupuleuses qui énervent la Poësie lyrique, et lui font perdre même toute sa grace').[19] Rémond de Saint-Mard, on the other hand, offered an interpretation of the idea which certainly contains anticipations of the later discussions of genius ('ce beau désordre qui, bien analysé, n'est autre chose que le langage naturel d'un Poëte qui, maîtrisé par la Passion, est forcé de s'abandonner aux différents mouvements qu'elle lui donne').[20] It is true that even when dominated by passion the poet's language remains strictly bound to the dignity of his object (it is the 'dignité de sa matière' which is said to elevate and inspire the poet)[21] but Saint-Mard's reflections here clearly point towards the eventual liberation of poetry from the supremacy of reason.

However, this reference to the poetics of the ode form cannot take the place of an explanation for the aesthetics of genius. For like the discussion of the sublime, the debate concerning the freedom of the ode form also remains within the parameters of rule-oriented poetics. We only really encounter something new when enthusiasm and passion are no longer understood as capacities that are merely tolerated in the name of poetic licence but finally come to represent the essential definition of genius itself, and when the latter thereby enters into opposition to the rationality which prevails in science and in everyday life. In this connection the section from Diderot's *De la Poésie dramatique* which is entitled 'les mœurs' is significant. Here Diderot sketches a theory of the socio-historical conditions for the emergence of great epic and dramatic art. The anti-aristocratic animus behind these observations is obvious: 'Chez un peuple esclave, tout se dégrade. Il faut s'avilir par le ton et par le geste, pour

ôter à la vérité son poids et son offense.'[22] But Diderot does not content himself simply with criticizing the social position of the court poet whom he compares with the fool who can only speak freely because he is actually held in contempt. He goes on to formulate the idea that great poetry can only arise in archaic social conditions. Such a social state would be characterized by powerful affective relationships between family members, by direct dealings between the rulers and the ruled and by a religion at once bloody and ecstatic and permeating all the forms of social life ('C'est au temps où les enfants s'arrachent les cheveux autour du lit d'un père moribond [. . .], où le peuple parle à ses maîtres, et où ses maîtres l'entendent et lui répondent [. . .]; où les dieux, altérés du sang humain ne sont apaisés que par son effusion').[23] If this sketch of the historical conditions for the emergence of great poetry were followed through to its logical conclusion it would lead us to the end of art: since these specified archaic social conditions clearly belong to the historical past, any renewal of great epic and dramatic poetry is inconceivable. Diderot does not in fact draw this conclusion but projects his idea on to a suprahistorical plane. It is no longer particular archaic social conditions which he regards as the condition of great poetry now but rather periods of catastrophe: 'C'est lorsque la fureur de la guerre civile ou du fanatisme arme les hommes de poignards, et que le sang coule à grands flots sur la terre, que le laurier d'Apollon s'agite et verdit.'[24] For as he says: 'La poésie veut quelque chose d'énorme, de barbare et de sauvage.'[25] Here we seem to see the emergence of an aesthetic justification of world-historical catastrophe as explicitly formulated by Karl Philipp Moritz: 'If thousands fall to the sword in battle on a single day, that is really something *mighty* and this is what we desire; our soul desires to be extended and our imagination wishes to encompass much.'[26]

Let us clarify once again the course of Diderot's thought. Starting from a critique of contemporary civilization as something unpoetic ('plus un peuple est civilisé, poli, moins ses mœurs sont poétiques'),[27] he proceeds to privilege an archaic social state as the condition for the emergence of great poetry. Then by dehistoricizing this idea he is able to create a connection between historical catastrophe and great poetry. In opposition to the conception repeatedly formulated elsewhere by Diderot himself, which represents poetry as part of the Enlightenment attempt to bring about humane conditions of life in general, poetry here abandons the Enlightenment project altogether. And the same is true of the idea of

genius which as Diderot claims to show is only roused and driven to express itself creatively through extraordinary events like those described above.[28] It is obvious that the opposition underlying Diderot's concept of genius/poetry here is the same as that underlying Rousseau's critique of civilization. However, whereas Rousseau employs nature above all as a theoretical vantage point with which to settle his account with civilization, Diderot seeks through poetry to introduce a moment of 'naturalness' into society. Poetry, in this sense, would then represent an archaic form of activity at odds with the developmental tendencies of a society which is based upon the advances of science and technology.

There is one immediate objection which we have to deal with before turning to address two historico-sociological explanations which have been offered for the aesthetics of genius. Is it not arguable that the aesthetics of genius propounded in the second half of the eighteenth century is only a repetition of the platonizing concept of the poet as seer, the *poeta vates*, and the associated concept of poetic inspiration, the *furor poeticus*, which were already developed within Renaissance poetics? There are two elements in this objection which have to be separated from one another: firstly the reference to a specific tradition, and secondly the question whether this reference possesses any explanatory value. There can be absolutely no doubt that the concept of poetic madness was familiar to the proponents of the aesthetics of genius. However, pointing out the existence of such a tradition is not sufficient to explain its revival, let alone the fact that the concept of genius now becomes the central component of a new aesthetics. The poetic apologists of eighteenth-century France were of course also acquainted with the concept of the *furor poeticus* and frequently employed it in their own writings yet they did not go on to develop a doctrine of genius.[29] Thus the formulation of an aesthetics of genius in the second half of the eighteenth century and its continuing validity for art as a bourgeois institution subsequently (fundamentally shaken only with the avant-garde movements of this century) require an explanation that is independent of the question concerning the significance to be ascribed to the Renaissance idea in relation to the concept of genius.[30] In general we can say that such references to literary sources and traditions can never have the status of an explanation and that they rather call for an explanation themselves.

Genius is the elevation of the free bourgeois individual. Thus the concept of genius and the doctrine of enthusiasm can be regarded as a poetological reflex of an image of man that proclaims the creative freedom and the unlimited possibilities of the outstanding individual. The figure of the artist or scientist of genius displays the same features as that of the dynamic entrepreneur of original accumulation which entered upon an expansive phase in France during the seventeenth and eighteenth centuries with the growth of manufacturing production and overseas trade. Where the artist of genius demands freedom from censorship and emancipation from restrictive institutional rules or intellectual prejudices, the entrepreneur calls for economic freedom of trade and the abolition of the guild system.[31]

This correlation of the concept of genius with the characteristic figure of the dynamic entrepreneur appears initially plausible because in fact there is a real relationship between cultural–political *dirigisme* (*doctrine classique*) and politico-economic *dirigisme* (*mercantilisme*) under the system of absolutism. Yet we should be very wary of concluding from this that the critics of rule-oriented aesthetics should therefore be located socially among the entrepreneurial class. In Germany, for example, the young Herder was certainly one of the most emphatic defenders of the new aesthetics of genius but he combined this position with an explicit repudiation of free commercial trade and clear opposition to the dissolution of the old guilds.[32] And the claim that what we see in the concept of genius is 'an ideological evalation of subjective autonomy and the bourgeois concept of freedom',[33] would also have to be very carefully examined. Freedom as understood by Montesquieu for example is distinguished from independence precisely by virtue of the fact that it stands in relation to law.[34] One should therefore seriously consider whether or not in fact a nostalgic return on the part of bourgeois intellectuals to an ancient feudal (pre-absolutist) independence might play a role in the concept of freedom which underlies the aesthetics of genius. At least as far as the German *Sturm und Drang* movement is concerned this seems to me to be the case.

Yet even if we ignore such problems as these, the explanation in question still seems unsatisfactory. For on the one hand the concept of genius which arose after 1750 is derived from an economic process of development that took place over a period of 200 years and no real discussion of this late emergence of the concept is offered. On the other hand, in this suggested explanatory framework the question remains unanswered as to why even after the defeat of feudalism the concept of genius should still retain its exemplary function, although the society in opposition to which the idea was first developed itself no longer exists.

In the context of an interpretation of the *Sturm und Drang* movement Klaus Scherpe has developed an explanatory approach which is capable of resolving the latter problem. He understands *Sturm und Drang* as a secession movement on the part of bourgeois intellectuals in which the 'unconditional communication of personal experience' is set against the self-sufficient anti-feudal ideal of virtue characteristic of the Enlightenment. 'The oppositional movement on the part of the younger generation of bourgeois intellectuals who produced the literary revolt of *Sturm und Drang* did not correspond at all to the initiatives of a bourgeois class bent on radical change – it was motivated rather by a distinct lack of revolutionary incentive.'[35]

Scherpe obviously proceeds on an explanatory level which is quite different from that of Opitz. Whereas the latter regards the concept of genius as a 'poetological reflex' of the entrepreneurial spirit and thus explains it on the basis of the economic dynamics of the emergent bourgeois class, Scherpe's explanation is located within the context of a sociology of the bourgeois intellectual. On Scherpe's interpretation the concept of genius should be understood more as a reaction of the bourgeois intellectual against the self-sufficiency of the bourgeois class within a still feudal context than as a protest against feudalism itself. These two interpretations, which I have contrasted with one another here principally out of an interest in the methodological issues, are thus distinguished both by the respective levels of interpretation involved (explanation in terms of society as a whole in contrast to a group-sociological explanation) and by the kind of explanatory arguments employed in each case (opposition to feudalism versus opposition to 'bourgeois civil society'). Scherpe's approach seems to me to represent the more sophisticated one in so far as he expressly considers the concrete social situation of the very group that created the concept of genius and enjoyed direct experience of it and yet does not neglect the conditioning social framework as a whole in the process.

However, there are still questions to be asked about Scherpe's unconditionally 'progressive' interpretation of *Sturm und Drang* as a kind of secession movement when we consider the traditionalist orientation of Herder's critique of civilization. The protest of *Sturm und Drang* against the German bourgeoisie is not intended to further the realization of the bourgeois–capitalist mode of production. On the contrary, it already registers those forms of alienation which this system produces: the elimination of regional peculiarities through centralized administration, the destruction of established traditions through rational criticism and the subjection of interpersonal rela-

tionships to the principle of the maximization of profit. If it is indeed true that the critique of civilization implied by the *Sturm und Drang* movement is already directed against the first manifestations of bourgeois–capitalist society (even though as is well known this was far less advanced in Germany than in other countries of western Europe), then the following thought suggests itself: is it not possible that it was the very persistence of pre-capitalist conditions of life in the German territories which made the German intellectuals educated in the Enlightenment tradition acutely sensitive to the forms of alienation which accompanied the new mode of production? Rousseau's critique of civilization, to which Herder pre-eminently appeals, also arose from the collision between traditional forms of experience and the 'modern' Parisian form of life.[36]

Let us return once again to the different kinds of explanatory argument employed in our two interpretations, namely to the question whether the protest which is inherent to the aesthetics of genius is directed against feudal or against bourgeois society. I think we can discover a possible solution to this interpretive problem if we undertake a very careful examination of the phenomena under attack from the radical cultural critique which constitutes the heart of the aesthetics of genius. The struggle against the aesthetic rules is first of all a struggle against courtly–aristocratic conventions. But we must also recognize that the status of rules within the feudal–absolutist institution of literature constitutes precisely the moment of rationality which it owes to the legally schooled bourgeois. Thus the struggle against the rules paradoxically represents a struggle against the bourgeois elements within the feudal–absolutist institution of literature. Or to put it another way: the prevailing institution of literature, just like the absolutist system to which it owes its existence, is a thoroughly contradictory historical phenomenon. It combines the functional roles of representation and *divertissement* with an attempt to establish a rational system of rules which also explains Voltaire's option for the *doctrine classique*. The fact that here rationality is bound up with the feudal–absolutist system forces the opponents of feudal absolutism to turn towards the irrational.[37]

Even the social critique, expressed in its most radical form as it was by Rousseau, had an intrinsically contradictory phenomenon as its object. Take the case of luxury for example. This is undoubtedly an expression of ostentatious feudal display and is criticized as such. But we must also recognize that the critique of luxury only represents one aspect of the phenomenon, namely that of conspicuous consumption as a status symbol. Defenders of luxury like Voltaire,

on the other hand, emphasize the aspect of production involved. They argue that luxury actually creates potential employment (cf. Voltaire's *Le Mondain*). However we decide to assess this argument (as an accurate description of the economic conditions of the time or merely as a justification of social inequality), it is an undeniable fact that luxury does presuppose a certain level of development in the bourgeois mode of production (in manufacturing, trade and the money economy). Thus in attacking feudal prestige consumption the critique also strikes at one of the motivating forces of the capitalist economic system.[38]

From what has been said so far we can propose the following thesis: since the social critique of the second half of the eighteenth century is directed against a contradictory object, in which both feudal and bourgeois elements are combined, it cannot unambiguously be identified either as an anti-feudal critique or as an early critique of bourgeois civil society. In so far as the critique strikes at a certain bourgeois 'content' (like trade and the money economy for example) through feudal 'forms' (like luxury), it is possible to understand why it survives the demise of feudal society proper. And something similar may well be true for the concept of genius. For genius cannot unambiguously be defined in its incipient form simply as an anti-feudal or as an anti-bourgeois protest concept either. In attacking feudal–absolutist rule-oriented poetics the concept of genius also strikes at one moment of bourgeois rationality. Likewise, the nature–culture opposition which underlies the concept of genius is not exclusively directed against aristocratic culture but also against those social conditions in which the increasing division of labour in most spheres of life inevitably introduces a constriction of potential experience. It is precisely because the concept of genius is opposed to social conditions in which bourgeois 'content' has been developed beneath a feudal 'husk' that it is also able to continue functioning as an exemplary concept once the bourgeois form of life has successfully established itself in a dominant position.

6

Morality and Society in Diderot and de Sade

On the contemporary significance of the Enlightenment

The concept of application is central for critical hermeneutics.[1] The concept can be explicated in a number of different ways which in turn reflect various kinds of interpretive approach. 'Application' may imply the recognition mediated by historical insight that existing society has become what it is and consequently is not immutable. The preconceptions which are conditioned by the social position of the interpreter and which guide the life praxis as well as the interpretation of the interpreter can be recognized in the course of the hermeneutic process and thus lose the moment of blind compulsion that formerly belonged to them. The dislocation of this prejudicial structure facilitates a kind of praxis directed towards the transformation of society – at least this is the hope of those like Habermas who take their stand upon the emancipatory power of reason. But application can also mean employing works of the past as a means of understanding and thus addressing contemporary problems. If we follow the first approach, for example, and take an eighteenth-century text as our point of departure, we would understand it primarily as a document which expresses the self-understanding of bourgeois culture in its period of ascendancy. If we then compare it with our own present, it reveals the transformation which has taken place in this self-understanding since the time of the Enlightenment. However, if the text in question also happens to be a literary work of art, then even if it is to be understood as a document it requires specific procedures of analysis which can do justice to its

particularity as an artistic product. If we follow the second approach, the text is not understood principally as a document at all but is regarded instead as a way of promoting the understanding of our contemporary situation. In this case we are not concerned so much with recognizing its purely historical character but with identifying its continuing contemporary relevance. We cannot attempt here to resolve the problems posed for any socio-historical investigation of literature by the fact that works of art typically do continue to possess a certain validity over and beyond the period in which they originated.[2] We must simply note that this 'trans-temporality' allows us to develop an approach to works of the past which, to formulate the issue cautiously, maintains a more direct relationship with those works than the purely historical approach is capable of doing. Horkheimer's important essays from the 1930s have clearly shown that both kinds of approach to the works of the past by no means have to exclude one another. For here he situated the intellectual systems of the past in their real specific historical context while *simultaneously* relating them to the interpreter's own present.[3] Whether in any investigation of a work the historical or the hermeneutic 'actualizing' approach takes precedence principally depends on the object in question and its potential relationship to the present.

Now the problem of moral norms in the ascendant phase of bourgeois society in fact permits two such kinds of investigation. On the one hand we can analyse the real social function of these norms and so expose the functional mechanisms of bourgeois society in a particular phase of its development. We can then understand the norms at work in contemporary society as intrinsically historical and thus as susceptible to change. On the other hand we can pursue the legitimation problems encountered in bourgeois moral thought, that is, investigate the aporias which result from the attempt to develop a moral system of values that is not simply guaranteed by Christian faith. This approach is of contemporary relevance in so far as the question concerning the foundations of moral norms is still largely unresolved.[4] In addition we should also recognize the fact that the practical question of the non-coercive realization of norms is simultaneously involved in the whole problem of legitimation. For finding a rational foundation for norms means demonstrating that in a given situation the individual can only act rationally in following these particular norms rather than any others.

The most famous example of the first, emphatically historical, kind of investigation is represented by Max Weber's work 'The

Protestant ethic and the spirit of capitalism'. As far as the early bourgeois morality of Protestant asceticism is concerned, Weber emphasized two social functions in particular: (1) the creation of a bourgeois professional ethos which favoured the accumulation of capital through the 'ascetic compulsion of thrift'; (2) the creation of an explicit work ethic among the masses.[5] It is the great merit of the members of the Frankfurt Institute of Social Research to have developed these investigations further from a socio-critical perspective which emphasized their contemporary relevance. In his *Studies on Authority and the Family*[6] Horkheimer interpreted the bourgeois institution of the family as a specific form of socialization for rearing the kind of individuals functionally required by bourgeois society. Horkheimer confronts the historical necessity of rigid structures of authority in the past with their obsolescence in a new social stage characterized by the unparalleled development of productive forces. He thus acquires a criterion for the critical assessment of irrational authority and domination in his own present.[7] He anchors his critique in the inner connection between exploitation and oppression. In the context of state-interventionist capitalism it becomes clear that the latter is capable of alleviating, although not abolishing, exploitation even while the general state of unfreedom persists. It is this situation which explains the kind of critique which examines the prevailing moral norms more or less independently of the social basis the functioning of which they facilitate. It is now the repressive character of morality in general which is the object of criticism.[8] The Utopian projection of the future provides the standpoint from which such a critique is mounted. This kind of criticism is legitimate in so far as it really reveals the presence of repression, but its limitation lies in the fact that it can only grasp a better future as the wholly other to the present, that it fails to mediate between this present and the projected future, that it can only anticipate the future in an abstract Utopian manner.

From a conservative perspective Reinhart Koselleck has made a very significant contribution to the problem concerning the social function of norms and the critique of norms. In his analysis, as in Horkheimer's – albeit from a quite different social position – there is an attempt to mediate between the historical character of the problem and its contemporary relevance. According to Koselleck, the bourgeois thinkers of the Enlightenment attacked the absolutist state by appealing to a moral critique the political dimension of which they concealed to themselves. 'In the very moment in which the dualistic separations of prevailing political thought were sub-

jected to the claims of moral judgement, moral judgement is transformed into a political factor and becomes political critique.'[9] This critique 'first separates itself from the state in order, on the basis of this very separation, to extend its authority to the state in an apparently neutral fashion and subject the latter to its own judgement. Critique . . . falls victim to this appearance of neutrality and becomes hypocrisy.'[10] Such moral critique precipitates a crisis in depriving the absolutist state of its political foundations. But its own active role in the process is concealed by a philosophy of history in which the unfolding course of events is identified with the aims of the critics.[11]

In grasping the moral critique as a weapon employed in the struggle for bourgeois emancipation Koselleck has certainly identified an important truth, and he is also right in pointing out the moment of obfuscation involved with respect to the political dimension of this whole critique. It is remarkable how close Kosseleck comes here to the concept of ideology critique employed by the young Marx, although this concept undergoes a fundamental change in Koselleck's work. Bourgeois moral thought appears here as an ideology in the strict sense, i.e. an interpretation of reality that is at once rational and distorted. The claim to dominance being made on the part of a certain class is concealed beneath the concept of man as such, as are the decidedly political aims behind the critique. But these ideological 'concealments' are historically necessary ones which arise from the real social situation of the conscious agents involved. The bourgeois class *had* to fall victim to the illusion that liberation from the fetters of feudalism and the absolutist state which maintained this system would simultaneously promote the liberation of all men – precisely because in fact in this period the bourgeoisie represented the only class capable of advancing social progress, however problematic this progress may turn out to be. By introducing the concept of hypocrisy in this connection Koselleck himself subjects history to a moral judgement, the inappropriateness of which he implicitly concedes when he points out that this concealment worked very effectively for the bourgeois critics themselves. But Koselleck's own moral judgement has an important political function: it serves to discredit critique in general. Against the background of a pessimistic anthropology in the Hobbesian tradition critique here appears as something intrinsically reprehensible which precipitates 'crisis'. Koselleck is able to adopt this position because his analysis excludes any discussion of the aims which guided the moral critique. For him the existing order already enjoys a certain

validity simply because it represents order. Basically Koselleck attempts to appropriate for the conservative cause, precisely as a supposedly apolitical judgement, the moral pathos which the movements agitating for social progress claimed for themselves.

Any critique which hopes to have significant practical consequences must reflect upon the possibilities of its realization. In relation to the critique of bourgeois morality it must therefore clarify its own standpoint with respect to the general moral problematic. It must, however tentatively, try and give us some indication of how moral norms would function in a liberated society of the future. However, it seems to me to be a characteristic feature of the contemporary debate concerning the general problem of norms that this is precisely what we *cannot* do.

On an extremely high level of abstraction it is relatively easy to determine the connection between morality and society. In so far as the social function of moral values consists in realizing the general interest as opposed to purely particular interests, they testify to the failure of a form of social organization which has always sacrificed the particular to the universal. A philosophy of history operating from this perspective finds its subject in the bourgeois individual which, losing its power over the historical process, eventually becomes the representative of a defeated humanity and thus absolves itself from the task of realizing the claims of humanity for all.[12] As long as there is no prospect of realizing a society in which particular interests and the general good are harmoniously united with one another, then any speculation concerning the disappearance of morality must be premature. Thus the task which remains to us is to identify the contradictions within existing morality.

Herbert Marcuse justifiably criticized the bourgeois conception of authority as one in which 'autonomy and heteronomy are thought together'. 'The union of inner autonomy and outer heteronomy, the perversion of freedom into unfreedom, is the decisive characteristic feature of that concept of freedom which has dominated bourgeois theory ever since the Reformation.'[13] However, we must ask ourselves whether the contradiction between autonomy and heteronomy is not in fact constitutive for all moral action. For moral action draws its pathos from the free decision of the individual but this free decision can only realize itself in relation to some already given system of norms. Morality is only relevant as an essentially practical phenomenon and moral norms are practically effective principally in so far as they represent internalized norms. But internalization means that the process in which norms are constituted does not lie

within the subject's sphere of freedom. The subject always already finds these norms within itself. The same contradiction returns on the level of conscience as the central moral court of appeal. Within the field of conscience, or the super-ego, the 'antagonistic moments' of autonomy and heteronomy are inseparable from one another: 'heteronomous compulsion and the idea of a solidarity which transcends divergent individual interests'.[14]

If these suggestions concerning the contradictory character of morality are correct, then we must ask whether the aporias encountered in the eighteenth-century attempt to found a rational moral system of thought simply represent the aporias of bourgeois morality or those of rational moral thought in general. In the case of the problem of social equality we find here a concrete possibility which could in principle be realized today and one which opens up a perspective that transcends the purely legal formal conception entertained by the bourgeois theorists of the eighteenth century. But such a perspective is not available to us with respect to the moral problem. And this has significant consequences for the way in which critical thought approaches its object. The investigation of the legitimization problem involved in bourgeois norms possesses a more than purely historical interest and is of the utmost contemporary significance. This means that the contemporary interpreter cannot adopt a position that would regard the debates of the past concerning this problem as one whose solutions can simply be read off from history itself. On the contrary, the interpreter must recognize these past debates as a means of elucidating contemporary problems. This by no means implies that the debate concerning morality in the works of Diderot and de Sade should be treated as a suprahistorical phenomenon. Rather we must proceed from the recognition that it was emergent bourgeois–capitalist society which first created the conditions for the whole debate. The fact that these conditions are still in force is an indication of the particular character which belongs to our contemporary real historical horizon.

Diderot

Whereas the French nobility, at least before it was domesticated by the absolutist state, derived its claim to moral exemplarity of action from a century-old awareness of the superiority of its own class, the newly emerging bourgeoisie found itself confronted with the task of grounding a moral position independent of the elitist moral code of

aristocratic values. Yet in this connection it could no longer appeal directly to the traditional Christian system of norms, once the church had been recognized as a force which served to support the feudal order. For the bourgeois thinker the question concerning the foundations of moral action was no purely abstract philosophical question but an eminently practical one. It concerned the very possibility of humane coexistence in a society which was no longer directly based upon the belief in God and the future life.

Mandeville's claim that private vices are public virtues since luxury consumption supposedly creates demand and thus promotes the prosperity of society as a whole did not represent an appropriate ideology for the newly emerging class. For in Mandeville's writings the poverty and wretchedness of the many still appeared realistically enough as the necessary condition of the wealth of the few. Nevertheless, Mandeville had identified an approach to which repeated appeal was made throughout the eighteenth century and it is not at all difficult to see why. If private self-interest really promotes the general good, then there was an immediate solution to the fundamental problem of a secular moral system: namely the contradiction between the individual and the general interest and the concomitant problem of how man can be induced to act against his own interests.

In direct opposition to the theorists of human interest, the attempt was made by the theorists of sympathy to anchor the possibility of moral action anthropologically in the essence of man. If sympathy with one's fellow human beings is originally rooted in human feeling, then the moral problem simply becomes the task of elevating this original feeling to the heights of conscience. The basic difficulty with this theoretically satisfying solution to the problem lay principally in the fact that it clearly stood in contradiction to actual practice. As is well known. Rousseau took this contradiction as an occasion not for revising the theory but for transforming it into a species of social critique. If man is good by nature and yet acts badly, this can only be explained through the corrupt character of society itself.

Diderot takes up this problem in dialogue form in 'Le Neveu de Rameau'. As a self-confident bourgeois citizen Diderot the narrator debates with the famous composer's nephew, whom he describes as a man full of contradictions – 'un des plus bizarres personnages de ce pays', 'un composé de hauteur et de bassesse, de bon sens et de déraison'[15] – concerning a whole range of questions, among which however the problem of grounding moral action occupies a prominent place. Although the following remarks in no way claim to

present a complete reading of 'Le Neveu', an interpretation of those sections of the work which are concerned with the moral problem cannot be attempted without a general understanding of the dialogue as a whole. Such a general understanding can most effectively be developed through a comparative discussion of alternative interpretive approaches to the work.

The main point of difference among the various interpretations of 'Le Neveu' principally concerns the standpoint adopted by Diderot himself. Most interpreters are agreed that Diderot the author is not to be identified with either of the positions represented by the partners in the dialogue. D. Mornet claims that Diderot is here confronting two philosophical positions which he is capable of defending in turn: that of the materialist philosopher for whom man is utterly determined by his physical organization and thus incapable of moral action, and that of the 'prédicateur de morale' who grounds morality upon a spontaneous affective bond that supposedly exists between all men.[16] There are two unsatisfactory features in this reading: on the one hand, Mornet turns a fundamental incoherence in Diderot's thought into a presupposition of the interpretation; the statement of the problem which ought to be solved by an interpretation of Diderot is here presented as a result of such interpretation. On the other hand, Mornet neglects the literary aspect of the work and the question of its intended effect by ascribing both positions defended in the dialogue to the real Diderot.[17] R. Laufer attempts to avoid the defects of this approach by pursuing the intellectual dynamics of the text itself. According to his reading, a first section is dominated by 'the good conscience of the philosophe', in a second section this position is destroyed by the nephew's arguments, while in a final third section the artistic 'sensibilité' of the nephew is pitted against moral 'insensibilité' and the 'philosophe' retreats to his tub like Diogenes. Laufer argues that with this conclusion Diderot actually distances himself from both positions which he is unable to bring together into a satisfactory synthesis. 'This non-identification with the thoughts expressed or with his characters is Diderot's hidden message to the reader.'[18] However we judge the details of Laufer's interpretation here, we must certainly retain his insight that the reader is drawn into the problem at issue in the dialogue precisely because Diderot as author does not present himself here.[19]

In a number of works R. Desné has developed an interpretation which is directly opposed to all of those mentioned so far.[20] He understands 'Le Neveu' as a debate between Diderot the Enlightenment thinker and an open opponent of Enlightenment thought. It is

certainly true that the nephew is not merely depicted as a parasite who consorts with enemies of the Enlightenment but also as one who denies the very possibility of Enlightenment in general. And it is also the merit of Desné's approach to have exposed the conformist element in the nephew's behaviour. In spite of these partial insights, however, this interpretation seems to me to misunderstand the dialectical character of the work. Desné reduces Diderot to the measure of another bourgeois ideologue whereas in fact Diderot goes beyond this precisely by writing the dialogue. In so far as he identifies the first-person narrator of the dialogue with Diderot the author, he also fails to do justice to the literary dimensions of the work which Laufer correctly grasped when he pointed to the active involvement of the reader which the text invites. We can see that this latter point is not simply the expression of a contemporary critical perspective influenced by the experience of modern literature but actually corresponds to the original reception of other similar works of Diderot's if we consider a review of his moral tales by J. J. Engel in 1773:

Diderot's tales consists of so many philosophical ideas which he throws out but which he himself develops only up to a certain point, concerning which he comes to no firm and sure conclusion, and which indeed do not easily permit such a conclusion. If we would really judge his work, we can in honesty but propose a view on these ideas ourselves, labour with our author to develop them and venture an initial if not final attempt to decide upon the several difficulties involved.[21]

This contemporary testimony to the effectiveness of Diderot's technique supports the hypothesis that it is not merely at the end of the dialogue, as Laufer contends, that Diderot invites the reader to reflect upon the problem, but that within the dialogue the frequent interruptions are also intended to provoke thought in the reader. That is why, and this is our second hypothesis, the discussion of the problematic moral issues does not lack intellectual coherence. On the contrary, a problem which remains unresolved on one level is taken up again on another. Thus a certain progression of thought, albeit a non-linear one, is combined with a number of provocations directed to the reader. This combination, which does not itself solve the problem of mediating theory and practice with one another, nevertheless represents a step towards such a solution. For someone whose own thought has been activated by the text is more likely to draw practical conclusions from it than one who has simply adopted someone else's thoughts in a more or less passive manner.

If we wish to understand the problematic moral issues in 'Le Neveu', we should try and determine the perspective from which Diderot sees the nephew. This is clearly revealed by the following remarks of the narrator:

Il y avait dans tout cela beaucoup de ces choses qu'on pense, d'après lesquelles on se conduit; mais qu'on ne dit pas. Voilà, en vérité, la différence la plus marquée entre mon homme et la plupart de nos entours. Il avouait les vices qu'il avait, que les autres ont; mais il n'était pas hypocrite. Il n'était ni plus ni moins abominable qu'eux, il était seulement plus franc et plus conséquent, et quelquefois profond dans sa dépravation.[22]

In Diderot's eyes Rameau is by no means a moral monster led out before the horrified public that they might take all the more pleasure in the awareness of their own morally superior behaviour. On the contrary, Diderot wishes to present in Rameau precisely the unscrupulous average citizen but one who pursues a rigorous consistency in thought and action from which most citizens would recoil in horror. It is very important to realize this since the true significance of many of Rameau's remarks can only be properly revealed against this background.

The central problem of 'Le Neveu', namely whether there really is a rational foundation for morality which does not conflict with the interests of the acting individual, is initially discussed in the context of another question which is not directly connected with the moral problem, namely the question concerning the uses of genius in relation to humanity in general. As Rameau sees it, Racine would have done better to become a rich merchant in the Rue Saint-Denis in which case he could have procured an enjoyable life for himself and his friends. Diderot the narrator counters this view by claiming that Racine's work can promote the cause of humanity in later ages through the effects of his work upon human sensibility ('Dans mille ans d'ici, il fera verser des larmes. . . . Il inspirera l'humanité, la commisération, la tendresse').[23] In this connection, then, it is not only material and ideal values which stand in irreconcilable opposition to one another, but also fulfilment in the present age and fulfilment in the future.

On this level the opposition is incapable of being resolved and so the author transposes it on to another level. And here we face the question: in what does the true happiness of man consist? Rameau has already presented his answer on this matter: in the total satisfaction of our physical needs. If society gives the individual the

opportunity of attaining this happy state through the pursuit of vice, then there is obviously no reason to seek virtue:

Et que puisque je puis faire mon bonheur par des vices qui me sont naturels, que j'ai acquis sans travail, que je conserve sans effort, qui cadrent avec les mœurs de ma nation, qui sont du goût de ceux qui me protègent, et plus analogues à leurs petits besoins particuliers que des vertus qui les gêneraient en les accusant depuis le matin jusqu'au soir, il serait bien singulier qu'j'allasse me tourmenter comme une âme damnée pour me bistourner et me faire autre que je ne suis.[24]

Rameau's observation that his maxims actually concur with currently accepted forms of behaviour ('les mœurs') makes his interlocutor out to be unworldly. But the anti-Enlightenment use of the concept of *la nature* here is even more significant. Since in the eighteenth century the concept of nature is always an evaluative one, the vice described as 'natural' appears as something intrinsically valuable, a fact that is merely confirmed by the practical utility of vice in society. What can the Diderot of the dialogue say to counter this? Above all he attacks the reduction of happiness to physical well-being and material pleasure. Without actually rejecting these as such, he appeals to a higher kind of happiness: 'Je ne méprise pas les plaisirs des sens. . . . Mais, je ne vous le dissimulerai pas, il m'est infiniment plus doux encore d'avoir secouru le malheureux.'[25]

On this level too it is impossible to identify a standpoint from which the two opposed conceptions might be judged. Both speakers appeal to their own experience. The narrator Diderot has a stronger position here in so far as he does not simply repudiate the sort of happiness defended by Rameau but rather asserts the possibility of a form of happiness which goes beyond physical well-being. But what here appears as a strength in Diderot's position has already been exposed by Rameau as its weakness when he denounced the belief that happiness is the same for everyone as a chimera ('Vous croyez que le même bonheur est fait pour tous. Quelle étrange vision!').[26] Thus Rameau does not have to contradict Diderot's experience but merely to deny its validity for man in general in order to strike at the heart of the Enlightenment enterprise. With this, the level on which experiences are compared or contrasted with one another is abandonded and the question is posed in all its universality. On Rameau's view of the matter virtue is merely a peculiarity of the few. The vast majority of human beings act according to the quite different maxim which enjoins the immediate satisfaction of their needs. And Diderot the narrator can hardly deny that this is indeed the case.

Consequently everything ultimately depends upon the question whether or not this state of affairs can be changed and if so by what means.

At this point the whole problem of education demands to be addressed. And here again we are confronted with two quite opposed conceptions of the issue. For it is not merely the Diderot of the dialogue who defends a specific educational programme. Rameau does so too and indeed it is his programme which, in accordance with Rameau's pre-eminent role in the dialogue as a whole, is much the more fully developed of the two. Rameau's conception is a thoroughly consistent one: an education which takes the happiness of the child as its aim can only consist in the complete accommodation to the prevailing system: 'Je veux que mon fils soit heureux, ou, ce qui revient au même, honoré, riche et puissant.'[27] Rameau explicitly rejects any responsibility for encouraging an education to vice by claiming that he is only behaving in perfect accordance with the prevailing customs ('c'est la faute des mœurs de la nation et non la mienne').[28]

Rameau sees the most important task of education to lie in impressing the value of money upon the child at the earliest possible age and vividly presenting its value in a pantomimic scene. Thus the child learns not only what one can actually buy for one's money but also and above all that the possession of money procures the security in which one can pursue what one wants. In so far as Rameau sets up the actual behaviour of bourgeois man as exemplary, he lets bourgeois morality be revealed as ideology. And the only thing which the Diderot of the dialogue has to counter this view are his experiences which tell him that wealth and happiness are by no means the same. And he admits the weakness of his position when he concedes in advance that it is only quite 'peculiar people' ('gens bizarres') who share his point of view: 'il y a des gens comme moi, qui ne regardent pas la richesse comme la chose du monde la plus précieuse, gens bizzares. – Très bizarres. On ne naît pas avec cette tournure-là. On se la donne, car elle n'est pas dans la nature [sc. de l'homme].'[29]

It is only on this level of universality (the nature of man or of education) that agreement between the interlocutors is attempted. In opposition to the myth of the natural goodness of primitive man, both of them consider man in his natural state as a being who pursues the immediate satisfaction of his needs without any regard for his fellow man: 'il tordrait le col à son père et coucherait avec sa mère.'[30] And both of them draw the conclusion that a 'proper

education' is necessary for this reason. But the agreement here can only be an apparent one and is actually shown to be such. For the ideas of education held by the interlocutors are naturally related to their respective conceptions of the nature of human happiness. Diderot breaks off the argument at this point because it would have to appeal to positions already developed earlier in the course of the dialogue. He retains the semblance of agreement while simultaneously revealing its purely apparent character. Once the necessity of education has been conceded, the form it should take must be determined by reference to the desired *educational goal*. When the fact that Diderot defends a higher and more humane goal cannot be elucidated by the further exposition of the goal itself, then any continuation of the discussion is superfluous. Here Diderot touches on a fundamental weakness of every theory of society which attempts to transcend the existing order: it can only reveal the better life through a critique of the inadequate existing order. If the latter is dogmatically affirmed, critique has no purchase from which to begin.

In the dialogue Rameau appears not only as the cynical critic of all moral behaviour but also as a brilliantly gifted musician who has never actually created a work. The opposition between Rameau's artistic 'sensibilité' and his moral 'insensibilité' allows Diderot to address the problem concerning the possibility of action directed towards transforming reality from another point of view. He does so by asking the question how Rameau's moral insensibility has come about and why Rameau, in spite of his great musicality, has never produced a work. Rameau's answers are of two kinds: in the first place he simply contents himself with an argument from physiological determinism and claims that he is literally lacking in moral fibre ('une fibre qui ne m'a point été donneé').[31] But he also proffers a social explanation and refers us to the influence of his environment ('ou peut-être c'est que j'ai toujours vécu avec de bons musiciens et de méchantes gens').[32] The same double argumentation recurs a little later on.[33] Rameau cannot explain his own moral insensibility for both the explanations he offers contradict one another. Whereas the theory that maintains the physiological determination of human character excludes the possibility of any fundamental transformation through education, the latter becomes all the more important to the extent that we ascribe to society any significant influence upon man. Rameau sees man as quite dependent upon his material situation. Wretched conditions deter the creative man from producing anything and, what is worse, disfigure man in general. 'Que diable d'économie! des hommes qui regorgent de tout tandis que d'autres,

qui ont un estomac importun comme eux, une faim renaissante comme eux, et pas de quoi mettre sous la dent. Le pis c'est la posture contrainte où nous tient le besoin. L'homme nécessiteux ne marche pas comme un autre, il saute, il rampe, il se tortille, il se traîne.'[34] Poverty changes man, imposes certain forms of behaviour upon him and thus in the last analysis turns him from a moral being into a cripple. Here Rameau expresses views which show that Diderot has transcended the position of the Enlightenment bourgeois thinker, that he is capable of articulating positions which do not correspond with the interests of the emergent class in so far as they decisively take up the cause of the oppressed. All the 'philosophe' can offer in response is a retreat into a freedom which is bought at the price not only of material well-being but of social influence as well. We can hardly talk here of a 'militant self-assertion of consciousness' as Desné does. Rather it seems as if the conditions of the possibility of Enlightenment have been recognized in all their precariousness.

Diderot is one of the few major Enlightenment thinkers whose thought does not remain caught up within the confines of bourgeois ideology and this is because he takes the claims of the working population for a decent human life really seriously. E. Köhler rightly points out that 'in thinking through the social relationships of the Ancien Régime Diderot was capable of pushing forward to an appreciation of the Fourth Estate, the productive class in the narrower economic sense, and thus of transcending the limits of bourgeois ideology'.[35] The fact that Diderot cannot be identified with an unambiguously bourgeois position also finds political expression in his justification of violent revolution.[36] Köhler's observation is also significant for the interpretation of 'Le Neveu'. We have already seen that Diderot understands the nephew simply as a particularly consistent example of bourgeois behaviour characterized as it is by the ruthless pursuit of self-interest. Yet Diderot is far too much of a dialectician to reduce the figure to this *one* dimension. The nephew is also a proponent of some extremely powerful objections against the whole Enlightenment enterprise, objections which Diderot the narrator is incapable of directly refuting. These objections, which could be summed up in the single claim that Diderot the narrator remains the victim of an inconsequential idealism without practical relevance, derive their weight not least from the fact that with his exclamation 'Ah! monsieur le philosophe, la misère est une terrible chose'[37] the nephew becomes the mouthpiece for urgent and immediate need. From this point of view the virtues of Diderot the narrator appear as a mode of behaviour

appropriate to someone who can afford to be virtuous or as a form of disfigurement.

Diderot cannot strictly demonstrate the necessity of orienting our action towards humane values (because it is all too obvious that in a bad society self-interest rather than altruism leads to success). He allows Rameau openly and theoretically to formulate the kind of conduct actually practised by everyone (the ruthless pursuit of self-interest). In doing so he surely hopes to reveal the necessity of moral action *ex negativo*. If this interpretation is correct, we should see the dialogue as an attempt to ground the necessity of moral conduct from the revulsion we feel before the consequences of a consistent amoralism. The weakness of the position lies in the presupposition that human behaviour can ultimately be interpreted in terms of the union of theoretical insight and practical action. But the characteristic form of bourgeois behaviour consists precisely in the union of selfish action with altruistic morality. This hypocrisy, which Diderot considers typical for the average bourgeois citizen,[38] is extremely difficult to eliminate through the exercise of rational insight precisely because it corresponds so closely to the twofold need for the untrammelled expression of self-interest and the maintenance of a good conscience.

de Sade

Initially nothing would seem more confusing for the claims of sociological interpretation in this area than the fact that de Sade takes up precisely the same problematic formulated by Diderot in 'Le Neveu de Rameau'. Confusing, because it is hardly plausible to ascribe to de Sade an interest in the cause of that class from which the nineteenth century proletariat was destined to emerge.

If sociological interpretation is not prepared to capitulate before its problems, then two possible lines of approach present themselves in this connection.[39] Common to both these interpretive approaches is a decisive rejection of the tradition of moralistic condemnation with respect to de Sade. One interpretation sees de Sade as a representative of the individualist revolt against society. This approach does not enquire into the real social position of the author or the possible connection between his thought and this social position since it regards society generally as a coercive system against which the individual rebels in desperation. This tradition of de Sade interpretation, which must ultimately be seen in connection

with the artistic avant-garde movements, originally goes back to Apollinaire's claim that de Sade was the freest spirit who has ever existed and continues through the interpretation championed by the surrealists right up to some of the approaches developed within the Frankfurt School.[40] The other interpretation takes de Sade's class position as its point of departure, defines this position as that of the higher nobility and thus proceeds to categorize his thought as straightforwardly reactionary: 'reactionary in its denial of any rational meaning in history and archaic in its attempts to legitimize despotism'.[41]

We can indicate the limitations of both these interpretations as follows: the first approach certainly identifies the moment of individual protest but it simultaneously detaches this protest from the real historical situation to which it owes its existence; the second approach, on the other hand, identifies the original historical context of the phenomenon but fails to grasp the continuing relevance of that moment of protest rooted in de Sade's thought. If it is the case that both interpretations contain an element of truth, then the task must be to establish some connection between them. Thus we shall have to try and elucidate the progressive historical moment within an authentically reactionary mode of thought.

There can be no doubt at all about the aristocratic self-understanding of de Sade himself. L. Ducloux has rightly pointed out that we should see de Sade's astonishment that he should be prosecuted for beating a beggar woman in its historical context, i.e. as an expression of the typical self-conception of a member of the higher aristocracy.[42] In de Sade's case the connection between behaviour of this kind and his own thought is tangibly revealed in the fact that he can only imagine the total liberation of one individual in terms of the subjugation of another. For de Sade the instinctual drive is always in the right when it encounters any sign of resistance on the part of the object of desire. The conflict between the dominator and the dominated is not eliminated. On the contrary, the subjugation of the one becomes the condition of the liberation of the other.

What is so striking in de Sade's work is not so much the explicit presentation of perversion as the way in which the characters provide a detailed commentary upon their own actions. They certainly do not act as blind victims of an omnipotent instinctual drive but rather as fully conscious human beings deliberately shaping their own lives. Their attempt to satisfy every prompting of instinct is accompanied by an equally urgent need to justify their actions as well. But this justification in no way follows the usual pattern

according to which the individual might seek the other person's understanding for deviant behaviour by appealing to the influence of external circumstances or the irresistible power of instinct.[43] On the contrary, the justification here takes the form of a general onslaught against all the prevailing moral ideas. In de Sade the 'criminels' take the stage as convinced partisans of the Enlightenment whose principal intention is to expose virtuous behaviour as a form of unenlightened conduct that is determined by prejudices ('préjugés') and empty imaginings ('chimères'). In her conversation with the financier Dubourg the poor but virtuous Justine, who is seeking his financial assistance, discovers the inhumanity of a society which is wholly dominated by the principle of exchange. Dubourg makes it very clear that a morality based upon self-interest can yield no principle that suggests we ought to help the poor: 'à quel titre prétendez-vous que l'opulence vous soulage quand vous ne lui servirez à rien'.[44] The financier admits that the awareness of one's own altruism might well satisfy one's sense of pride. But he holds this kind of satisfaction to be an illusory one which possesses a far lower degree of reality in relation to the more tangible pleasures of libertinism. Justine is forced to recognize that owing to her total lack of means she has no alternative but to sell herself as a sexual object. The very virtue which constitutes the essence of her self-understanding is precisely what makes a materially bearable existence impossible for her. Thus Dubourg can logically characterize virtue as a 'chimère' the only value of which lies in the satisfaction of our pride: 'une chose qui n'a de valeur que celle que votre orgueil y met'.[45]

Now when Enlightenment critics attacked the idea of pride as a 'chimère' they were motivated by the recognition that pride represented a class-specific value and they contrasted it with virtue as a universal human value. But de Sade here attempts to lead such Enlightenment critique to its own absurd conclusions by radicalizing it. His characters posit physically verifiable pleasure as the only value and from this perspective pride and virtue alike fall victim to critique as fantastic illusions.

Comte de Bressac can stand as another example of these 'criminels' who attempt to 'enlighten' their victims in de Sade: in order to enter into his inheritance as quickly as possible Bressac intends to do away with his mother and he tries to enlist Justine's help in the enterprise. But in order to convince Justine of the innocuousness of murder he must first destroy her commitment to religious faith. He attempts to do so by depicting religion, and here he closely follows

the tradition of eighteenth-century materialism, as nothing but an empty superstition and a means of social oppression: 'ce dieu que tu admets n'est que le fruit de l'ignorance d'un côté et de la tyrannie de l'autre; quand le plus fort voulut enchaîner le plus faible, il lui persuada qu'un dieu sanctifiait les fers dont il l'accablait, et celui-ci abruti par sa misère crut tout ce que l'autre voulut'.[46] There can be no doubt that this argument represents a genuine strain of Enlightenment thought. In the *Discours sur l'inégalité* Rousseau had depicted the social contract as a skilful exercise of deception on the part of the rich to lend their usurped position the status of an unquestioned right.[47] And D'Holbach repeatedly attacked Christianity as an instrument of human oppression.[48] But what is provocative about Bressac's argument is the fact that here a consistent rationalism results in a justification for crime. Whereas the alliance between rationalism and humanism had never previously been questioned, de Sade replaces this with an alliance between rationalism and anti-humanism.

De Sade undertakes this separation of Enlightenment rationalism from the ideal of a humane society by appealing to the concept of nature so central in the eighteenth century. For the Enlightenment thinkers in general 'la nature' occupied a curious intermediate position between the realm of the ideal and the real. The concept designated at once both something that is and something that ought to be. 'It justifies the *natural* promptings of instinct and represses them in the name of a morality which also claims to be natural.'[49] It is no accident that de Sade makes the concept of nature the crucial term in the argumentation of his hero. For this concept is so to speak 'the geometrical site of the contradictions of the epoch'.[50] Employed as it had been by the thinkers of the Enlightenment as a polemical concept in their great struggle against 'le fanatisme' and 'le despotisme', the idea of nature was also supposed to supply a regulative norm that would exclude the justification of pure egoism. Now the peculiar feature of de Sade's use of the concept lies in the fact that he retains its emphatic character as a normative concept while simultaneously emptying it of anything that points beyond existing reality. Whatever happens to exist is also legitimized by the mere fact of its existence as part of the one all-encompassing 'nature'. Against charitable behaviour he raises the objection that poverty is part of the natural order of things: 'le pauvre est dans l'ordre de la nature'.[51] And here the connection between this line of argument and the interests of the dominating class is quite clearly revealed: 'Le pauvre remplace le faible, je te l'ai déjà dit, le soulager est anéantir l'ordre

établi, c'est s'opposer à celui de la nature. . . . C'est travailler à une
égalité dangereuse pour la société, c'est encourager l'indolence et la
fainéantise.'[52] The forger Dalville, who ruthlessly exploits Justine
like a domestic animal, cannot refrain from trying to enlighten her
about the rightness of his conduct towards her. Nature has created
both strong and weak creatures so that some might subjugate others.
Civilization can only be distinguished from the state of nature in that
in the former the position of man is determined by wealth rather
than simply by physical power: 'la priorité du fort sur le faible fut
toujours dans les lois de la nature à qui il devenait égal que la chaîne
qui captivait le faible fût tenue par le plus riche ou par le plus fort, et
qu'elle écrasât le plus faible ou bien le plus pauvre'.[53] Here we see
the explicit rejection of the humanization or moralization of nature
common in the eighteenth century,.[54] Yet at the same time the
concepts of natural order ('l'ordre de la nature,' 'les lois de la
nature') are still retained as normative concepts.[55] Thus the function
of 'la nature' as a polemical concept originally employed to promote
the ideal of a humane society, which bourgeois culture still hoped to
realize, is transformed here into an instrument for the cynical
justification of any act of oppression. This is precisely what reveals
the contradiction within the Enlightenment concept of nature and
thus its ideological status. For behind the contradiction between
nature as both norm and descriptive category there ultimately lies
concealed the dominating character of the political power pursued
by the bourgeoisie. Bourgeois domination appears as nature. In
retaining the normativity of the concept of nature while also
emptying it of all normative content, de Sade exposes the contradic-
tory element in the concept itself:

il est essentiel que l'infortune souffre; son humiliation, ses douleurs sont au nombre
des lois de la nature, et son existence est utile au plan général, comme celle de la
prospérité qui l'écrase; telle est la vérité, qui doit étouffer le remords dans l'âme du
tyran ou du malfaiteur; qu'il ne se constraigne pas; qu'il se livre aveuglement à toutes
les lésions dont l'ideé naît en lui: c'est la seule voix de la nature qui lui suggère cette
ideé, c'est la seule façon dont elle nous fait l'agent de ses lois.[56]

Once our reason has been turned exclusively into an instrument for
satisfying individual interest, it leaves the realization of the
appropriate order to the general plan of the world, i.e. to the power
of nature which finds its agent precisely in the individual who
pursues the unrestrained subjugation of his fellow human beings.
Here Enlightenment becomes fatalism. The renunciation of reason
as a force for shaping reality is not overtly expressed because it forms

the foundation of the whole system the partial rationality of which only obscures the irrationality of society as a whole.

In our investigation we deliberately took our point of departure from a work (the first version of *Justine*) in which the description of perverse sexuality plays a relatively subsidiary role, and within this work from those scenes in which morally reprehensible conduct (like the exploitation of the impoverished young woman in a situation of distress) occupies a more central position than sexual perversion. The reason for proceeding in this way should by now be clear: de Sade is not a pornographic writer. He is not primarily concerned with violating a range of contemporary sexual taboos. The provocative quality of his work is a philosophical one.[57] But this aspect cannot be read off solely from the discursive argumentative sections of his work. On the contrary, we should proceed on the assumption that description (or scenic representation) and discursive argument mutually illuminate one another. In the scenes described for us the perverse or immoral actions strike the reader as a deliberately provocative feature. In the discursive sections this particular feature is transformed into a quite universal claim that the immoral behaviour in question represents the only rational way to behave. The function of the discursive passages is to intensify the original provocation of the reader produced by the scene even further by rejecting the possibility of finding any rational foundation for moral condemnation. From this perspective we can see that the discursive element is functionally related to the provocative character of the scenes which this element serves to intensify. Likewise, the scenes themselves are related to the discursive element: they provoke the original moral indignation of the reader but this indignation only finds its properly philosophical dimension in the discursive account. The interdependence of scenic presentation and discursive commentary is thus of particular significance for understanding the philosophical intentions of the author.

de Sade and the Frankfurt School

I would now like to return to the two types of interpretation which we outlined above, the one concerned with the functional significance of de Sade's thought in its original historical context, the other with the influence which his thought has exercised beyond his own age. We showed that any dialectical reading of de Sade's work will have to accommodate both of these *levels of interpretation*. As far as

the first level is concerned, *Les Infortunes de la vertu* shows that de Sade employs Enlightenment concepts in a way that can only be described as anti-Enlightenment in spirit since the intention here is to lead Enlightenment critique to absurd conclusions. But it is on the second level of interpretation that the truth content which belongs to de Sade's originally anti-Enlightenment thought properly reveals itself. On the one hand de Sade allows us to perceive the contradictory character of one of the central concepts of Enlightenment critique ('la nature') and thus the ideological aspect of this critique as well. On the other hand de Sade reveals what bourgeois morality seeks to repress, namely the instinctual potential of man (however historically transformed or deformed this may have been). To interpret de Sade *simply* as a reactionary thinker who represents the transition from feudal to bourgeois society and links the decline of his own class with fantasies of universal destruction would be reductive, because we would then be considering de Sade's thought *solely* within its original context. Such an interpretation can no more perceive the truth content of this thought – which a dialectical theory must struggle to extract – than can an interpretation which completely overlooks the conditioning historical context in which it arose.

In the early 1940s Horkheimer and Adorno made an attempt to identify this moment of truth in de Sade's thought in their *Dialectic of Enlightenment*. The basic ideas behind the excursus entitled 'Juliette or enlightenment and morality' can be summarized as follows: 'The moral teachings of the Enlightenment testify to a hopeless attempt to replace an enfeebled religion with an intellectual reason for enduring life in society when the interest in doing so is lacking.'[58] Whereas most Enlightenment writers concealed their failure to provide a rational justification of moral behaviour behind their moral teachings, according to Horkheimer and Adorno it was the merit of the 'dark' writers of the period, and pre-eminently of de Sade, to have revealed the truth of enlightened reason. 'They did not postulate that formalistic reason is more closely allied to morality than to immorality.'[59] In other words, they realized that reason stands at the disposal of any end whatsoever. 'Since it [sc. reason] exposes substantial goals as the power of nature over mind, as the erosion of its self-legislation, reason is, by virtue of its very formality, at the service of any natural interest.'[60] In the background here lies the claim that the horror of fascist domination, under which human beings represent no more than so much disposable material, is already implicit within the principle of enlightened reason. For the Enlightenment of modern times, according to Horkheimer and

Adorno, is distinguished from earlier stages of demythologization through its radicality: 'the brilliant light of enlightened reason banished as mythological any form of devotion which claimed to be objective and grounded in actuality'.[61]

The conservative implications of the thesis advanced by Horkheimer and Adorno are obvious. Just as they speak of the 'elimination of anything which is intrinsically binding' through the exercise of reason,[62] so Gadamer can talk of 'the prejudice against prejudice in general' and the 'enfeeblement of tradition' which this prejudice has produced.[63] Thus it is not surprising that Gadamer can cite *Dialectic of Enlightenment* with such approval.[64] Of course, merely pointing out the conservative content of the Horkheimer–Adorno thesis does not amount to an adequate critique of it. This can only be accomplished if we also take account of the specific historical conditions in which the work arose. It was Horkheimer and Adorno's desire to understand their own present which constituted the original point of departure for the book. For fascism to be possible in the first place, they believed there must be something concealed within the development of bourgeois society which lay even deeper than the exploitation already denounced by Marx. It was within reason itself, seen as a power increasingly divorcing itself from nature, that Horkheimer and Adorno discovered the origin of the process which culminated in fascism. The problem with this kind of explanation lies in the fact that it attempts to understand fascism on the basis of a philosophy of history concerning the origin of human society rather than in a historically concrete manner. Since the causes of the phenomenon to be explained are sought in an event which precedes all history, the actual historical present that the theory was attempting to explain can no longer be grasped in its historical specificity at all. What happens in the present thus appears as the inevitable result of the process in which man as a rational being extricated himself from mythical bondage to nature. Thus the reception of de Sade in Horkheimer and Adorno remains bound up with the theory of domination developed in *Dialectic of Enlightenment*. This perspective does not claim to provide us with a historical interpretation of de Sade's work. A brief comparison of their position with that of the spokesmen of the Enlightenment may serve all the more clearly to show that Horkheimer and Adorno are somewhat overhasty in their readiness to credit de Sade with victory over his Enlightenment opponents.

As we have seen, de Sade makes use of the conceptual terminology of the Enlightenment and puts such language specifically in the mouths of his 'criminels'. The latter claim to lead a life guided by

reason and they unmask virtuous behaviour as something guided by prejudice. When the great Enlightenment writers like Montesquieu, Voltaire and Diderot attack prejudice they certainly do so with the aid of, and in the name of, reason, but their appeal to reason is still connected with a prior conception of a humane social order as an end in itself. This end is not for them itself an object of rational critique but rather represents an ultimate point of reference from which all critique takes its bearings. Now the distinguishing characteristic of de Sade's treatment of the rationalist structure of Enlightenment thought lies in the fact that he severs this connection between the employment of reason and the conception of a humane social order as an ultimate end. But de Sade's critique thereby comes to acquire a fundamentally different character from that of the Enlightenment thinkers. When Voltaire, for example, attacks religious fanaticism as a 'chimère', he is inspired by the historical memory of the cruelties of the religious wars and the persecutions of the Huguenots after the revocation of the edict of Nantes. His critique is a concrete one which is directly related to the reality of human suffering. It measures religious doctrine against its real practical effects rather than against its own claim to truth. In the case of de Sade the situation is quite different. Renouncing the idea of a humane social order, he connects rational action solely to the egoistic interests of the individual. The employment of reason has a final point of reference for him too, namely egoism. From this perspective de Sade is able to show that moral action is irrational because it conflicts with our own interests.

Thus de Sade would reveal the fact that in a society based upon egoism moral action is irrational in so far as it is opposed to the interests of the agent. This insight could not be acquired from a bourgeois standpoint in the eighteenth century. From this perspective the attempt had to be made again and again to reconcile particular interests with the common good precisely because bourgeois interests interpreted themselves as universal ones. This knowledge could only be attained from the standpoint of a class which had a direct experience of the disparity between the particular and the universal interest. On the one hand this applied to the claim of the underprivileged to enjoy a decent life, as this was articulated by Diderot (thereby challenging the good conscience of the bourgeois Enlightenment to which Diderot himself in many ways belonged). On the other hand it also applied to de Sade who expressed the ruling claims of a declining class, now transposed into the sexual and moral realms. It is precisely the distance de Sade enjoyed as a

member of such a declining class with respect to the determining social forces of his time which vouchsafed him insights into the contradictions necessarily concealed from the bourgeois thinkers of the Enlightenment. Thus his attack upon the dominant morality of his time turns into a consistent critique of the fundamental concepts of this moral order and an exposure of its illusory nature. The uninhibited egoism of his characters thus simultaneously represents an unmasking of the fundamental principle of incipient bour-geois–capitalist society and a defence of the individual's claims to personal happiness and instinctual gratification. There is no doubt that in Diderot's 'Le Neveu de Rameau' these claims appear in the form of a cynical accommodation to the existing order, while in de Sade's characters they represent the claims of a minority to a position of dominance. But even in the extreme deformation in which this claim to happiness appears in de Sade, the central thought concerns the salvation of the particular over against the immemorial domination of the universal. It is important to emphasize that in de Sade the liberation of the individual always simultaneously implies oppression of the other and that the claim to happiness can only be realized in a kind of repression. Peter Gorsen expresses this dilemma as follows: 'On the one hand de Sade desires a republican state where each individual is sovereign, but on the other hand he can only imagine the happiness of the individual as a sadistic form of love which is exercised by the stronger upon the weaker.'[65] However, it is questionable whether, as Gorsen thinks, this 'paradoxical character' belongs to 'any philosophy directed towards changing society which contemplates a revolutionary transformation of the existing order that is *completely beyond* the real possibilities and which can only articulate this transcendence and concretize itself in a psychopatho-logical image of existing reality'.[66] This fails to point out that the experiences of any individual are not solely determined by 'existing reality' but also, and primarily, by the individual's particular position in society. As a member of the higher nobility towards the close of the *ancien régime*, de Sade was in a position to experience the world differently from someone of an earlier generation such as Rousseau, who has with some justice been seen as a representative of the *petite bourgeoisie*.

It is necessary to insist upon the deformation involved in de Sade's experience, conditioned as it was by his upbringing and intensified by decades of prolonged imprisonment. The conclusion to be drawn from this is not that we should attempt to reduce de Sade to more 'normal' dimensions. The only question concerns what we can

possibly learn from such an extreme experience. Certainly one thing we can learn above all is a certain pessimism and distrust towards all projects for a harmonious human society. De Sade reminds us of man's instinctual potential and its drive to gratification at any price. He shows us how instinct can take reason into its own service. The ferment of de Sade's thought must be incorporated into any theory of human progress which wishes to intervene effectively to change reality.

7

Naturalism, Aestheticism and the Problem of Subjectivity

Preliminary remarks

On returning to Germany after an extended stay in Paris Hermann Bahr wrote as follows in an essay first published in 1891 under the title 'The crisis of naturalism': 'The curiosity of the reader and the inclination of the writer turns inwards once again, away from the depiction of the external world that surrounds us to become a confession of the innermost depths within us, away from the "rendu de choses visibles" to the "intérieurs d'âmes".'[1] In this passage Bahr seismographically registers his experience of the Parisian literary circles associated with the aesthetic movement. In the early 1880s the conservative critic Ferdinand Brunetière could still attack naturalism in literature by employing traditional critical concepts and reproach Zola for example with an ignorance of literary history and general lack of culture. And he could still apply the *bienséance* rules of classicist literary doctrine in his critique.[2] But the critique of naturalism which was mounted by aestheticism was not directed against the violation of such traditional aesthetic norms. On the contrary, it put the whole naturalist project of reproducing social reality into question.

There are a number of thoroughly reliable procedures available for producing a novel along romantic or naturalistic lines; but the romantics and naturalists of recent times do not even seem to have noticed that the real task is to draw forth from within oneself that innermost utterly particular reality which is unknown to others and to ourselves and to fashion novels out of this material.[3]

According to the aestheticist school, then, naturalism misunderstands precisely what it is that literature is called upon to accomplish: the reproduction of subjective experience in all its uniqueness and irreplaceability. In so far as naturalism concentrates upon the representation of the external world, it loses hold upon the inner world of the subject.

Despite its considerable influence at the time, it is not difficult to identify Brunetière's critique of Zola as an expression of the moral and aesthetic norms of the conservative bourgeoisie of the second half of the nineteenth century and thus recognize its very limited range of validity. But this certainly cannot be said to the same extent for the aestheticist critique of naturalism. Among other things this is probably because the aesthetic conceptions of late bourgeois society were themselves decisively influenced by aestheticism. So it was, for example, that Proust, whose aesthetic views have continued up to the present day to influence the evaluative criteria employed in literary criticism and research, also adopted the critique of naturalism we have outlined above. When he defines the aesthetic meaning ('sens artistique') of literature as a 'submission to inner reality' ('soumission à la réalité intérieure'),[4] he is simply repeating a view of the matter which was quite typical of aestheticist writers at the turn of the century.[5] And the same holds for Proust's rejection of the realistic description of things:

The kind of literature which is quite content with 'describing things', with offering us a wretched compilation of the external forms and surfaces of things, is in fact the furthest removed from reality, although it calls itself realistic; it impoverishes us and actually depresses us more than any other kind of literature since it violently destroys the communication of the present self with the past, the essence of which is preserved in things.[6]

At the close of the nineteenth century Charles Morice was already formulating just this conception of the thing as a sign or symbol of the inner experience of the subject when he wrote: 'The external appearance of things ('l'aspect des choses') is only a symbol which it is the task of the artist to interpret. Things have truth only in the artist, they only possess an inner truth ('une vérité interne').'[7]

In this argument between aestheticism and naturalism there is clearly much more at stake than the question of appropriate artistic procedures. What is at issue is rather the institutionalization of literature in bourgeois society itself. The real objects of contention here are those general ideas about literature which serve to define its social function. If literary research unreflectively adopts the aesthe-

ticist radicalization of the autonomous concept of art or, more concretely, turns the Proustian aesthetic into the very horizon for contemporary aesthetic experience, it will be just as unable to perceive the real significance of this dispute as an approach which erects the identifiable social engagement of a work as the sole criterion for literary evaluation. In both cases the interpreter here sets up his or her own concept of literature as the only correct one. In this way the interpreter enters the dispute between these two competing conceptions of institutionalization but is largely unable to acquire significant knowledge about either of them. It is only possible to thematize the institutionalization as such once we understand that with the historical avant-garde movements the autonomous concept of literature has entered upon a stage of self-criticism which still remains unresolved even in Sartre's conception of engaged literature. Or to put the matter another way: the contemporary crisis of the concept of literature, which could be roughly indicated by juxtaposing Günter Wallraff's documentary literature on the one hand with Peter Handke's neo-aestheticist prose on the other, furnishes a starting-point for the attempt to understand something about this dispute between naturalism and aestheticism concerning the institutionalization of literature, something which is not simply already contained in either of the two concepts of literature on their own.

Let me now try and formulate more precisely what has been said so far in relation to the problem of subjectivity. The aestheticist critique of naturalism provokes a corresponding counter-critique since the aestheticist writers assume a particular concept of the subject as the only valid one. According to their view, the subject is utterly individual and does not actively engage either with other subjects or with the objective world and is only capable of comprehending the objective world as a symbol which refers in turn back to the subject. In the emancipatory phase of bourgeois society, on the other hand, the subject was only able to constitute itself in and through engagement with the objective world and it is the loss of just this dialectic between subject and object which lies behind the aestheticist critique of naturalism. Nevertheless, this critique is by no means without significance. Even if it takes its point of departure from a reduced and solipsistic concept of the subject, the aestheticist critique does identify an essential limitation of the naturalist programme, namely its inability to find a way of representing subjective experience.

The programme of French naturalism

Within the field of literary criticism and research the whole naturalist programme has been almost unanimously repudiated by writers representing the most varied political and theoretical positions. The spectrum of condemnation stretches from Brunetière to Lukács. Since the naturalist programme is also repudiated by writers who certainly recognize the literary value of Zola's work one cannot but suspect that there is something about the programme itself which conflicts with the prevailing modern conception of literature and art. In fact the offence in question is not difficult to discover. It lies in the attempt to bring literature into close proximity with science, an attempt which threatens to lose hold of the specificity of literature itself. This is the problem that has to be pursued here. But first we must attempt to disclose the original socio-historical significance of the naturalist literary programme.

In his *Roman expérimentale* published in 1880 Zola had actually referred to the physiologist Claude Bernard and his *Introduction à l'étude de la médicine expérimentale* and proceeded to claim that the novelist, like the physiologist, essentially performs an experiment when he places a character equipped with a specific set of qualities into a particular environment and subsequently observes the reactions of the character. The standard refutation of Zola's comparison consisted in pointing out that the essential difference between the physiologist's experiment and that of the novelist is that while the experiment of the former takes place in reality, that of the latter transpires in the novelist's mind.[8] But this valid enough observation hardly helps us towards a closer understanding of the naturalist programme.

It is the great merit of Aimé Guedj[9] to have pointed out that Claude Bernard by no means always understands the concept of 'expérimentation' in a strictly scientific sense but sometimes relates it quite closely to our everyday experience. In this connection there is one particularly instructive passage quoted by Zola where Bernard equates his 'méthode expérimentale' with the learning process of everyday experience in which we deal with people whose intentions we do not know: 'In this case we must check a man's actions against his other actions; we observe how he behaves in a given situation, in a word, we turn to the experimental method.'[10] From this we can see that the concept of 'experiment' that Zola takes over from contemporary science is not strictly limited to the rigorous meaning of the

term as employed in empirical natural science but also covers the process in which we rationally acquire experience in everyday life.

If we really wish to understand the criterion behind the claims implied by the term 'le roman expérimentale', we must first be quite clear that we are dealing with distinctly polemical writings here. As Zola explicitly says himself: 'ce sont ici des articles de combat, des manifestes'.[11] The real object of debate is the institutionalization of literature in a modern society which is dependent upon scientific and technological progress and which finds itself in a situation of potentially fatal rivalry with other societies of the same kind (above all with Germany). On Zola's view of the matter these are the external conditions within which the question concerning the social function of literature is to be posed.[12]

Zola takes a successful performance of Victor Hugo's *Ruy Blas* as the occasion for a settling of accounts with the prevailing institution of literature: 'As soon as we consider it [i.e. Hugo's play] from the point of view of history or human logic and attempt to find practical truths, facts or documents in it, we discover an astonishing confusion of errors and lies and fall into a void of lyrical madness.'[13] Zola's evaluative criterion here is 'truth'. On the one hand he understands truth as correspondence with the results of historical research ('history'), on the other as correspondence with a mode of behaviour capable of being measured against everyday experience ('human logic'). On these criteria Hugo's drama inevitably fails the test and Zola describes the result disparagingly in terms of 'music' and 'rhetoric' ('C'est de la musique et rien autre chose').[14] Such art produces a purely emotional effect which cannot stand up to the comparison with reality.

The romantic school has turned patriotism into a simple question of rhetoric. To be a patriot it has become sufficient to employ the word 'Fatherland' as frequently as possible in the drama or any other literary work, to wave the flag and compose tirades on the subject of heroic deeds. . . . But this merely provides a certain sensuous stimulation for the accomplishment of noble deeds. This aims at the nerves but it does not address the understanding. . . . But this nervous stimulation only exerts a superficial and wholly temporary influence as far as military victory is concerned. In these modern times of ours victory depends increasingly upon the technical understanding of the general who is conducting military operations, upon the hand which knows how to apply the scientific formula of the epoch to the prosecution of the war.[15]

This passage is illuminating in a number of respects. On the one hand it reveals the motivation behind Zola's obstinate attempts to

render literature more scientific. He is not only concerned here with legitimating his own literary practice but also with trying to establish a new concept of literature which will liberate it from the taint of irrationality and thus turn it into a useful instrument for our scientific civilization. On the other hand the problematic character of the whole enterprise is also clearly revealed here. The rationality which Zola opposes to an irrationalist literary practice is the truncated instrumental means–end rationality which is characteristic of positivist science. This is a rationality which does not itself possess any criteria which would permit a rational decision concerning alternative conceptions of value (in the passage quoted Zola merely discusses the appropriateness of the means to a given end, here military victory over Germany, while the question as to whether the end itself is worth pursuing is not addressed).

It would be a mistake to assume that Zola's struggles were only directed against the romantic movement. In fact he understands romanticism simply as the contemporary expression of a conception of literature which he calls 'idealistic'. When Victor Hugo's followers praise the 'elevation to the ideal' ('envolement dans l'idéal'), Zola is particularly suspicious of this attempt to transcend the given reality of the here and now. The claim that Hugo raises the onlooker beyond the sphere of everyday life ('il nous enlève à notre vie vulgaire et nous mène sur les sommets')[16] is what provokes Zola's opposition. He repudiates the ideality common to both classical and romantic art in the name of his own concept of truth. For Zola a literature which wishes to rise beyond anything that we can experience in everyday life is already implicitly false.

When Zola attempts to bring literature as close to science as possible, he does so principally because on his view only a literature beholden to the positivist conception of truth is capable of imparting knowledge about real social relationships and thus playing a constructive role in the development of modern society. However, he is content to leave the practical realization of his insights (e.g. the necessity of transforming the environment, the negative influence of which upon the conditions of human life he has clearly revealed) to the legislative powers that be.[17] Thus we could characterize Zola's conception of literature as an instrumental one. Within external social conditions taken as given the function of literature is seen to consist in the acquisition of practically useful insights into the social and biological conditioning factors of human behaviour and in the communication of these insights to the reader.

However, a grave problem arises from this attempt to bring literature closer to science, or rather to subject it to the positivist conception of truth: the institution of literature can now no longer clearly be differentiated from the institution of science. Zola's thoroughly contradictory attempts to define the precise position of the literary producer reveal that he recognized this problem himself. For he wavers here between two quite distinct conceptions: on the one hand a far-reaching exclusion of the writer's subjectivity from the creative process, and on the other a restoration of the idea of the primacy of the creative personality (an idea otherwise fiercely contested by himself).

Zola develops the first of these conceptions in the context of his critique of romanticism. The concept of the 'document' plays a central role in this programme. For here Zola aims at the reporting of observations rather than at the reproduction of the subject's experiences. Thus he emphatically rejects all those conceptions which declare the personality of the artist to be the very centre of the literary creative process.[18] In so far as we strive to bring literature into proximity with science then the subjectivity of the writer appears as a moment which conflicts with the desired objectivity. Thus subjectivity is only permitted an effective role in the domain of linguistic articulation which Zola treats as a quite subordinate aspect: 'Let us determine the method ('fixons la méthode') which must be shared by all and let us then accept all the rhetorical techniques that can be developed, let us consider them as an expression of the writer's literary temperament.'[19]

Here 'method' is understood as the objective and 'rhetoric' as the subjective dimension of the literary process of production. In this context Zola is clearly anxious to restrict the writer's subjective contribution to the creative process as much as possible since he sees this as an irrational potential which runs counter to his instrumental definition of literary function. But this tendency to exclude the writer's subjectivity soon creates problems of its own. How then can we distinguish a novel from a social-scientific study? What are the specific qualities of an artistic novel? How can the novel exercise an effect upon the reader if it organizes all its observational results in a purely rational manner? Zola attempts to resolve these problems by appealing back to the 'personal expression' ('l'expression person-nelle') of the writer after all. He contrasts the personality of the truly significant writer with the hard-working professional author. The latter is an industrious toiler who turns out a given number of pages

every day and succumbs to the illusion that it is possible to produce a good book in the same way as one would produce a good pair of shoes[20] but he is unable to respond to his subject-matter with all the fibres of his being ('il n'y a pas dessous un homme qui a véritablement senti').[21] The significant writer on the other hand is quite different. He identifies with the subject-matter of his work and so is also able to give it truly living form. That is why the works of such a writer also exercise an emotional effect upon the public.[22] The argumentative logic here is very simple since the originality of the significant work is explained by reference to the originality of the authorial personality. And in this connection Zola appeals to the traditional concept of genius which is actually quite incompatible with his attempt to render literature more scientific. The very obviousness of this glaring contradiction is instructive. For it points to a fundamental problem in the naturalist project which attempts to formulate and polemically to establish a concept of literature appropriate to a democratic society based upon scientific and technological progress. Zola is unable to explain the position of the productive subject within his own concept of literature. Or to put it another way, his concept of truth is not adequately mediated with subjective experience. In this unresolved problem concerning the place of subjective experience within the naturalist concept of literature, we cannot fail to see the starting-point for the aestheticist assault upon naturalism. This problem also reveals the latent presuppositions of the whole process known in the history of literary criticism as the 'overcoming of naturalism'. Zola claimed to be formulating *the* conception of literature appropriate to the Republic ('la République sera naturaliste ou elle ne sera pas')[23] If this conception failed to establish itself and the avant-garde movements of the twentieth century took aestheticism as their point of departure instead, then this development can be explained by the inadequacies of the naturalist conception we have discussed above.

The consequences of the naturalist conception of literature for the development of the epic material

The clearest answer to the question concerning the consequences of the naturalist concept of literature for the development of epic material was formulated by Lukács in his 1936 essay 'Erzählen oder Beschreiben?' [Narration or Description]. The fact that Lukács condemns naturalism on the basis of a suprahistorical normative

aesthetic position has often prevented his later interpreters from appreciating the value of his particular observations.[24] It is these observations, and not the contradictions of Lukács aesthetics in general, with which I shall be concerned in the following remarks.[25] In this connection we shall see that it is quite possible to learn from these observations without thereby subscribing to his evaluation of the issues involved.

Whereas Zola in his programmatic writings interprets naturalism as a further systematic development of the realistic novel of the first half of the nineteenth century, Lukács starts from the assumption that two fundamentally different 'creative methods' can actually be discerned here. The more recent procedures, the origins of which he finds in Flaubert's work and in Zola's naturalism, Lukács calls 'description' and explicitly contrasts it with the method of 'narration' characteristic of classical realism as represented by Goethe, Balzac, Stendhal and Tolstoy. Lukács points out that description is certainly to be found in Balzac as well as in naturalist literature. The difference between the two methods arises from the different functional value which is ascribed to description in each case. Whereas in the writings of the great realists the descriptive parts of the work are functionally subordinated to the acting individuals, in Flaubert and in naturalism generally description becomes an autonomous element in its own right.[26] What Lukács deplores as the autonomous separation of description can be interpreted as a move away from the privileged representation of acting individuals towards the representation of social life-worlds. It has been noted with some justice that the reader of Zola's novels often remembers the milieu in which the characters move more clearly than the characters themselves.[27] We could almost speak of a reversal of dependency with respect to the relationship between character and environment. In the realistic novel of the first half of the nineteenth century the description of milieu functions either as a means of characterizing the individuals in the text (the description of the Pension Vauquer at the beginning of Balzac's *Père Goriot* for example helps to characterize its residents) or as a depiction of that part of the world with which the hero must engage if he is to realize himself (here we might think of the different life-worlds in which the character of Julien Sorel is developed). In both these cases the description of milieu is functionally related to the characters. In the naturalist novel on the other hand the character frequently becomes the medium through which the social life-world is mediated.[28] The author is not primarily concerned with the characterization of the particular individual, nor

indeed with the character's active engagement with reality, but rather with the representation of a social life-world.

This displacement of the principal object of representation can be observed particularly clearly in a novel like *Au Bonheur des dames*. The main character Denise, despite close family ties with the world of small business, starts working in a large store, rises from the position of minor sales assistant to that of departmental manager and eventually marries the owner of the store. The function of the character is to present the conflict between small business interests and those of the big store. It is not the milieu that helps to characterize the figure here but rather the figure who helps us to experience a social life-world. Zola's notes for the novel clearly reveal such displacement:

In *Au Bonheur des dames* I wish to write a poem to modern activity. . . . I require for example a sales assistant, poverty in a silk dress, a girl whose hardships I will depict and whom I will show happy or rather unhappy at the end. Yet it will be necessary to find some kind of intrigue. . . . The task is to find a major figure, a man or preferably a woman, in whom I can personify the declining world of small business.[29]

Thus the real object of representation is modern activity in general ('l'activité moderne') or the last throes of small business ('le petit commerce agonisant'). The characters and the action are secondary by comparison and serve principally to thematize the life-world in a vivid fashion.[30]

Lukács sharply criticizes the autonomous separation of description from two points of view. First, because if this procedure is adopted then society can no longer be perceived as a totality (in its functional interconnection), as it still can in Balzac. Second, because the work no longer represents an organic totality in accordance with the concept of symbol as developed in classical–idealist aesthetics (where the work of art mediates the individual and the universal in sensuous form). The observations which underlie this critique are broadly valid ones. Zola thematizes particular domains of social reality, writing novels for example about the world of mining (*Germinal*), the big department store (*Au Bonheur des dames*), the stock exchange (*L'Argent*) or the Parisian artistic milieu (*L'Œuvre*). The renunciation of any attempt to represent the totality of social relationships is complemented by the precision and exhaustiveness with which the external appearance and the functional mechanisms of a specific domain of the social world are presented. Thus in

L'Argent, for example, every other sphere of social activity not directly connected with the operations of the stock exchange is completely excluded. And exactly the same is true of other novels by Zola. He can only grasp the totality of capitalist society as the sum of the particular social domains, as an aggregate rather than as a functional interconnection of moments. The renunciation of the attempt to represent the interconnection of society as a whole within the individual work, in however tentative a fashion, should be understood as an expression of the positivist conception of science which was characteristic of the naturalist writers. For the positivist also believes that we can only acquire knowledge of the whole through the summation of infinitely numerous partial items of knowledge.

However, we must recognize that the positivist restriction of knowledge to a purely summative conception of totality also harbours a certain critical moment at least from Zola's perspective. Thus in *L'Œuvre* he puts the following words into the mouth of the writer Sandoz, who bears a very strong autobiographical reference to Zola himself:

How marvellous it would be if one could dedicate one's whole existence to a work in which one attempted to reproduce things, animals, human beings, the mighty ark itself ('où l'on tâcherait de mettre les choses, les bêtes, les hommes, l'arche immense'). Not all in order like in our philosophical manuals, in some sort of idiotic hierarchy which gives comfort to our own pride, but rather in the full flood of universal life; a world in which we would just be one contingency among others ('un monde où nous ne serions qu'un accident'), where the dog running by or even the paving stone would complete and explain us; finally the great totality itself, without top or bottom, neither dirty nor clean, just as it is. . . . Certainly, novelists and poets must turn to science for today this is our only possible source. But what should we adopt from it and how should we engage with it? And now I realise that my mind begins to swim. . . . [31]

Zola emphatically rejects any hierarchical concept of totality which he clearly recognizes would merely serve to legitimize domination. Even the privileged position traditionally ascribed to man strikes him as an expression of non-egalitarian thought. The democratic impulse which animates Zola's conception of literature is very clearly revealed here. Enlisting the support of contemporary science is intended to help us to purify our ideas about literature from all those evaluative concepts which derive from a hierarchically organized society and fundamentally contradict the egalitarian principles of democratic society.[32] And indeed conservative critics were quick

to perceive the democratic impulse behind the naturalist concept of literature.[33] Thus when *L'Assommoir* was published the critic of the *Gazette de France* spoke of this 'repulsive literature' which had been spawned by the advances of democracy: 'une littérature infecte s'est produite à la faveur des triomphes de la démocratie et du radicalisme comme ces couches d'insectes puants et malfaisants qui pullulent dans la vase et augmentent la pestilence après les débordements'.[34]

With a conception of totality like that outlined above the writer pushes his legitimate suspicion of every hierarchical conception of order so far that he now attempts to perceive relationships in the world directly without recourse to any kind of construction. And this has consequences for the attitude which the literary producer takes to the object of representation. For strictly speaking the author should now no longer appear as the point of reference which bestows meaning: 'In the end then we shall simply supply so many studies, without crises or resolutions, an analysis of one year in someone's life, the history of a passion, the biography of a character, notes extracted from life and logically arranged.'[35] This document can speak for itself. The task of the author is not to bestow meaning on the world but to arrange the documentary material in front of him.[36]

But we can also understand this change in the attitude of the writer in another way, namely as the renunciation of symbolic representation. For now the representation presents nothing but itself and no longer functions as a sign of something universal beyond it. It can now present reality in all its richness. Lukács rightly saw this change as a repudiation of the classical aesthetic conception of the work of art. As soon as the completeness with which one social domain is depicted becomes the very purpose of representation, then the principle of continuous juxtaposition gradually begins to replace the idea of presenting the inner relationship between the particular element and the work as a whole. In other words, Lukács criticizes Zola as a precursor of the avant-garde, which he rejects in the name of his own conception of social realism oriented towards the organic–symbolic concept of the work of art familiar in idealist aesthetics.[37] Here too we must draw a distinction between his instructive observations, which certainly illuminate one aspect of Zola's work, and the general assessment which he makes on this basis. The assessment is particularly problematic in so far as its presupposes the suprahistorical validity of the idealist aesthetic conception of the work of art.

But we can also question this assessment on the level of individual analysis. Zola's novel *Au Bonheur des dames* can be regarded as one

which is more decisively marked by the principle of autonomous description criticized by Lukács than almost any of the others. Not only does Zola repeatedly describe the external appearance of the ever-expanding department store, he also provides us with almost monographically detailed information about business administration and sales techniques, about the conflicts which arise between employees and customers and so on. In short, the novel tends towards a kind of reportage. But this reportage aspect of the novel specifically brings critical insights to bear upon one particular domain of social reality (commodity aesthetics, stimulation of needs, customer manipulation, for example). And here the author's positivist ambition to provide an exhaustive reproduction of all the aspects of a given domain yields significant results.[38] In the struggle between small business and the larger commercial concerns of the department store Zola emphatically sides with the latter which he sees as an expression of social progress. But he conceals neither the mechanisms involved in customer manipulation, mechanisms which extend far into the psychological structure of the subject by virtue of the sensuous appeal of the mass commodities on offer, nor the fact that it is just such customer manipulation which makes the economic success of the big department store possible in the first place. However, when Zola attempts to represent human beings as active subjects intervening in the events described, then the novel immediately threatens to become ideological and thus lose its (admittedly limited) authenticity as reportage. When the salesgirl marries the owner of the store at the end of *Au Bonheur des dames*, the lower-class readers whom Zola has succeeded in reaching are given to understand that everyone can fulfil the dream of ultimate happiness by the application of industry and perseverance. Thus the sentimental story of the humble salesgirl prevents us from perceiving the real harshness of the struggle between the wage-earners and the owners of capital.[39]

That every attempt to humanize the social conflicts represented in the novel only leads to ideological distortion is no isolated case in Zola's work. Thus in his novel *L'Argent* Zola's efforts to provide a psychological explanation for the mania of commercial speculation end up by turning the stock-market speculator into a demonic figure of superhuman dimensions.[40] We could therefore actually reverse the assessment offered by Lukács. The very closeness of Zola's novel to reportage which he criticizes would then reveal itself as the real basis of Zola's critical insights into society, while the 'interaction between human beings and the events of the external world'

demanded by Lukács would at least in Zola's case merely encourage the danger of ideological representation.[41]

When Zola turns to the representation of a social life-world, he can only grasp the human being as a part of this world. Regarded in functional terms within a particular social life-world, for example, Denise is reduced to the characteristic qualities of industry and perseverance (*Au Bonheur des dames*), Saccard to speculative fever (*L'Argent*), and Nana to sensuousness (*Nana*). Sometimes, however, two characteristic qualities present themselves, one of which proves dysfunctional with respect to the general role played by the character. While Denise's solicitous affection for her brothers and sisters only strengthens those characteristics of industry and perseverance which are functionally positive for her life in the department store, the gourmandizing of Gervaise contradicts the complex of characteristics which leads her to pursue an independent *petit bourgeois* existence (*L'Assommoir*). We can also observe an ideological turn in the representation whenever Zola, in opposition here to his own insights into the primacy of the social life-world over individual action, allows such personal qualities a fundamental part to play in determining the action. When Saccard comes to grief on account of his own abstract urge for conquest rather than through the irrationality of stock-market speculation, or when Gervaise fails to realize her ambition among other things because she has such a sweet tooth, then the purely contingent characteristics of the protagonists become decisive factors in the unfolding of events and Zola's insights into the power exercised by the real circumstances of life also get lost in the process.

And here we encounter the same sort of contradiction as we did on the general level of the naturalist programme itself. There we saw how the scientific pretensions of the novel were taken back again through the ideology of the great creative individual. Similarly here, on the level of the epic material, the primacy accorded to the representation of the social life-world is taken back again through the psychologization of the action. It is tempting to conclude that this can be explained by the fact that Zola was expressly aiming to capture a mass readership. For Zola was one of the last bourgeois writers who still attempted to weld together the quite divergent material resources of the serious novel and the light entertainment novel and this attempt certainly deserves our respect. Nevertheless, we cannot avoid pointing out the artistic, and here that means the ideological, deficiencies produced by aiming to satisfy the expectations and the needs of a mass public.[42]

Given the lack of representative evidence concerning the original reception of Zola's work by this mass public, we shall have to try and discover whether our assumptions are justified by examining the reviews of his contempararies. Of course, we must also remember that the majority of reviewers reflect the prevailing conception of literary institution. And this means that they also still apply the moral–aesthetic criteria of the *doctrine classique* to Zola's novels and in accordance with the rules of *bienséance* strongly criticize the undignified material and the reproduction of lower-class language in his work. These criteria were probably quite without significance as far as the vast majority of Zola's readers were concerned. But things are different, however, when even those reviewers generally quite unsympathetic to Zola's work find themselves repeatedly forced to admit that his characters really do produce an impression of great vitality. Thus, in a review of *L'Assommoir*, Henry Houssaye, like many others, is incensed that a writer of Zola's stature should stoop so low ('nous nous indignons qu'une telle plume se soit volontaire-ment jetée dans la boue') but he writes: 'His characters lead a purely animal life, certainly, but they do live.' The critic of *Le Bien Public* emphasizes that Zola has located the social question within the domain of 'living reality' rather than merely on the level of economic debate and philosophical theory. And the reviewer of *La Vie Littéraire* praises the clear and vivid delineation of the characters ('le ciseleur vigoureux et délicat en sa rudesse').[43] On the basis of this evidence we can conclude that Zola's depiction of character must also have produced among the mass public that same impression of 'vitality' which the reviewers of *L'Assommoir* so unanimously confirmed. On the other hand, it would appear that the descriptive sections of his work met with resistance among the mass public. Thus we find the presentation of documentary material in *Au Bonheur des dames* being censured for its monotony: 'the considerable number of penetrating observations would be more interesting if the whole picture were less drawn out'. One critic even traces the relatively poor success of the serial publication of the novel back to the abundance of its descriptions ('Le portrait sous ses différentes faces, de l'immense bazar y tient trop de place pour satisfaire aux exigences du journal').[44] Thus the claim that Zola occupied an intermediate position somewhere between the avant-garde documentary novel and the literature of light entertainment is confirmed by the evidence we have quoted concerning the contemporary reception of his work.

The ideology–critical interpretation of *Au Bonheur des dames* outlined above can also be supported by examining the contempor-

ary reviews of the novel. Although such a critique is not explicitly formulated in these reviews, the proximity of Zola's work to entertainment literature was already noticed in the period itself. Zola's 'happy ending' is compared with the just rewards of virtue in Scribe's comedies and the conclusion of Erckmann-Chatrian's extremely successful novel *L'Ami Fritz*.[45] But what is interesting is the fact that this proximity is by no means assessed in a negative fashion by the reviewer of *Le Mot d'Ordre*. The distinction which has become so familiar to us between serious literature and entertainment literature had not yet become universally established in France at this time. But there is something else which is even more revealing here: if earlier critics of Zola had repeatedly found occasion to express a certain moral–aesthetic distaste for his subject-matter, with the publication of *Au Bonheur des dames* they were agreeably surprised to discover 'not only a healthy, moral work but also one of the most moving and pathetic narratives imaginable'. For in this novel Zola deals with 'the trials, the struggles, the courageous nature of a modest and admirable young woman'. Thus we are hardly surprised when one reviewer explicitly emphasizes in a positive manner the consoling function of the book for readers of the lower classes, in comparison with Zola's other novels ('Les demoiselles de magasin, qui liront peut-être ce livre dans la mansarde, à la lueur d'un bout de bougie, à l'heure des tentations mauvaises que leur envoie le Paris nocturne en train de s'amuser, y trouveront plus de consolation que dans Nana').[46] This positive evaluation of the affirmative moments of the novel on the part of conservative critics supplies the only possible empirical confirmation of the ideology–critical interpretation outlined above.

To sum up then, Zola fights for an institutionalization of literature which corresponds to a democratic society based upon the advances of science and technology. The central point in his programme is the scientific transformation of literature which is reflected on the level of the epic material in the priority now ascribed to the representation of the social life-world and, closely connected with this, in the repudiation of the principle of authorial constitution of meaning. In fact Zola deviates from this programme, which takes up the conception of literary institution characteristic of the bourgeois Enlightenment in understanding literature as the communicative medium for the articulation of political issues, because he adapts his work to those needs for compensation and consolation felt by large circles of the reading public. In order to satisfy such needs he 'psychologizes' the representation of action. Whereas according to his scientific

concept of the nature of literature individual subjects simply possess a functional role, in his novels he actually gives them a determining part to play in the action and thus tends to fall victim to the very ideology of the autonomous individual which he otherwise contests in the name of positivist science. The interpretation outlined above might now suggest that Zola's whole problematic could simply be reduced to the opposition between the (avant-garde) documentary novel and the literature of entertainment. Or formulated in another way: if he had oriented himself strictly to the scientific concept of literature, or one approaching the scientific model, Zola might have exercised a decisive influence upon the actual development of the institutionalization of literature, as well as upon the development of the epic material. But in fact such a view is problematic in several respects. The idea that a single writer or even a group of writers could change the institutionalization of literature fails to recognize the socially conditioned character of institutional conceptions of literature. Zola is only able to attack the prevailing institution of literature with any prospect of success if he also satisfies the real needs of broad circles of the reading public. Without this mass success he would simply have remained an outsider who might later have been discovered as a 'forerunner' of the future avant-garde.

There is another aspect to this question which is even more important: if it is true that within developed bourgeois society literature is institutionalized as a domain in which those problems of subjective experience excluded from a social reality organized according to principles of purposive rationality are articulated, then we must admit that the whole naturalist programme stands in direct contradiction to this process of institutionalization. The scientific transformation of literature ruptures the experiential continuum which connects the author with the object of representation. The fact that Zola subsequently reintroduces the personality of the author as he does merely highlights this problem without actually resolving it (cf. the section on the 'Programme of French naturalism' above). Within Zola's concept of the representation of the social life-world the subject only occupies the place of a functional role-bearer and does not appear as intrinsically problematic. The subject serves to present social conditions in a vivid way, not to thematize the problems of subjectivity as such.

Zola's contemporaries saw this quite clearly. When the famous critic Jules Lemaître described the principal figures of Zola's novel *L'Œuvre* as 'physiological puppets' (des bonhommes physiologiques'),[47] this could simply be read as the typical comment of an

anti-naturalist writer who misses in Zola's work the conflict of values he expects from a novel. Yet Zola's supporter d'Armon, who wrote a critical rejoinder to Lemaître's criticisms, says very much the same himself: 'For him [sc. Zola] an individual is merely a fragment from an immensely large series of facts' ('un individu n'est pour lui qu'un fragment d'une immense série de faits').[48] Zola wishes to understand the subject as the direct outcome of certain biological and social processes that can be analysed without remainder into heredity and social environment. Yet such an approach must appear inadequate to those who believe the function of literature lies in reflecting the unresolved problems of bourgeois subjectivity. From this point of view the lack of experiential perspective in Zola's work naturally appears as an object of criticism:

Anyone who has experienced passion talks about it with a feeling of melancholy, like René [sc. the hero of the eponymous experimental novel by Chateaubriand] or with a sense of horror, like Augustine; but always with genuine feeling ('avec une émotion juste'). Monsieur E. Zola is fearful that he has not depicted such passions with the required detail and presents them to us under the microscopic lens! . . . These are representations that leave us cold since they have been constructed in a spirit of cool calculation, like reports of war by one who has never found himself under fire.[49]

This criticism is revealing precisely because it shows that the problematic which leads to the aesthetic turn to the subject is already implicit within naturalist literature. The displacement of representation towards depiction of the social life-world logically leads to a type of documentary novel which tends to exclude the thematization of problematic subjectivity. Zola's friend Céard realized this fact. He regrets that in *Germinal* Zola did not renounce individualized figures altogether since his subject-matter, the mining industry, suggests the idea of treating the mass of human beings as a single individual.[50] The fact that an opponent and a supporter of naturalism can substantially agree with one another in this way, despite radical differences of general evaluation, permits us to conclude that the naturalist turn towards concentrating upon the social life-world does tend to exclude the representation of problematic subjectivity.

Finally, we should draw attention to a certain difficulty in the structure of our argument. The critique directed at the inadequacies of the naturalist representation of subjectivity depends upon aestheticism, while the narrowly defined solipsistic concept of the subject which is characteristic of aestheticism is also open to serious criticism in turn. Our argument seems to court the charge of circular reasoning. But this is not in fact the case. A dialectical critique which refuses to

introduce any norms that cannot already be discovered within the world of actuality criticizes the given by revealing its own contradictions. The unresolved problematic of subjectivity is the contradiction at work within naturalism. It is a contradiction that will find a false resolution within aestheticism.

Aestheticism and the turn to the subject. The 'discovery of the self' in Maurice Barrès

We saw above how the subjectivity of the writer represented an unresolved problem for Zola. In his programmatic writings he sometimes grasps this subjectivity as a moment that conflicts with the desired objectivity of representation, whereas on other occasions he understands it as the organizing centre of the novel itself. This contradiction also returns within the individual works in so far as Zola either restricts the subjects represented to the dimensions of the social life-worlds in which they move or allows these reduced subjects to determine the action. If he does the latter, he threatens to relinquish his own insights into the real power of the social situation (cf. the psychologization of economic life in *L'Argent*) or to transfigure reality (one might think here of the rise of Denise in *Au Bonheur des dames*). Above all, however, the displacement of representation towards the different social life-worlds which the writer observes from without largely excludes the possibility of incorporating his own subjectivity into the work except by way of thematizing the subjectivity of the artist as such. To try and verify this conclusion, which we have supported by reference to the early reception of Zola's work, I would like to take a brief look at the novel *L'Œuvre*. Thematizing the figure of the artist as it does, this work represents the closest approach to the immediate experiential world of Zola himself and one in which we can therefore expect to find the presentation of an individual subject that is not simply limited to the performance of his or her social role (or the failure to perform it). But in fact this is not the case: the artists who figure in the novel only appear in their roles as artists. Just like the saleswomen in *Au Bonheur des dames*, they are almost exclusively absorbed in this their social role. The theme of the novel, the failure of an exceptionally gifted painter who attempts to produce the masterpiece of his dreams, might well have facilitated the presentation of a problematic subjectivity in a way which would precisely have revealed the social nature of the latter. However, these possibilities

inherent in the chosen theme only find expression in the novel against the wishes of the author, as it were. Instead of having his hero fail because the very contradictions of modern reality can no longer be represented symbolically in a single vivid image (a theme which is certainly sounded in the novel), Zola appeals to a 'scientific' explanation and assumes an unfortunate innate disposition on the part of the artist as the principal cause of his failure. As a consequence, the artist's struggle to accomplish his great work turns into a purely apparent one whose final outcome has long since been decided in advance on the level of biological determination. Strictly speaking the individual has no subjectivity because, inescapably determined by innate dispositions, he is unable to give shape and form to his life through an active engagement with the world at large.

It is all too easily understandable if the younger writers who tended, unlike Zola, to repudiate bourgeois democracy were the ones to attack precisely this unresolved problematic of subjectivity within naturalism. Paul Bourget had already published his influential studies on nineteenth-century literature, centred as they were upon the problem of subjectivity, under the title *Essais de psychologie contemporaine* in 1883. Formulated in the language of contemporary sociology, one could say that Bourget regards literature primarily as a specific form of socialization. He analyses Stendhal, Flaubert, Baudelaire, Renan and Taine from the principal perspective of the type of experience respectively expressed in their works. The young Barrès then adopts this conception as an explicit programme. The title of his trilogy of novels published between 1889 and 1891 as *Le Culte du moi* [The Cult of the Self] programmatically announces the turn towards the experience of the individual. In the foreword to the first volume of his novel Barrès proposes, in direct opposition to the objectivistic concept of reality espoused by the naturalists, a definition of reality as something which depends upon the habitual attitudes and perceptions of the individual subject. 'This is a short realistic monograph. Reality changes along with the observer ('avec chacun de nous') for it is the totality of our habitual ways of seeing, feeling and thinking.'[51] The idea of 'realism' here does not refer to the exactness with which the observable reality of a specific milieu is reproduced but rather to the authenticity of a personal experience. In opposition to the scientific pretensions of Zola, Barrès writes: 'This is no logical investigation ('enquête logique') concerning the transformations of sensibility; rather I am directly reproducing visions and emotions profoundly felt.'[52] In accordance with his

subjectivist approach, Barrès denies any significance to the represen-
tation of the social life-world. The representation of all external
action naturally becomes a quite subsidiary matter if the principal
aim of the novel consists in a sort of inner biography (cf. 'ce roman
de la vie intérieure' and 'cette monographie . . . est aussi une partie
d'un livre de mémoires').[53] This has direct consequences for the epic
material itself. We have seen how Zola, in spite of his emphatic turn
towards the realm of everyday reality, did not renounce construction
as far as the action was concerned. But we would have to describe
the novels of *Le Culte du moi* as quite fragmentary by comparison.
In so far as Barrès does not simply wish to report a given experience
but also intends to project a method for individual living, he exploits
the possibility of alternating the presentation of felt subjective
experience with the process of reflection. It is characteristic of the
form of the book that Barrès not infrequently contrasts the reflective
parts of the work in an abrupt fashion with the presentation of
subjective experience. Thus in the first volume of the trilogy, which
recounts the crises in the life of a young man, he separates the
external events of this life and his hero's reflections upon them from
the main text of the novel and prints these sections in italics ('les
concordances'). It would not be difficult to find other evidence for
the idea that Barrès clearly intended to avoid producing the closed
form characteristic of an organic work of art, that he was seeking
rather to reproduce experiences and reflections as so many isolated
and individual elements in a deliberately fragmentary fashion.

It is precisely this repudiation of the closed form of the organic
work of art which must have contributed to the extraordinary and
often documented effect which *Le Culte du moi* exercised upon the
younger generation of writers in the 1890s.[54] For the work more or
less encourages its readers to appropriate fragments of the communi-
cated experience for themselves.[55] Above all the general existential
effect of the book may be explained by the fact that here we find an
individual subject relating his experiences. Whereas Zola only allows
the reader of a novel like *L'Œuvre* which thematizes problematic
subjectivity the pessimistic recognition that 'this is how it is', Barrès
sets before the reader a mode of behaviour which promises a
solution to the problems of his or her own subjectivity. Barrès turns
the novel explicitly into a guide for the individual conduct of life.
The inclusion of the writer's own subjective experience in the work
itself, which brings the novel close to the genre of memoirs,
facilitates a kind of effect upon the reader which the objectivist novel
of naturalism cannot hope to exercise. In so far as the novel does not

attempt to represent a given domain of society but rather to reproduce the experiences of a subject, it can be accommodated relatively easily within the psychological economy of the reader's own experience. This explains why the subjectivist novel could successfully exercise an influence upon the modes of behaviour and thought of contemporary (bourgeois) youth which was denied to naturalist literature, despite the very considerable sales of Zola's novels.

In what follows I would like to analyse the type of experience related in Barrès's *Le Jardin de Bérénice*, namely the experience of 'dilettantisme'. In his *Essais de psychologie contemporaine* Bourget had described this as the capacity to transport oneself with pleasure into the most varied attitudes of thought and life without definitely adopting any of them as one's own. Now Barrès problematizes this type of experience by emphasizing its fractured quality and basic lack of unity:

As far as I myself am concerned, from my very earliest childhood reflections on I have always feared those barbarians who accused me of being different. I venerated the eternal within myself and this led me to develop a method of enjoying the thousand different facets of my ideal. . . . And this meant endowing myself with a thousand different souls in turn; in order that another might arise, one must perish; I suffer under this dispersal. In this sequence of imperfections I yearn to recover from myself within some all-encompassing unity. Am I then unable to unite all these dissonant tones in a single mighty harmony?[56]

The first-person narrator of Barrès's book is aware that he is different from the industrious citizens around him, the 'barbarians' whom he simultaneously despises and fears. This sense of otherness expresses itself in an extremely variable and mercurial sensibility. He opposes the purposive orientation of instrumental rational action with his infinite susceptibility to different impressions and experiences. However, this universal sensibility lacks any internal principle of unity. The self here is merely an infinite series of psychological states which are not connected with one another in any way. Thus the problem of discovering a unitary self becomes the central issue of the work.

Barrès and his hero Philippe seek to find this missing inner continuity by turning towards the outside world. Standing alone on an ancient tower in Aigues-Mortes, Philippe gazes out over the roofs of the medieval town and the marshy landscape of the Camargue. In the distance far out to sea he sees the wind-filled sails which symbolize escape and a yearning for the unknown. For a moment

this absorption in the contemplation of the landscape satisfies him but he never loses his awareness of its momentary character. 'For I am but *a minute* of this country and for *this single moment* it rests in me.' The thought of all the others who have sought the same unity of soul before this very landscape ('pour s'en faire une belle âme unique') brings the satisfying moment to an end.

Philippe also seeks this missing unity of soul in the person of Bérénice, a young dancer who is grieving for the death of her lover: 'No one had a more favourable opportunity to acquire a great unity of inner life ('une grande unité de vie intérieure') than this young woman, completely absorbed as she was in her devotion to her dead lover; I wished I could share in her experience.'[57]

The first-person narrator here is well aware that the real Bérénice has quite banal thoughts and problems which do not fit so comfortably within the image of the woman mourning for her lost lover, but he ignores this insight and transforms the real girl into a living symbol of commemoration and simple humanity. Here we are less concerned with analysing in detail the symbolic qualities which the narrator ascribes to the figure of Bérénice than with grasping the general procedure involved. The characteristic feature of the latter is the total control which the self exercises over the world, irrespective of whether it is the living world or the natural world. Like the landscape of the Camargue, so Bérénice too is considered solely from the perspective of her usefulness to the self.[58] The 'dilettante' who turns away from the instrumental commercial interests of the citizens whom he despises as 'barbarians' is not actually free from the same characteristic pattern of thought and behaviour. On the contrary, he carries the exercise of purposive rationality over into the realm of human interpersonal relationships. In so far as Philippe 'uses' Bérénice to resolve his own psychological problems, he refuses to enter into an authentic relationship with her. The action of the story makes this transparently clear. Philippe persuades Bérénice into marrying a man whom she does not love, a man who embodies an optimistic undialectical belief in progress that is hostile to all tradition. And Bérénice is destroyed by this marriage. Philippe admits that he misinterpreted the situation but consoles himself with the thought that he has none the less preserved what is best in her for himself.[59] A short while later he smiles at his earlier enthusiasm for a young woman who was 'after all only an affecting little creature' ('qui ne fut en somme qu'un petit animal de femme assez touchante').[60] And when Philippe proclaims the liberation of the wretched ('les misérables') at the end of the book, what is stressed here is also

his ability to draw some advantage from their presence ('pour qu'auprès d'eux je profite').[61] The 'dilettante' is incapable of breaking out of this preoccupation with the self. However, his inability to enter into authentic interpersonal relationships does not appear to him as a problem. It appears rather as a characteristic feature of a methodically pursued life-style. Alienation is here almost elevated into a principle according to which one should attempt to live. The 'dilettante' who can no longer connect the manifold variety of his subjective experiences into the unity of a single overall experience[62] responds to this self-alienation by attempting to subjugate the world to himself as a way of acquiring a unified self. The violation of nature with which the narrator reproaches the positivist technocrat who wishes to see ancient buildings replaced by factories is reproduced in his own treatment of Bérénice. In an exaggerated form, we could say that he transforms Bérénice into precisely what he wishes to discover in her: the symbol of a unified self. But in order to become such a symbol of something else the real Bérénice must perish.

This proximity to violence belongs to some of the more disquieting and hitherto inadequately explored aspects of aestheticism.[63] The underlying principle of aestheticism, which permits any arbitrary transposition of reality and the possibility of transforming everything into anything by use of analogy, is less innocuous than it might appear. It always contains a certain moment of violence inflicted upon reality.[64] The crisis of the bourgeois individual at the close of the nineteenth century seems to produce structures of behaviour which, without being directly conditioned in an economic sense, nevertheless display a striking analogy to the phenomenon of imperialism.

If we now attempt to summarize the historical content of Barrès's early work, we could say that the 'dilettante' is only able to overcome the disintegration of his experience in so far as he succeeds in actually producing the content of that experience for himself. As Barrès literally says in his own interpretation of *Le Jardin de Bérénice*: 'It is we who create the universe; this is the truth which leaves its mark on every page of this little work.'[65] If naturalism had grasped reality as objectivity and passed over the problem of the subjectivity of experience, the anti-naturalist novel in the hands of a writer like Barrès can obviously only address the problem on condition that reality is construed in turn as the production of the subject itself. For naturalism reality ossifies into an object in which we cannot hope to intervene, while for aestheticism it becomes a posit of the subject. We can also formulate this obvious dilemma in

another way: the naturalist writer captures reality in all its manifold appearances but that reality remains external to the subject (hence the corresponding priority ascribed to description); the aestheticist writer on the other hand captures the active subject but this activity remains a purely ideal posited meaning which leaves the external world unchanged. Thus the dialectic between subject and object is broken.

I do not wish here to reduce the duality and opposition involved in naturalism and aestheticism to the subject–object problem of philosophy. What is at issue is rather the insight that these two movements correspond to one another, even if only by way of reciprocal negation. In this dissociation of the subjective and object-ive dimensions we can recognize *one* real historical experience: namely that in which social reality is experienced as a realm which eludes the formative intervention of the subject. The passive con-templation of reality represented by the naturalistic description of the separated individual domains of society on the one hand and the active aesthetic subject which is forced to deny the objectivity of the external world in order to control it on the other are both expres-sions of the alienation experienced by the subject in this phase of the development of bourgeois society.

Problems of the sociology of literature

Before we turn to the problem of finding a historical–sociological explanation for the so-called 'overcoming of naturalism', i.e. the turn to aesthetic subjectivism on the part of so many writers, some general remarks are required. Literary research operating along historical–sociological lines has failed in the past to pay sufficient attention to the problem of different explanatory levels of interpre-tation. It has frequently contented itself with offering a single explanation, without discussing alternate explanatory possibilities, or with presenting a variety of quite unconnected approaches. In the first place it is necessary to distinguish between explanatory approaches which refer to the structure of society as a whole and those which refer to the socio-political constellation of forces in a particular epoch. Among the first group, for example, belongs Max Weber's theory of rationalization, which has subsequently been developed by Jürgen Habermas and others, according to which the development of bourgeois capitalist society can be described in terms of a progressive tendency towards rationalization in every

sphere of life.[66] To the same type of theory belong the explanations which appeal to the increasing articulation of the division of labour and the alienation resulting from it, as well as those which investigate the development of the literary market. The problematic character of such approaches consists in their extraordinarily broad explanatory range. Because they are principally concerned with the explanation of literature within bourgeois society as a whole they cannot offer us much help in understanding specific historical phenomena, like the naturalist novel for example. This is no reason to renounce these explanatory approaches, especially since their object cannot simply be dissolved into the sum of individual short-term socio-political determinants. Two things would seem to be required in this connection: on the one hand we have to reflect upon the relationship between the explanatory approach and the phenomenon to be explained, which means renouncing any attempt to grasp individual phenomena by means of a general global approach. On the other hand we must try and discover certain 'thresholds', as it were, where an initially cumulative process acquires a new qualitative character.

To the second type of explanatory theory oriented towards the socio-political constellation of a certain epoch belong all those approaches which attempt to provide an exact historical–sociological correlation between literary works or groups of works and particular classes and social strata within a given society.[67] The danger which attends this kind of approach is that of historical reductionism. The recognition that an individual work or group of works functions as the expression of the socio-political interests of a class or stratum remains entangled in historicism as long as it is not supplemented by reflection upon the possibilities for subsequent actualization latent in the original works. Likewise this is no reason for repudiating such explanatory approaches altogether. But here too we must reflect more carefully than has previously been the case upon what such an approach fails to explain: the fact that within the superstructure of a particular social formation there are a limited number of problems and attempted solutions which can subsequently be actualized in a relevant fashion under very different historical conditions.[68]

I would now like to try and concretize these preliminary observations with specific reference to the opposition between naturalism and aestheticism. There are good reasons for correlating naturalism as represented by Zola with the group which Jean-Marie Mayeur describes in his analysis of the Republican victory of 1875 as 'the faction of the Third Estate which accepted democracy, not in the

sense of social equality but in the sense of general equality of opportunity'.[69] More precisely, one could situate the militant republicanism of Zola which stands so directly in the Enlightenment tradition within the context of the 'new bourgeois strata' ('les couches nouvelles') of the 1870s identified by Gambetta. Alongside the smaller industrialists, businessmen and the representatives of the liberal professions, this group principally included the new upwardly mobile strata who occupied an intermediate position between the bourgeoisie on the one hand and the peasants and wage-dependent labourers on the other. We have to accept the vagueness involved in such concepts as the 'faction of the Third Estate' or that of the 'new strata' if Mayeur is correct in claiming that in this phase of the Third Republic 'general preferences in world-view outweighed real social antagonisms' or, more concretely, that 'the power of the republican myth' was still so considerable that it was not unusual for workers to support their own boss if he was a Republican.[70]

Nor is it particularly difficult to determine the socio-political position of the young Barrès. As a boulangiste Deputy he belonged to the radical opposition movement hostile to parliamentary democracy which claimed to pursue 'national' and 'social' aims and can be interpreted as an expression of disillusionment on the part of the masses when the Republic was shaken by economic and political crises.[71] The fact that Barrès was a supporter of General Boulanger initially suggests the idea that the subjectivism he defended arose out of the crisis of the French Republic after the mid-1880s. This explanation certainly captures one aspect which was decisive for the rejection of naturalism: the turn away from a concept of literature that was fundamentally characterized by the idea of equality. Barrès clearly formulated what was to take the place of this concept of literature: 'scenes quite different from those of mediocrity, souls quite different from vulgar ones' ('des milieux autres que des milieux de médiocrité et des âmes différentes des âmes vulgaires').[72] The following example clearly reveals the political implications of the attempted transformation of epic material at work here: 'Certainly there are more struggles to describe and more interesting conflicts, for example, within the soul of a deposed empress who has known both the heights of fame and the depths of ruin than are to be found in the soul of a cleaning woman whose husband comes home drunk every night to beat her, or in the soul of a Sioux Indian tied to the stake.'[73] In contrast with Zola's egalitarian view of the world in the Enlightenment tradition, Barrès here defends an elitist position based upon hierarchical principles. He only shows a 'psychological'

interest in exceptional human beings or those in exceptional situations (although this by no means excludes a tendency to mystification as shown in the idea of the soul of the people or 'l'âme populaire').

In spite of the general plausibility of the explanatory approach which traces the so-called 'overcoming of naturalism' back to the French political–economic crisis of the time (cf. in this connection the contribution by Hans Sanders), we should have misgivings about it in two respects. The chosen approach is both too wide and too narrow. Too wide, in so far as the crisis of the liberal Republic affected very broad groups of the population, while the turn to the subject outlined above was only adopted by a part of the younger bourgeois generation.[74] Too narrow, in so far as the success of aestheticism in the 1890s represented a quite general European phenomenon and thus cannot be explained solely in terms of national political developments in France.

In addition we should also bear in mind that the opposition to naturalism pre-dates the crisis of the Republic and represents an intrinsically heterogeneous phenomenon. Zola's first great success with the publication of *L'Assommoir* in 1876 proved to be a scandal. Brunetière had already published a damning assault upon the 'Roman expérimental' in 1880 in the prestigious *Revue des deux mondes*. The resistance displayed to naturalism by the conservative bourgeoisie who still took their bearings from the traditional aesthetic norms is as old as the naturalist programme itself. We must distinguish this critical response from the opposition which split away from the naturalist party after the publication of *La Terre* in 1887 and has gone down in literary history on account of 'The Manifesto of the Five'. This sorry pamphlet is probably best explained by a group-psychological analysis which would set itself the task of examining the internal tensions within the naturalist party.[75] It is precisely the absence of any substantial arguments against naturalism on the part of the authors of the manifesto that strongly suggests this kind of explanation.[76] On the other hand the aestheticist and subjectivist attacks upon naturalism, like those most effectively mounted by Charles Moréas and Maurice Barrès, are different again. However, there is one level on which the various opponents of naturalism, despite their profoundly different conceptions of literature, all pursued a single aim and that is the level of the literary market. If we examine Jules Huret's *Enquête sur l'évolution littéraire* from this perspective, then we get the very strong impression that many authors were principally concerned with improving

their own position in the market. Huret too, at the end of the introduction to the book edition of his enquiries, feels driven to conclude that 'the literary product must also submit to the harsh competitive law of life ('la loi féroce de la concurrence vitale') and that here, as in every profession, material interests tend to overwhelm and oppress the spiritual ones'.[77] That Huret attempts to explain the disputes of the literati in a social–Darwinian way from 'the base necessities of the struggle for existence' is of less significance in this connection than the fact that among the majority of the authors questioned we find a strong desire to get their point of view accepted, a desire which cannot be explained in a purely individual–psychological manner but demands to be interpreted in economic terms as part of the struggle to obtain a share of the market. The fact that they repeatedly charged one another with commercialism clearly shows that the writers themselves were quite aware of the economic dimension to their literary disputes. One writer who dissociated himself from Zola, although he was numbered among the realists by Huret, described the standard critique of naturalism as a purely 'commercial reaction which they are trying to exploit at the expense of naturalism'.[78]

This awareness of questions touching the literary market, sharpened as it was by the extraordinarily high sales of Zola's work, also left its mark on certain categories involved in the aestheticist conception of literature. The significance of a concept of novelty quite empty of all material content among aestheticist writers of the most varied kind can only really be explained as an internalization of the competitive principles of the literary market. The following quotation shows that this connection was a very real one: 'An unbridled and salutary need for originality ('un effréné et salutaire besoin d'originalité'), a contempt for all imitation, the strict duty imposed upon every individual to be himself if he is to count for anything.'[79] Originality appears here not as the result of an individual process of self-development but rather as a demand which is imposed externally, i.e. by the literary market, and one with which every author is forced to comply.

This dependency of literature upon the market certainly helps to explain the virulence of the disputes between writers at this time but it can hardly tell us anything about the actual direction of literary development. It is symptomatic that the market-conditioned criterion of novelty remains completely empty of content. This is also true of the theory of literary evolution defended by Barrès in the *Enquête* and formulated by Edmond de Goncourt in the 'Préface' to

his novel *Chérie*. On this theory every new literary movement represents a reaction against the preceding one. Thus, according to Barrès, the naturalists were reacting to the conventional social novel of Octave Feuillet who was only interested in representing the members of the upper classes. He himself, together with the other authors of the younger generation, were reacting in turn against the naturalists who had laid an exclusive emphasis upon the purely external dimensions of human behaviour.[80] The distinction between Zola's conception of literary development and that defended by Barrès is extremely instructive. Zola struggles against romanticism in the name of truth and science precisely because he is convinced that his conception of literature is the one which is really appropriate to a democratic–egalitarian society. Barrès on the other hand ties the process of literary evolution to the abstract principle of renewal. There seem to be two things behind this: firstly, a cunning market strategy (this theory allows Barrès to present his own novel as thoroughly contemporary and depict the naturalist novel as obsolete without having to condemn the latter as such); and secondly, a genuine (albeit distorted) insight into one principle of literary evolution under the conditions of the most intense commercialization of literature. For in fact the subjectivist novel of a writer like Barrès takes its point of departure from particular problems left unresolved by the naturalist novel. Barrès's insight is distorted in so far as he simply opposes representation of the external world to that of the inner world in an abstract manner and thus conceals the way in which he treats the problematic of subjectivity himself. And this is where the political dimension of aestheticism is to be found, as our analysis has shown.

If these two explanatory approaches (the crisis in the Republic and the dependence of literary production upon the market) cannot completely explain the turn towards subjectivism, this may well be because they identify the encompassing economic and political conditions of the whole debate but do not specify the problem that is really at issue. We have to grasp the debate between naturalism and aestheticism as a historically specific expression of a problem posed by the structure of society. As we have seen, naturalism followed the tradition of the bourgeois Enlightenment which understood literature as the medium of moral–political debate for the citizen. This concept of literature can be called an instrumental one in so far as literature is employed here as a means to a social end. Aestheticism on the other hand radicalizes the autonomous concept of literature

which grasps the work of art as an end in itself. Both these concepts of literature find themselves in a contradictory relationship to bourgeois society. The instrumental concept of literature accepts the rationality of bourgeois society but pushes on towards its total realization. Paradoxically, it meets with resistance precisely because it wishes to realize the principles of bourgeois society. The reason for this lies in the fact that this concept of literature constantly runs the danger of either neglecting the subject or accommodating it to given ends. The autonomous concept of literature is directly opposed to bourgeois society. In so far as it satisfies the human needs excluded from the process of rationalization at least in an ideal fashion, it paradoxically complements a society which it simultaneously places in question. The danger which this concept of literature courts is that of blind irrationalism.

The recognition that these two concepts of literature represent opposed answers to the problem of the rationalization of all domains of life thrown up by bourgeois society does not exclude the attempt to provide a historical–sociological explanation for the particular epochal form which this opposition takes. Immanent development, which nevertheless owes its existence to the thematic problems of a specfic social formation, and determination through the epochal socio-political constellation of forces mutually involve one another. The rivalry between two different forms of literary institution within bourgeois society became that much more acute towards the end of the nineteenth century, among other reasons, when naturalism made the aggressive claim to formulate and effectively establish the only concept of literature appropriate to a democratic society. Within the context of literary life, which was characterized by extraordinarily intense competition among writers, those authors less sympathetic to naturalism felt themselves impelled to take up the problems latent in the material of the naturalist novel and to develop them in a way that permitted them to maintain the greatest possible distance from naturalism itself. The subjectivist turn is already prepared within the unresolved problem of the subject in naturalist literature. The precise way in which the aestheticists dealt with this problem is conditioned by their social position. The repudiation of the egalitarian principles of parliamentary democracy logically leads to the development of a narrow solipsistic and elitist concept of the subject.

However, our analysis has tried to show that truth is not merely to be found on the side of naturalism. As long as the interpreter simply

adopts either the naturalist or the aestheticist position, then he or she remains caught up in the contradictions of bourgeois culture without being able to perceive this culture as a whole. Both these movements are only two sides of a single problem which could rather drastically be characterized as the dissociation between a social experience without the subject and subjective experience without society. The dissociation between naturalism and aestheticism, between a literature for the masses and a literature for the educated elite, reveals the failure to realize an egalitarian bourgeois culture in which the experience of society and the experience of the subject might be related to one another.

8

Dissolution of the Subject and the Hardened Self: Modernity and the Avant-garde in Wyndham Lewis's Novel *Tarr*

Wyndham Lewis's story of an artist's life *Tarr* belongs among the early products of artistic modernism in the field of the novel (the first version which was published in 1918 had already been written by 1914).[1] There may well be complex reasons why the book, in spite of receiving favourable critical attention on a number of occasions, has still not been admitted to the canon of modernist literature by writers concerned with the subject.[2] Lewis's later leanings towards fascism have probably been less decisive in this connection (for as we know similar attitudes have not prevented the canonization of Pound's work) than the fact that with his essay collection *Time and Western Man* he appeared on the scene as an engaged, not to say enraged, critic of literary modernism. Finally, as regards the specific treatment of the literary material Lewis took nothing like the unambiguous turn towards modernism which became characteristic of Joyce's work.[3] It is true that Lewis's way of employing images recalls the kind of procedures later to be adopted in a systematic fashion by Virgina Woolf;[4] and the Joycean technique of paralleling narrative time and narrated time can already be seen at work in *Tarr*: the first part of the novel, accounting for approximately sixty pages of the text, recounts a single morning in the life of the eponymous hero, a young English painter living in Paris. Above all it is the unusual compositional structure of the novel, whereby the hero is relegated to the background through the three succeeding parts and pride of place is given to the eccentric German Bohemian

character Kreisler instead, that places the book firmly in the context of modernism which operates with such radical discontinuties (quite irrespective of the formal similarity with *Ulysses* which also initially traces the life-stories of two protagonists quite separately). Yet in spite of these elements of modern literary techique, we should recognize that the modernity of the book lies above all in its thematic content, namely in its analysis of an epochal subjectivity.

The following considerations do not claim to represent a comprehensive interpretation of the novel.[5] Here I am only concerned with the novel from one particular perspective: its thematization of the opposition between modern and avant-garde artistic practice and thus at the same time of the opposition between two different articulations of subjectivity. Tarr is the modern artist who directs his whole existence to the creation of a work that shall transcend time. In order to achieve this, Tarr believes it is necessary to separate himself from life. He interprets the autonomy of art in an existential fashion. He is not concerned with the independence of artistic works with respect to the theoretical claims of knowledge or with respect to the practical claims of morality but with the artist's own form of life. Since life draws sustenance from the same instinctual sources as does the production of art, the artist must renounce life for the sake of the work.

With most people, who are not artists, all the finer part of their vitality goes into sex if it goes anywhere: during their courtship they become third-rate poets, all their instincts of drama come out freshly with their wives. The artist is he in whom this emotionality normally absorbed by sex is so strong that it claims a newer and more exclusive field of deployment. Its first creation is *the Artist* himself. This is a new sort of person; the creative man.[6]

In so far as the novel is concerned with Tarr, it narrates the production of the artist himself. Tarr has entered into a relationship with a German painter called Bertha; he senses that he is dependent on her although he finds her environment distasteful (the room with the plaster cast of Beethoven and the photograph of the Mona Lisa in it[7] or the circle of art-loving German women around Fräulein Liepmann[8] for example). 'Tarr could not look upon the Mona Lisa without a sinking feeling.'[9] Consequently he decides to try and free himself from Bertha. However, he does not do this simply by leaving her but rather by staging the process of emancipation itself. After a whole week's separation Tarr then resumes his visits to Bertha and begins once again to enjoy his former love:

In reality Tarr was revisiting the glimpses of the moon, or the old, distant battlefields of love, in a tourist spirit . . . he was living it all over again in memory, the central and all the accessory figures still in exactly the same place. . . . Bertha's women friends were delightful landmarks: Tarr could not understand how it was he had not taken any interest in them before. They had so much the German savour of that life lived with Bertha about them.[10]

Lewis allows his protagonist to enjoy the experience of Proust's first-person narrator at high speed at it were. If the Proustian narrator requires a whole lifetime in order finally to attain the insight that it is only recollection which is capable of investing a meaningless existence with meaning, then Tarr succeeds in deliberately provoking a comparable experience in the course of a few weeks. Once his relationship with Bertha is over, everything connected with her acquires a peculiar attractive character of its own. Moreover, it is tempting to see in this drastic concentration of the Proustian experience and in the insistence upon the deliberate nature of the process an anticipation of the critique of the 'time-cult' of modernity which Lewis was to formulate in his *Time and Western Man*. If we pursue this line of interpretation, then Lewis's account of the 'production' of the modern artist would simultaneously represent a polemical attack upon the conception associated with the name of Proust. However this may be, it is certainly true that Lewis understands the development of the artist as a process which is dictated by the will of the individual and one which cannot attain its ascetic goal without a certain ruthlessness towards others, whereby it acquires a nostalgic pleasure of its own at the same time. What is interesting about this account, among other things, is the fact that it still remains unclear to the reader right until the very end of the book whether Tarr is only feigning the intended indifference towards his friend Bertha or whether in fact he has really come to feel this indifference himself. It is only once he has married Bertha, because she is expecting a child by his rival Kreisler, and at the same time as he is beginning a new relationship with the German–Russian woman Anastasya, that the reader realizes Tarr actually has accomplished his original project. For as opposed to Bertha, who stands for 'life' within the novel, Anastasya has to be interpreted as an allegory of art. In her case beauty is combined with a 'masculine' intelligence.

At first sight it might seem astonishing that the depiction of the modern artist whose existence is directed towards the production of the work of art should principally be concerned with relating his life rather than his artistic labours. But in fact this follows logically from

Lewis's philosophy of art. If indeed art is ascetic in essence, as Tarr explains in one of his conversations on art,[11] then the process of emancipating oneself from life must be regarded as a decisive presupposition of artistic creativity. Or to put it another way, the production of the artist precedes that of the work. In his conversation with Anastasya this idea is extended to cover the work of art itself:

> . . . deadness is the first condition of art. The armoured hide of the hippopotamus, the shell of the tortoise, feathers and machinery, you may put in one camp; naked pulsing and moving of the soft inside of life – along with elasticity of movement and consciousness – that goes in the opposite camp. Deadness is the first condition for art; the second is absence of soul, in the human and sentimental sense. With the statue its lines and masses are its soul, no restless inflammable ego is imagined for its interior: it has *no inside*: good art must have no inside: that is capital.[12]

What is true of the artist also holds for the work of art. Just as the artist must separate himself from life in order to be able to produce the work, so the work itself is grasped as something dead. For only what is dead can survive time. The anti-romantic tendency in the tradition of artistic modernism, the programme of which was most significantly formulated by Valéry, emerges here once again. It is not the intensity of subjective experience which represents the essential condition for the successful production of the work but rather the combination of the sensible and the intellectual: ' . . . everything we *see* . . . must be reinterpreted to tally with all the senses and beyond that with our minds: so that was my meaning, the eye alone sees nothing at all but conventional phantoms'.[13] The danger of such an intellectualist concept of art lies in a formalism which relies upon the capacity of the subject to organize sensuous elements rationally with reference to predetermined specific effects. Lewis is aware of this danger and for this reason gives Tarr the opportunity of adumbrating a dialectic between refinement and formlessness: 'For a maximum human fineness much should be left crude and unformed. . . . There is no more absolute value in stupidity and formlessness than there is in dung, but they are necessary.'[14] In opposition to theorists like Valéry or Adorno, who insist upon complete articulation in the form of the artistic product, Tarr's reflections open up a perspective which points beyond the strict concept of form characteristic of modernism. Thought through logically to its conclusion however, the pursuit of formlessness also leads to a dead-end. Renunciation of the act of formation simply

turns the abstract picture into an interior wall from which the plaster has begun to crumble away.

But this is not Tarr's problem. He obviously only introduces this formlessness as a contrast effect and remains quite confident in reliance upon his own ability to confer form on the work of art. After his separation from Bertha we see Tarr at work sketching 'three naked youths sniffing the air, with rather worried hellenic faces and heavy nether limbs'.[15]

> By the end of the afternoon he had got a witty pastiche on the way suggestive of the work of the hellenizing world – it might have been the art of some malicious Syrian poking fun at the Greek culture. Two colours principally had been used, mixed in piles upon two palettes: the first was a smoky, bilious saffron, the second a pale transparent lead. The significance of the thing depended first upon the suggestions of the pulpy limbs, strained dancers' attitudes and empty faces; secondly, the two colours, and the simple yet contorted curves.[16]

One is tempted to link this passage with the so-called classicist phase in the work of Picasso. Lewis interprets the allusion to ancient Greece ('the hellenic faces') or the imitation of hellenism ('the pastiche of the work of the hellenizing world') as a parody of culture. The artist who defines himself in anti-bourgeois terms despises the culture of the bourgeois world which is repudiated as inappropriate to the age (Tarr's revulsion against the interior of Bertha's studio). Yet at the same time his own work remains bound to this culture, elements of which his work adopts and then disfigures. In so far as the polemical rejection of bourgeois culture merely adds another chapter to its history, so too the existential interpretation of aesthetic autonomy is tied to what it turns against. Neither the self-stylization of the artist as one who ascetically denies life, nor the polemical cultural gesture of the work of art allows us to break out of the 'nature park' of bourgeois culture.

A more radical attempt to break out from this situation is inscribed within the logic of development of culture in bourgeois society. This is represented in the novel by the German painter Kreisler who stands out by the eccentric manner in which he comes on the scene. Lewis places the figure of Kreisler within a network of mutually contradictory interpretations. Bertha perceives him through the prism of her own free-floating altruism: for her he appears as a poor fellow who does not really know what he is doing. Anastasya interprets his eccentric behaviour with reference to herself and explains it in terms of his unsuccessful attempt to win her

favour. For Tarr on the other hand, Kreisler is a failed artist who is trying to return to life: 'I believe that all the fuss he made was an attempt to get out of Art back into Life again. He was like a fish floundering about who had got into the wrong tank. *Back into sex* I think would describe where he wanted to get to.'[17] It is all too obvious that the various interpretations of Kreisler's character correspond to the perceptual and intellectual proclivities of each of the interpreters involved. Lewis does not firmly commit the reader to any one of these interpretations. On the contrary, in so far as he correlates them so closely with the characters who are doing the interpreting, he allows them to cancel one another out and challenges the reader to work out his or her own interpretation of the situation.

It is true that Kreisler is introduced as a painter but in contrast to Tarr art does not represent the focal point of his existence. Characteristically he does not participate in Tarr's conversations on the theory of art. On the only occasion when he is encouraged by his colleagues in the café to express an opinion about art, he indulges in a polemical outburst against modern painting which any philistine would be happy to endorse:

What do I call beautiful? How would you like your face to be as flat as a pancake, your nostrils like a squashed strawberry, one of your eyes cocked up by the side of your ear? Would not you be very unhappy to look like that? Then how can you expect anyone but a technique-maniac to care a straw for a picture of that sort; call it Cubist or Fauve or whatever you like? It's all spoof. It puts money in somebody's pocket, no doubt.[18]

When his colleagues push him finally to provide his own definition of the beautiful, Kreisler chooses to compliment the cocotte sitting next to him before going on to kiss her: 'I call this young lady here . . . *beautiful*.'[19] The debate on the theory of art is transformed into a dramatic scene.

The dominant behavioural pattern characteristic of Kreisler seems prefigured here: that of theatrical self-stylization. However, this is not the only pattern of behaviour which he follows for Kreisler is conceived as an intrinsically self-contradictory figure. The transition from art back to life is captured in an almost allegorical fashion in the scene in which Kreisler rapes Bertha who has just been posing for him as a model. His observation 'Your arms are like bananas!'[20] does not lead him to attempt a deforming artistic transposition of the image but rather occasions an instinctual release on his part. Lewis

himself dramatizes the scene by casting it half-ironically in the light of the ancient classical concept of destiny (comparable in this respect to the way in which Tarr treats classical antiquity): 'Destiny has more power over the superstitious: they attract constantly bright fortunes and disasters within their circle. Destiny had laid its trap in the unconscious Kreisler.'[21] That is how the chapter begins. This dramatization corresponds to the general disposition of the character. Kreisler is not represented as a bundle of spontaneous id-impluses (which is how he is schematically presented by Jameson in his interpretation of the novel): he is also the German student who belongs to the duelling fraternity, who will appear before Bertha half an hour after the assault offering to shoot himself in order to obtain her forgiveness and finally thanking her on his knees before the puzzled Bertha requests him to leave.[22]

The narrator describes Kreisler's behaviour in this scene as 'dramatic hypocrisy'.[23] But moral judgement is hardly appropriate here for completely understanding the contradictoriness of the figure. In this connection the narrative itself is more instructive than the narrator's commentary.

She [i.e. Bertha] saw side by side and unconnected, the silent figure engaged in drawing her bust and the other one full of blindness and violence. Then there were two other figures, one getting up from the chair, yawning, and the present lazy one at the window – four in all, that she could not for some reason bring together, each in a complete compartment of time of its own.[24]

But it is not only Bertha who is no longer able to perceive any unity among the various ways in which Kreisler appears from one moment to the next. Even there where the narrator is recounting Kreisler's actions from an inner perspetive, the picture is still dominated by discontinuities. Thus, for example, Kreisler takes great pains to try and borrow forty francs with which he hopes to redeem his evening dress from the pawnbrokers but finally drops each of these attempts in turn.[25] Then he suddenly decides to enter the circle of Fräulein Liepmann dressed in his everyday clothes. The imperative which dictates that he observe the correct social form is abruptly checked by the different behavioural pattern of self-dramatization. The consciousness of his own failure (he only dares to dream about Anastasya but never to address her) allows his sense of world-weariness to turn into a desire for self-abasement.

In his schooldays Kreisler had been the witness of a drama affording a parallel to what he was now preparing. His memory hovered about the image of a blood stained

hand, furiously martyred. But he could not recall to what the hand belonged. The scene he could not reconstruct had taken place in his fourteenth year, and it had proceeded beneath the desk of a neighbour during an algebra lesson. The boy next to him had jabbed his neighbour in the hand with a penknife: the latter, pale with range, had held his hand out in sinister invitation, hissing 'Do it again! Do it again!' – The boy next to Kreisler had looked at the hand for a moment and complied. 'Do it again!' came still fiercer. This boy had seemed to wish to see his hand a mass of wounds and to delect himself with the awful feeling of his own black passion.[26]

Kreisler's acts of aggression are always directed against himself too. He wants to incite the world against himself and obeys the same logic as that described by Sartre in Flaubert, the logic of 'qui perd gagne'. Kreisler is driven by the insane hope of achieving something extraordinary in and through his self-abasement: not indeed as a work that will endure (he has long since abandoned that idea) but as a momentary act. Even before the dadaists and the surrealists attempted to bring art back into life praxis, Lewis describes the failure of such an attempt. He exposes the destructive and self-destructive forces within the avant-garde project, forces which Breton, for example, was only able to control because he broke off the process of radical surrender to instinctual potential as soon as it threatened to become dangerous.

Thus we would ultimately seem to arrive at the problem of the relationship between aesthetics and morality, a problem which has continued to beset the subject of aesthetics ever since the autonomy of art was proclaimed, precisely because aesthetics has no categories with which to thematize this problem properly. If we are to address the question, we require a discriminating sense of judgement. Polemical positions deriving from the tradition of German idealist aesthetics are too simple here. The reproach that moralizing criticism has nothing to do with aesthetics does not even help us to grasp the process of 'immoralism' which was initiated during the nineteenth century by Flaubert, Baudelaire and others. In the first place it is necessary to recognize that anti-moralism, the attack upon the prevailing moral attitudes, is a moral position. With his prose text *Assomons les pauvres* Baudelaire intended to be provocative and thus produce a moral reaction on the part of the reader. Tarr quotes this text at the end of his conversation with a liberal compatriot whom he despises so much that he refrains from physically assaulting him as a possible way of giving the man some backbone.[27] Both the heroic stylization of aggression and the critique of aggression

represent a moral position. Anyone who refuses to recognize this fact, and attempts to salvage aggression by transposing it into the aesthetic realm in order to protect it from moral criticism, is trying to avoid the consequences of their own thought. Lewis makes no secret of his sympathy with aggression for it strikes him as simply truer than Bertha's free-floating altruism and readiness to help others. Behind all this lies the old Nietzschean claim that the instinct is truer than the culture which overlays it. Once again this is a moral position, just like the Victorian puritanism to which it is opposed. Consequently the opposition at work here is not one between amoral aesthetes on the one hand and moralists on the other, but one between the moralists of instinct and those of culture. The fact that today the moralists of instinct have got post-structuralist wind in their sails does not absolve us from addressing the question whether this opposition itself is not too simplistic and whether it has not already been overtaken historically by Freud.

Freud's so-called economic model of the mind distinguishes the three moments of the id, the ego and the super-ego. It recognizes the instincts (the id) as well as the reality claims of society (the super-ego) and understands the ego as the psychological site where these two mutually conflicting imperatives must find some kind of balance. Let us take one more look at the principal figures of the novel from this perspective. In the case of Tarr art assumes the place of the super-ego which requries the total renunciation of the instincts. This renunciation is accomplished and the ego adopts the demands of the super-ego and organizes his life accordingly. The result is a life split up into different social roles: the artist, the husband, the lover. This type of artist adopts the way of life of the professional person and thus reproduces his alienation. It is highly questionable whether or not we can ascribe any unified life-plan to the figure of Kreisler. In his case it is the student duellist's sense of honour, remote from reality as it is, which has taken the place of the super-ego. But this does not compel any instinctual renunciation on his part but rather short-circuits the instinctual energies and thus initiates a destructive process to which Kreisler himself also falls victim in the end. (The real empirical content of this character construction has actually revealed itself under National Socialism. It may well have been precisely Lewis's proto-fascistic sympathies, felt from within as it were, which afforded him insights that as far as I can see were not available to those on the left at that time.) If we now connect this psychoanalytical interpretative sketch with our

previous reading of the novel as an exposition of the opposition between modern and avant-garde artistic practice, we come to a rather disturbing conclusion: in Lewis's novel the modern and the avant-garde positions correspond to two equally aporetic forms of life in the crisis period of bourgeois society, the defensive armoured self of the professional person on the one hand and the diffused identity of the proto-fascist character on the other.

9

On the Actuality of Art:
The Aesthetic in Peter Weiss's
Aesthetic of Resistance

It is by no means unusual to discover descriptions and appropriations
of works of art in the field of the novel, and especially within the
genre of the *Bildungsroman* or educative novel which explores the
development of character. From the chapters on Shakespeare in
Goethe's *Wilhelm Meister* through to the famous descriptions of
Elstir's seascapes and Venteuil's sonata in Proust's *À la recherche du
temps perdu* we can trace the use of the work of art as a thematic
element in the novel. The bourgeois subject, whose formative
development the novel articulates, also acquires its own identity
specifically in and through an engagement with works of art. From
this perspective, the key position which is occupied by the descrip-
tions of pictures in Weiss's *Aesthetic of Resistance* is not at all
extraordinary. However this kind of literary–historical assessment of
the sections in his novel dedicated to the experience of works of art
would fail to grasp their real significance. The very range of the
sections in question, their emphatic position in the work as a whole
(both the first and second volumes of the novel begin with a
description of a work of art), and finally the peculiar intensity of
these parts of the book all suggest the inadequacy of such an
approach. I have tried to ask myself what it is that produces this

This chapter was written for the seminar on the work of Peter Weiss organized by
Henrik Landing and Arne Melberg and took place in Stockholm in January 1982 in
collaboration with Weiss himself. A Swedish translation of this piece appeared in the
journal *ord & bild* (1982), H.2, pp. 77–83.

impression of such concentrated intensity. It is certainly not due, at least not principally, to the works of art themselves, nor can it be explained simply by the way in which the language is treated (such an important factor in the descriptions of the works of art in Proust's novel). If this is correct, then we shall have to look for the reasons for the intensity of Weiss's descriptions of works of art between the levels of the object described and the language of description, that is, on the level of the narrative technique itself.

One might object to this attempt to approach the aesthetic peculiarity of Weiss's novel through a formal analysis of its artistic technique by claiming that such a procedure merely reproduces the position of those who maintain that art is exclusively a matter of form. In this connection I would merely like to make the following remarks: a literary discipline which aims to be historical and dialectical will not be able to do justice to its object if it simply tries to endorse a content-oriented aesthetic, especially given that we cannot possibly ignore the primacy of form in art since the middle of the nineteenth century. We should not attempt to negate this development in a purely abstract way. Rather we must take it up and elaborate it in a critical manner. A critique of formalism will specifically have to expose its real truth content. And we find ourselves in a similar situation with respect to the currently prevailing aesthetic conceptions as well. Since we can only communicate with one another about art *in* these conceptions, we can only begin to change them through the patient exercise of critique and not merely by proclaiming the death of idealist aesthetics. And I would suggest that a significant change in this domain has already been inaugurated precisely by Peter Weiss's *Aesthetic of Resistance*.

After returning to his Paris lodgings from the Spanish Civil War, in which he had fought alongside the international anti-fascist brigades, the first-person narrator of the novel stumbles upon the report of two survivors from the French frigate the *Medusa* which was shipwrecked off the African coast in 1812, as depicted by Géricault in his monumental painting *The Raft of the Medusa*. Here it is not the work of art which forms the point of departure for the narrative, as it did with the elaborate description of the Pergamon frieze at the beginning of the first volume of the novel, but rather the very report of the survivors describing the disastrous expedition. However, it would be a mistake to overstress this distinction. The first-hand account by the survivors of the shipwreck gives Weiss the opportunity to emphasize the real content of the incident depicted in the painting. But his procedure in the other descriptions of works of

art was hardly any different either. In each case Weiss is primarily concerned with restoring the momentary aspect of the depicted event (for the illusionist image can only ever reproduce a *single* moment within a sequence of events) to the process from which it has been torn free. This produces not merely a temporalization of the depicted event, whereby for example the moment represented by Géricault in which the shipwrecked sailors catch sight of the rescuing vessel is inserted into the broader story of the shipwreck itself; it also involves the insertion of the expedition into the context of western European colonialism as a whole. Thus in the final analysis the event depicted is opened out upon a world-historical process without, and this is crucial, losing sight of the individual experience of suffering that is involved in the particular event.

The principle of temporalization returns on two other levels as well, namely those of production and reception. By including Géricault's preliminary sketches and versions in his analysis Weiss breaks open the self-enclosed work-character of *The Raft of the Medusa* in favour of a reconstruction of the process of artistic production in which the subjective experience of suffering forcibly finds expression: ' . . . he possessed nothing but his artistic lan-guage, and this helped him not just to represent the sickness of an epoch, but even more to find a symbol for the agonies to which his own suffering nerves were exposed'.[1]

Finally, the mode of reception also contrasts with the usual ways of describing our response to art, for in Weiss's account the elements involved only occupy a subordinate position within a greater totality. Whereas in a traditional description of a picture the successive process in which the different planes of the picture are registered (as foreground, middleground and background) is only intended to facilitate an ultimately unified visual grasp of the picture, Weiss in contrast insists upon the processual character of the appropriation of the work. He either unfolds this processual character pluralistically as it were in terms of a discussion of the work among a group of friends, as in the analysis of the Pergamon frieze, or he recounts the gradual approach to the work as a laborious process on the part of the first-person narrator, as in the analysis of Géricault's painting. In this case the depicted scene or the artist's own engagement with the object appears on the one hand as something alien to the viewer, something towards which he or she must first grope their way: 'In this my first encounter I attempted to discern the traces of illumina-tion in the strongly darkened colours mixed with asphalt, dull and patchy as they were. . . . Gradually I began to distinguish a few

yellowish, bluish or greenish tones on the apparently monochrome pictorial surface.'[2]

On the other hand the first-person narrator also institutes a relationship between the sufferings of the painter expressed in the picture and the preparatory sketches and the troubled experience of the narrator's own generation: 'The inner laceration here awakened something of the fragmentation to which my generation had also been exposed.'[3] Otherwise, however, Weiss's interpretation of the picture as an enormous metaphor of suffering remains implicit. The appropriation of the work of art as it is described here is a process in tension between the poles of foreignness and involvement and calls for labour and effort rather than delighted contemplation of the object. This process of exertion does not lead us, however, to the tangible work itself but to the experience of insight into what art is capable of achieving: 'It had never been so clear to me before how in art values can be created which overcome the experience of exclusion and loss, how the attempt can be made to alleviate melancholy through the power of shaping vision.'[4]

Initially we have looked at the temporalization of the work of art on the levels of representation, production and reception as an artistic technique which contributes to that peculiar intensity that characterizes Peter Weiss's analyses of works of art. But in this connection it has also begun to emerge that his artistic technique bears a significance which is not explicitly formulated in the novel itself. For this new way of approaching the work of art also suggests a new concept of what a 'work' is, although this is not developed discursively within the text. Formulated as a general thesis we could say that *Aesthetic of Resistance* contains an aesthetic conceived in opposition to the tradition of idealist aesthetics. One aspect of Weiss's aesthetic concerns the work of art itself. At first sight Weiss's attitude to the concept of the 'work' seems a contradictory one. On the one hand he clearly displays a marked preference for those artistic products which avoid the self-enclosed character of the traditional work, for the fragmentary and the montage-like – he explicitly mentions Breton's *Nadja* as his favourite book. On the other hand he continues to hold to a much more traditional-looking concept of the closed work of art. 'Individual details still held him captive and diverted him from the conception of the totality', we read of Géricault.[5] But in the first place we have to admit that what strikes us here as a contradiction is not the expression of a theoretical inadequacy but rather touches upon a central problem of contemporary aesthetics. For we cannot unconditionally declare the

characteristic avant-garde hostility to the finished work as the most progressive aesthetic position: that would imply dismissing all those artistic products which aspire to the self-enclosed character of works as quite worthless, even before a particular analysis of them were to be undertaken. But it is equally impossible for us to appeal to the traditional concept of the work which sets up the work of art as a product of genius over against all other human products and surrounds it with the sacred nimbus of the absolute.[6] Now the way in which the work of art is approached in *Aesthetic of Resistance* offers us a possible escape from this dilemma. With the introduction of the temporal dimension into the work of art the latter loses the character of an internally complete finished entity, and it does so quite independently of whether the work corresponds to the model of the organic whole or that of the fragment. By making the work of art an element in a multi-layered historical process, a process in which the producer, the recipients and also those represented all participate in different ways, Weiss undoes the idealist metaphysics of art for which the work of art ultimately retained a position of transcendent value.

Before drawing any further conclusions from Weiss's treatment of works of art, we must return again to his analysis of *The Raft of the Medusa'*. For we have not yet mentioned what is possibly the most striking aspect of his narrative technique.

In the uprootedness from every context the painter recognised his own situation once more. He strove to imagine what it was like, the teeth sinking into the neck, into the leg of a corpse. . . . Working his way along the network of planks, amidst the darkened cloud-like water, Géricault felt the hand penetrating the open breast, grasping the heart of one he had held in a parting embrace only a day before.[7]

Generally speaking the perspective of the first-person narrator is defined by the fact that while he can indeed survey the workings of his own mind down to the subtlest nuances, he can only infer the inner life of other characters, unless there is some form of written evidence or letters on which to rely. The credibility of such first-person narration depends precisely upon this narrowing of perspective which interprets the events described from a single point or view. *Aesthetic of Resistance* is a first-person narrative novel, but Weiss also endows his narrator with a capacity which in the normal course of things only belongs to the omniscient authorial narrator. Weiss's first-person narrator is able to project himself into the inner life of the other figures in the text. By connecting these two different

narrative positions the author combines the claim to authenticity characteristic of first-person narrative with the claim to objectivity characteristic of authorial narrative. But in the passage we have just quoted Weiss actually goes beyond the omniscient position of authorial narrative. He not only allows the reader to participate in Géricault's own efforts to imagine the situation in which the victims of the shipwreck found themselves, he also recounts the process in such a way as to suggest that Géricault had actually experienced the shipwreck himself. In just the same way we read later on of 'Géricault and his companions, exhausted, plagued with injury, wandering bare-foot among the turmoil . . . '.[8] Of course this narrative technique helps to reveal the intensity of Géricault's engagement with the subject of his picture but that is far from being its only significance. Weiss abolishes the conventional line of demarcation which separates visions and the products of the imagination from our actual perception of reality. He does not do so in order to create a *surréalité*, a synthesis of imagination and reality like that attempted by the surrealists, but because he believes that individual and collective worlds of madness are just as real as the external world which we can see and touch. Under the impact of their experience of the First World War the surrealists had discovered that there was actually something insane about the remorselessness with which the rationalistic outlook attempted to relegate everything that contradicted its claims to the realm of madness. But in the last analysis the surrealists only used this discovery to try and renew creative art, which is where everything which did not conform had found its limited and allotted place ever since the *Sturm und Drang* movement and the romantic period. After the historical failure of surrealism Peter Weiss has attempted to elicit what art is really capable of accomplishing. And we should not seek the answer to this question, at least not exclusively, in any of his explicit formulations, but rather in the engagement with the works of art as narrated in the text. If we consider the narrative technique analysed above in this connection, it reveals the work of art as an event instituted to question the separation of our existence into so many individual spheres of life hermetically sealed off from one another. If dissociation is a sign of madness, then an art which undoes this dissociation would be beholden to reason.

The transgression of the line of demarcation observed above has a corresponding moment in the domain of aesthetics itself. Let us return to that first encounter with Géricault's painting which we have already quoted:

Gradually I began to distinguish a few yellowish, bluish or greenish tones on the apparently monochrome pictorial surface. The dominant sensation was no longer that of extreme excitement created by the sighting of the ship on the horizon, but rather one of distress, a feeling of hopelessness. Now it was only pain and abandonment which could be read from the powerfully contained composition – it was as if every tangible documentary element had disappeared from the picture through the scabby scorification of the colour and all that was left was an expression of the personal catastrophe of the painter.[9]

The 'sensation . . . of extreme excitement created by the sighting of the ship' refers to the shipwrecked men and women. Through the immediately preceding sentence, unequivocally formulated from the perspective of the viewer of the painting, the sensation is simultaneously ascribed to the onlooker. Because Weiss does not distinguish the different levels of reality by the use of different tenses the onlooker is momentarily drawn into the picture: the feeling of hopelessness affects the onlooker and the victims of the shipwreck alike. In spite of this the onlooker does retain a certain distance with respect to the painting which is grasped specifically as a 'powerfully contained composition'. The 'fictive' world of the picture and (within the novel) the 'real' world of the narrator are placed on the *same* level, just as Géricault's 'unreal' imaginary identification with the victims of the wreck was placed on the same level with the 'real' creative process of the painter. In this way Weiss questions the very opposition between the fictional and the real which is central to the idealist conception of art.[10]

Idealist aesthetics grasps the work of art as *semblance* (Schein). In this understanding of art the status of what is non-actual in this sense is intrinsically connected with a metaphysical truth claim. In so far as the work of art is projected as an alternative to the purposive–rational process of labour in the everyday bourgeois world, all trace of the actual process of production must be eliminated from it: 'Slender and light, as if from nothing sprung, the image stands before the delighted gaze', as Schiller puts it in the poem 'Das Ideal und das Leben'. But this is only possible if art as a realm of semblance is strictly separated off from the world of actuality. Schiller explicitly regrets that 'we have still not adequately learnt to separate existence from appearance and thus firmly to establish the limits of both *for all time*'.[11] I do not intend to offer a critique of idealist aesthetics here and I only introduce this example to reveal the anti-idealist thrust of Weiss's 'aesthetic'. He does not attempt to conceal the labour and effort experienced by the producer of the work of art but aims on the contrary to disclose afresh this process of

labour within the finished work itself: a process which leads us through the individual creative artist to a confrontation with historical events. Weiss refuses to ascribe to the work of art any special status that would separate it from the real life of the producer or the recipient of the work.

In a certain sense, therefore, Weiss takes up the original intention which motivated the historical avant-garde movements when they attempted to bring art back into an immediate relation with life praxis. But he does so in a way which is very different from the neo-avant-garde 'happening' and this is above all because Weiss retains an emphatic concept of the 'work'. By firmly connecting the work of art, both on the side of production and on the side of reception, to the concept of labour, he is able to liberate art from idealist metaphysics and restore its character as a kind of use-object. But in order to realize that the work of art is *not* thereby degraded in any way, we must already have begun to go beyond the metaphysical conception of art. By means of a dialectical critique of the categories of idealist aesthetics a contemporary aesthetic theory might well come to conclusions in substantial agreement with those of Peter Weiss.

If now we look for historical points of contact for Weiss's conception of art, we shall find them principally in the field of Enlightenment aesthetics which strongly emphasized the utility of literature as a medium for interpreting and examining the problems of human social behaviour. However, the very fact that the equally emphatic moral–educative function of art characteristic of Enlightenment thought has no equivalent in Weiss's conception clearly reveals the limits of such a comparison. It is quite true that he appeals to pre-autonomous conceptions of art but they do not simply coincide with the instrumental conception of art which was characteristic of the Enlightenment. In fact it is reflection on the genre of the *epic* which is more likely to advance our understanding in this connection. Of course, as literary theorists we all think we know, at least since Hegel, that the epic is historically situated in what Hegel called the heroic age of human history and is consequently quite inappropriate to the modern age. Nevertheless I think that any serious attempt to understand Weiss's *Aesthetic of Resistance* will have to examine very carefully the possibility that his work represents an attempted renewal of the epic, in which perhaps Dante's *Divine Comedy* has functioned as a model for him rather than the Homeric epics. Weiss's engagement with Dante goes back to the mid-1960s at least, when in addition to his *Preliminary Studies on the*

Divine Comedy as a tri-partite Drama he also wrote the *Conversation concerning Dante*.[12] Particularly in the latter we find a whole series of remarks which can easily and convincingly be applied to *Aesthetic of Resistance*, especially since Weiss himself here explicitly tries to relate Dante to our contemporary world. In the first place there is Dante's desire to represent what cannot be grasped:

In our world too, people are trying thoroughly to explore the nature of degradation. Of course for a long time we were told that such things could not really be encompassed in words at all. These things were just as ungraspable as the nethermost circles of hell seemed to Dante in his time. And then we finally came to recognise nevertheless that precisely this apparently ungraspable reality has to be described, and described as accurately as possible.[13]

In answer to the question what it was that enabled Dante to describe the ungraspable, one of the partners in the dialogue says: 'The faith in his own capacity for endurance, and in the power and intelligibility of his language made the work possible for him.'[14] Dante's technical device of the 'catalogue' is also mentioned in this connection: 'He presents every kind of suffering to us, he catalogues every possible sin; he trembles and weeps at the sight of them but he still keeps some distance from the spectacle before him and manages to go on writing.'[15]

Aesthetic of Resistance is also concerned with the exploration of degradation, with the description of the apparently ungraspable. Weiss wants to hold on to the suffering of those who were persecuted and destroyed by the Nazis but at the same time he also wishes to pass on the names of those who, at least before the publication of his book, were known only to a small number of historians who specialized in the history of the anti-fascist resistance movement in Germany. Weiss's intention here is an epic one. It is precisely because he is concerned with the sufferings of these concrete individuals and simultaneously with the reality of human suffering in general, that Weiss is able to place the victims of the shipwreck in Géricault's painting on a level with the real victims of shipwreck and these in turn on a level with suffering men and women everywhere. The elimination of the lines of demarcation between different domains of reality lends to *Aesthetic of Resistance* the pathos of a modern epic.

Peter Weiss's epic is also grounded solely upon 'the faith in his own capacity for endurance', i.e. upon the author as moral subject. But here Weiss sets himself in direct opposition to the currently

prevailing conception of the artist. Literary criticism, largely influenced as it is by the doctrine of aestheticism, conceives of the artist as an 'artistic' personality, and from this perspective morality appears as a heteronomous element, and in the final analysis as something specifically inartistic. Behind this attitude there stands the contradictory process in which art has never completely succeeded in detaching itself from bourgeois morality. An amoral posture can still be regarded as an indication of artistic quality today because this process has unfolded in a contradictory manner and has never been brought to a final conclusion. We cannot attempt here to expose the confusions which are concealed behind the abstract universality of the concept of 'morality', a concept which designates both the falseness of prevailing ideas and the idea of personal autonomy. In any case, it must be recognized that in view of the currently prevailing aestheticized criteria of evaluation it is no small undertaking to base an artistic work so unreservedly upon the moral integrity of the author. This commitment alone compels us to reconsider our prevailing conception of the aesthetic.

10

Everydayness, Allegory and the Avant-garde: Some Reflections on the Work of Joseph Beuys

The aporias of either–or

Unrestricted quotation, allegory without reference, the independence of the signifier and the dissolution of art into a completely aestheticized everydayness: all these attempts to define the nature of the post-modern have one thing in common. They all assert the levelling down of oppositions which had remained valid ones for the modern age. This process must not be confused with the dialectical one known as 'sublation' ('Aufhebung'): the oppositions here are not 'sublated' in a third term but are rather eliminated as such in so far as one of the two terms in question drops out altogether. If a quotation no longer makes a specifically determinate reference to the work from which it has been taken but rather by virtue of vague allusion to the themes or techniques of another author or even epoch actually determines an image or text in its entirety, then the opposition between text and quotation disappears. The image is a quotation – but it no longer quotes anything determinate, for in order to do so it would have to construct a context against which that which is quoted could stand out in relief. The appeal to allegory, which does not link the individual elements of a work symbolically according to an organic principle but in accordance with the principle of 'meaning', became important for the aesthetics of modernity because it enabled the artist to escape the confines of idealist aesthetics which had forced us to conceive of form and content in art according to the metaphysical schema of subject and object. But

when under the sign of post-modernist thought the meaning which connects the parts is not merely loosened but actually revoked, then all that remains of allegory is a heap of fragments and unconnected signs. And when the signifier is no longer tied to the signified, then reference is replaced by movement through an infinite chain of signifiers. When, finally, art is dissolved into an aestheticized everyday world, art can no longer be perceived as a specific domain at all.

In so far as the kind of post-modernist discourse outlined here still makes any theoretical claims, it is susceptible to an immanent critique. We expect a theory to be able to explain the conditions of its own possibility either systematically or historically. Post-modernist discourse is not in a position to do so. There is a drawing by the Italian artist Clemente which depicts two figures running past one another in opposite directions, each of them holding on to one of the sides of a ring that bears the inscription 'symbolon'. Just as this programmatic drawing, which asserts the fragmentation of the sign, can only be understood as long as we suppose a semiotic system that remains intact, so too all post-modernist talk about the independence of the signifier does indeed employ a semiotic system that recognizes the opposition of signifier and signified. Post-modernist discourse is not only unable to identify the position from which it speaks, it demonstrates precisely its own impossibility.[1]

One might expect that any discourse the groundlessness of which has been exposed by immanent critique is thereby already disposed of. But this is not the case. In fact the fascination with post-modernist discourse persists. It must therefore draw its compelling power from sources other than internal consistency. In this connection it is tempting to think of the catastrophic aura that hangs over the world-historical horizon of the present age. Where the very survival of human life is put in question, the category of meaning also becomes questionable. Certainly this is not sufficient by itself to explain the collapse of our system of signs but it lets us glimpse the experiential context of a mode of thought which in the face of the unthinkable is no longer prepared to bow to the force of rational argument.

Reflections of this kind can render two aspects of the problem intelligible: on the one hand the fascination which such thinking exercises upon us, on the other hand the great lack of understanding which prevails between the post-modernist thinkers and their critics. The conclusions which can be drawn from this situation touch upon the limits of rational argumentation, but also upon the limits of the

kind of thought which views everything within the fixed perspective of catastrophe. After we have admitted the debilitation of rational argument produced by the historical situation, we will have to return to such argument once again because it seems to offer us the only means of clarifying our situation.

If we attempt to grasp post-modernist thought not as a stringent theory but as the expression of an epochal predicament, then it has to be taken seriously as such. This does not mean that we must accept it in all the abundance of its very different forms. On the contrary we can take up quite different positions with respect to these various forms:

1. Certainly the simplest is the happy hedonism of 'anything goes'. Particularly in the aesthetic field this is a view strongly suggested by the prevailing state of affairs. The coexistence of so many different artistic movements will then appear as a legitimate expression of pluralism, from which anyone can draw what suits their purposes, and the confusion of quotations from the most diverse contexts combined in a single work as an ironic playing with tradition.

2. Anyone who suspects such a simple endorsement of the post-modern predicament in which all variety is treated as equivalent and spread out before us in a single dimension, can find a more subtle form of endorsement with a Nietzschean gesture that affirms a radical rupture. Anyone taking this line can criticize the false riches of post-modern multiplicity initially in order then to reach a position of non-participation through a (fictive) leap out of their own time, a position which would allow them to take positive possession of what was criticized before. What formerly presented itself as a purely arbitrary choice now becomes the product of an act on the part of the subject, an act of 'neutralization'.[2]

3. If on the other hand we understand the post-modern situation as one in which the multiplicity of historical models that are indiscriminately appropriated for our purposes merely obscures the lack of work valid for our own age (in other words as a situation of historicism and eclecticism), then we cannot avoid enquiring after a standard, something which strict modernism found in the concept of advanced material. And here there are two paths we can take: either we pursue the question whether even in the post-modern age advanced artistic material in

Adorno's sense can still be identified (cf. Kilb's contribution to this problem), or we attempt to understand the causes which have led to an uncertainty concerning aesthetic standards, if not to their disappearance altogether (cf. the contributions of Berman and Fehér).[3] Both these paths are viable but they are not without certain risks of their own.

The danger inherent in the first approach lies in reproducing Adorno's decisionism. If it is true that the artistic developments of the 1970s and 1980s have rendered his position untenable and furthermore have opened our eyes to everything that Adorno was driven to exclude from the domain of valid works of art in order to hold fast to his rigorous concept of modernism, then we have to ask whether it is desirable to try and renew this concept. Furthermore we should bear in mind that the concept of advanced artistic material presupposes a logic of material development which can certainly be verified for particular artistic domains in narrowly defined periods (as in the development of cubism prior to 1914 for example) but which cannot be regarded as possessing a uniform character, even during the periods of classical modernism (Kandinsky and the cubists do not follow the same logic of the material, not to mention the surrealists). Of course the way in which Kilb opposes his 'one thing only goes' to the 'anything goes' approach is impressive: the play of empty allegorical references. But it seems to me that this does not really help us to get a conceptual grasp upon the very different types of authentic artistic achievement in the present, neither Peter Weiss's *Ästhetik des Widerstands*, nor the work/non-work of Joseph Beuys, for example, and this despite the fact that the latter does pursue specifically allegorical intentions. Whereas a systematic critique of post-modernist discourse seeks to identify its contradictions, a historically oriented critique enquires into its origins. In relation to the realm of aesthetic products the question becomes the following: how have we come to give up that separation established in modernity between the work of art as the centre of interest on the one side and the everyday world and trivial art on the other, and along with that the strict modernist concept of form, in favour of an uninhibited eclecticism and a tendency towards ubiquitous quotation? If criticism seeks a guilty party in this process, it will be able to discover it in the historical avant-garde movements of the past. For these movements in fact attempted to eliminate the distinction between art and the practice of everyday life and to loosen up the relationship with trivial art and indeed also succeeded

in putting in question the rigorous modernist concept of form (through the idea of *écriture automatique*, for example). Nevertheless, the assignment of guilt attempted in this connection by Berman remains a questionable undertaking. The universal aestheticization of American everyday life which he describes so convincingly more probably results from the imperatives of capitalist commodity production, or more precisely from the compulsion to perpetuate a consumer stimulus, than from the (however misdirected) project of a particular artistic group. Is not Berman here adopting a conservative model of cultural criticism which 'transposes the unpleasant costs resulting from a more or less successful process of capitalist modernization to modern culture itself [in this case the avant-garde movement]?'[4]

Now Berman is not alone in this critique of the avant-garde, formulated as it is under the impact of post-modernism. Ferenc Fehér's argumentation also tends in this direction,[5] and Jürgen Habermas, who decisively rejects the aesthetic anti-modernism of Daniel Bell, also clearly takes up a position against the avant-garde movements. Habermas perceives serious dangers for society in the avant-garde's attempt to 'de-differentiate' the different cultural spheres.

For Habermas the differentiation of the spheres of science, morality and art in fact represents a historical progress and he suspects the attempt to question this differentiation of powers as a regressive wish. However, it can hardly be denied that the insulation which obtains between the individual cultural spheres is *one* serious problem in our culture. The uncoupling of politics from morality certainly represented a progressive development in the time of Hobbes but it becomes very probematic in an age when the technical potential for destruction has grown to such a degree that all human life can be wiped off the face of the earth.[6] And similar considerations apply to the uncoupling of science from morality as well. It is precisely the success of science (in the field of genetic engineering, for example) which now makes it imperative for us to bring science back once again into a productive relationship with morality. As far as art is concerned, the pursuit of what one could call the obstinate autonomy of the aesthetic simultaneously represents both an advance *and* a loss of those dimensions which only become available to art if it ventures out of the secure domain of the aesthetic that has been allotted to it. These remarks are intended to suggest that we should not simply account the aforementioned separation of domains as a case of historical progress. It is not merely reconnecting

the results obtained by a culture of 'experts' back to the life-world that represents a major cultural problem for our society but also and above all the separation of the spheres as such. And it is a merit of the avant-garde movements to have exposed this problem, quite independently of the question whether the solutions they proposed have actually proved feasible or not.

It is perhaps here that we encounter the limits of an approach that tries to impose upon us a dichotomous schema of either–or. Thus either the separation of cultural domains represents historical progress, in which case it is to be accepted and the consequent problems dealt with as they arise (like that of 'reconnecting' with the life-world, for example); or it represents an evil, in which case we must strive to eliminate it and face up to the regressive consequences of this project. Either we accept art as an autonomous institution, in which case any attempt to go beyond this situation must be denounced as a false transcendence; or we adopt the avant-garde position, in which case we must in all consequence also propose the abolition of museums and theatres. Either we cling to the possibility of aesthetic evaluation, in which case we affirm the concept of advanced material even against our better historical judgement; or we accept the free utilization of any material and thus renounce all attempts to evaluate the aesthetic object.

As formulated here, these dichotomies might seem to suggest a decision in favour of the first alternative in each case. But since we have already seen that this option is burdened with specific problems of its own, we should ask ourselves whether the formulation of these alternatives in terms of an either–or decision might not be the very problem. Not merely because on closer examination we recognize that the 'or' position offered to us is such an unattractive alternative that it cannot possibly be accepted but because the dichotomous schema might not in fact do justice to the facts themselves.

Instead of trying to isolate the avant-garde impulse, we should ask ourselves whether it might contain a potential which could still be developed, if art is to be more than an institution that compensates for problems arising from the process of social modernization. Without that diabolical element in the avant-garde impulse towards the transcendence of art as an institution the art of the post-modern age might well rapidly degenerate into a kind of salon art without the salon. Theory is unable to produce by itself an answer to the question whether there is a third position that could release us from the compulsive logic of either–or (which in truth compels us to opt for the 'either'). Theory can recognize what has come to pass

historically but cannot lay down what shall be. Consequently I shall conclude the theoretical discussion here and turn instead to an analysis of certain aspects of the work of Joseph Beuys, a proto-typical representative of the avant-garde artist in the period after the end of the historical avant-garde movement. But I would not like the following analysis to be misinterpreted simply as an exposition of a theoretical problem which could equally well be presented with reference to some other artist. Beuys cannot be regarded as a test case and that is precisely what makes him relevant for theoretical reflection. The internal break in my argument recognizes the heteronomy of theory. If the latter understands anything, it can only do so by reference to the things themselves.

The transgressor

No one can doubt that Beuys belongs in the tradition of the historical avant-garde movement. He has stressed as much himself in the speech he delivered on receiving the Lehmbruck prize. There he tells us that he is concerned with 'a basic idea for the renewal of the social whole, one which leads in the direction of social sculpture'.[7] He takes up the Utopian project of the historical avant-garde which was once formulated by Breton as the creation of a world which men could finally live in ('un monde enfin habitable'). But Beuys also knows that the avant-garde movement was unable to realize this project and that he too will not be able to realize it. All that remains is to 'pass on the flame'.[8] I have spoken about the failure of the historical avant-garde movement myself in my *Theory of the Avant-garde*. And if one compares the project with what became of it, this talk of failure is certainly apposite. But such a judgement itself remains caught within the logic of the either–or. If we leave this logic behind, it seems questionable whether a Utopian project can ever fail since it is so intimately connected with that hope that can never be disappointed, according to the dictum of Ernst Bloch. We can also express this idea in another way: failure is the mode in which the avant-garde artist reaffirms the Utopian quality of the project, a project that would always be transformed into something else if it were to be realized.

Dadaism and early surrealism were sustained by the hope that the hidden potential for creativity and imagination could be released simply by destroying art as an autonomous institution separated from the practice of real life. Hence that assault upon institutional

art the shrill vehemence of which will never be equalled again. Now there is hardly a trace of all this in Beuys. It is certainly true that he distances himself from the concept of the artist, 'which is just what I do not wish to be.'[9] But this distancing gesture lacks the polemical edge which characterized the dadaist declarations. Whereas Raoul Hausmann spits at Goethe, Beuys can actually appeal to him as a writer who entertained a concept of science different from the dominant one of his time and as a man who pursued both art and science in exactly the same spirit. Instead of a direct attack upon art as an institution, what we see here is a movement which leads us away from art without completely abandoning it in the process. 'I actually have nothing to do with art – and this is the only possibility which permits us to do something for art.'[10] This paradoxical formulation captures a situation in which artistic achievement becomes dependent upon the capacity of the artist to transgress the institutional limits of art. Since what we have accustomed ourselves to calling the failure of the historical avant-garde movement the original impulse to transcend art has been transformed: it now knows that it is dependent upon what it rejects.

In fact Beuys wishes to produce a change in our attitudes, to establish a new relationship towards our own senses and the materials with which they come into contact, as well as towards the realm of thought and that which transcends the sensuous. But since the era of aestheticism the idea of transforming our modes of perception has become an empty cliché devoid of any experiential significance. Consequently, Beuys can no longer pursue his aims within the institutional context of art. On the other hand he cannot simply abandon the latter if he does not wish to repeat the avant-garde assault upon it. So it is that he becomes a transgressor who simultaneously transposes the borderlines that he constantly violates now from this direction and now from that. When one of his conversation partners tentatively described his drawings as 'a particular kind of exploration', Beuys agreed but immediately went on to add: 'Nevertheless I have not let myself lose sight of art altogether. Art as such is what I wanted to achieve. We have not yet achieved it.'[10] The paradox that we still have no art ('for it does not yet exist') only makes sense if we presuppose a concept of art quite different from the traditional one, a new 'totalized' concept of art as Beuys describes it. 'All human questions can only be questions of shaping and that is what I mean by the totalised concept of art. The concept refers to the possibility that everyone can in principle be a creative being as well as to questions concerning society as a whole.'[12]

Beuys has a peculiar way of using concepts which we could describe as a kind of semantic displacement. He certainly employs traditional terms but he transposes the semantic core of these concepts by bringing them into close proximity with a number of quite different ones which he also displaces in turn. Thus he transposes the concept of art by bringing it into a close relationship with that of science, but he differentiates the latter from the currently prevailing concept of science and defines it without regard to any methodological features. On another occasion the concept of art is transposed into an all-encompassing idea of 'shaping' which is not, on the other hand, supposed to exhaust the content of the concept. For, as a counterpart to this extension of meaning, Beuys still clings to the idea of a specifically artistic form of activity and speaks of 'social sculpture' in this connection. It is quite pointless to accuse Beuys of being logically inconsistent in his use of language here. On the contrary we must understand these inconsistencies as an appropriate expression of the fact that Beuys is working from an impossible position – one that is located neither inside nor outside of art as an institution but on a borderline that he constantly negates at the same time.

Material allegory

Beuys introduced two new materials into the domain of plastic art: fat and felt. His employment of these materials goes back to a traumatic experience of his own but their significance is not exhausted by the allusion they make to that experience. In 1943 Beuys's fighter plane crashed in the Crimea. After lying unconscious in the snow for days, he was found by Tartars who rubbed him with fat and wrapped him up in felt so that he was gradually able to recover his body heat. These two substances henceforth remained connected in his mind with the idea of rebirth from death by freezing through the heat-producing power of fat and the insulating capacities of felt. To this extent the substances in question form part of a personal mythology. The decisive thing, however, is that Beuys does not stop here but goes on to develop a theory of material substance arising out of his quasi-mythical experience. In this theory the felt functions as an insulator and protective covering but also as a material that permits the penetration of external influences as well. The grey colour is intended to evoke in the onlooker the whole wealth of the normal colour spectrum through a kind of reversal

effect. And finally the sound-absorbent qualities of felt represent silence.[13] Thus a whole dialectic of meaning is ascribed to the material (at once insulating element from and connecting element with the outside world, at once colourlessness and wealth of colour), a meaning which is then further realized in the artist's 'actions'.

What interests Beuys about fat is the different states of the substance as a whole: more or less solid when cold, more fluid under the influence of heat. It thus becomes a privileged object for demonstrating his theory of sculpture which distinguishes between chaotic (warm) states and organized (cold) states:

My initial intention in using fat was to stimulate discussion. The flexibility of the material appealed to me particularly in its reactions to temperature changes. This flexibility is psychologically effective – people instinctively feel it relates to inner processes and feelings. The discussion I wanted was about the potential of sculpture and culture, what they mean, what language is about, what human production and creativity are about. So I took an extreme position in sculpture, and a material that was very basic to life and not associated with art.[14]

Beuys creates a sort of alphabet for himself out of the materials. It is one which does not consist of phonemes but of complex concepts. We can certainly reidentify the meaning that he ascribes to the sensuous materials but this meaning does not arise inevitably from the immediate sensuous impression itself. Thus a piece of work like the *Fat Corner*, which was to be seen in the exhibition at the Guggenheim Museum, did not merely consist in the perceptible object itself, namely the fat smeared into the corner of the room, but also in the self-interpretation and commentary contained in the catalogue and finally in the photograph which almost alienates the plastic object into a two-dimensional form. The onlooker simultaneously becomes a reader who is encouraged to perceive a projected complex of meaning, in this case the opposition between the strict organizing principle of the right angles in the corner of the room and the semi-fluid fat which announces the mutability of 'social sculpture'. But the viewer is also exposed to quite different impressions: the stains on the wall, the rancid and slightly repellent smell of the melting fat which has long since lost the original triangular shape caught in the photograph. The associations produced in the onlooker by these impressions point in a quite different direction from the conceptual interpretation laid down by Beuys himself. Similar considerations also apply to his works in felt. The piles consisting of one hundred square pieces of felt covered by a copper sheet signify a heat-battery for Beuys: 'These felt piles [. . .] are aggregates, and

the copper sheets are conductors.'[15] The association produced in the onlooker by the work is more likely to be that of some bleak warehouse in which every object is just the same as any other. The allegorical meaning which Beuys has ascribed to the materials is overlaid with others arising out of the immediate act of perception.

The return of symbolic form

How far these different levels of meaning can diverge from one another can be seen from Beuys's 'action' entitled *How to Explain Pictures to a Dead Hare*. Beuys is sitting on a stool with its single leg wound about with felt; he has poured honey over his head; he has attached an iron sole to this right foot while his left foot rests upon an equally large felt sole; in his lap he cradles a dead hare; his right hand is raised in a confessional gesture; a number of drawings can be made out on the wall behind him. This stage of the action is all captured in a photograph by Ute Kolphaus.[16] The polemical content of the scene is quickly grasped by the onlooker: even a dead animal has a greater understanding of art than most people do (while the action takes place the gallery doors are closed and Beuys can only be seen from outside through the windows). The scene owes its pathos not least to the sight of the head covered in honey. Beuys connects this image with a clearly defined allegorical meaning: the head is the organ of rational thought which has ossified into deathly rigidity. By pouring the living substance of honey over his head, Beuys suggests that thought too can be a living thing, can become a different kind of thinking.[17] The scenic allegory presents us with that very semantic displacement which we already encountered in his public utterances. So much for the intended meaning of the scene. But someone who looks at the photograph *sees* something quite different: a head that appears disfigured by the blistering wounds of war and whose blank gaze contradicts the peculiar vitality of the hand. The stool leg entwined with felt, the vaguely perceptible switch of an electric appliance and the shoe wrapped up (in wire?) beside it evoke associations of bondage and torture. The emotive power of the image does not reflect the allegorical intention of the performer of the action, but rather cuts across it. Beuys certainly says something to us here but what he says is not the same as what he meant to say.

What is the significance of this discrepancy between the allegorical self-interpretation of the artist and the symbolically interpreted visual experience of the onlooker? It would certainly be a mistake to

play off one of these levels of meaning at the expense of the other. We cannot simply repudiate the allegory constructed by the artist as a *quantité négligeable* for it belongs to the work just as much as the emblematic *subscriptio* belonged to baroque art. Nor should we simply regard the meaning produced by the onlooker through the sensuous encounter with the object as a purely subjective contribution, especially since this interpretation is more likely to meet with intersubjective agreement than that proposed by the artist. We shall have to move back and forth between these levels of meaning which produce an extremely complex structure. If we must consider the allegorical self-interpretation of the artist as something which belongs to Beuys's works (and this seems to me to be beyond question), then we can learn precisely from these works that the subjectively projected meaning cannot be maintained. This does not imply that this meaning simply disappears. Once publically enunciated or formulated in a catalogue the meaning is already present but it remains only loosely connected with the object. What we actually experience here is the simultaneous constitution and disintegration of allegory. We recognize the allegorical projection of the artist but we immediately abandon it because it does not coincide with what we see.

The phenomenon we have described here must not be confused with the multiple levels of significance ordinarily encountered in works of art. In that case we certainly discover different meanings but they are all located on the same plane as it were. But here that is precisely not the case. Beuys imposes a clearly defined allegorical meaning on to his materials which we can certainly recognize intellectually but this meaning is not strictly bound to what we sensuously perceive. Consequently the object perceived enters into a symbolic sphere of meaning for us in which it is not grasped as a sign for something else but rather as identical with its meaning (however unclear the latter may be).

Benjamin's rehabilitation of the concept of allegory has played such an important role in contemporary aesthetic theory because with this concept the two sides of what we call form, namely the sensuous perceptible moment and the intellectual meaning (object and subject), are not fused into a unity but are preserved in their difference from one another. Thus allegory appears as a model that allows us to transcend the metaphysical presuppositions of idealist aesthetics and to turn the bifurcation which dominates our actual existence into a constitutive experiential principle of art. If our observations about Beuys's work are well founded we come up

against a limit here in the attempt to subject the domain of art to the characteristically modern principle of rationality (in the sociological sense). In so far as allegory preserves the distinction between the sensuously given and the meaning as independent terms and attempts to establish an unambiguous relation between them, then in its very structure it represents a model which corresponds to the principle of rationality. For both of them rest upon the separation of subject and object. The symbol, on the other hand, in which the sensuous moment cannot be separated from what it means, remains bound up with a metaphysical concept of form which is modelled on the idealist idea of the subject–object. Now if it turns out that we cannot help also reading Beuys's allegories as symbols, then it would seem that a certain metaphysical model still shapes our aesthetic experience. It is perfectly true that we can lay bare the metaphysical basis of this aesthetic experience through critical reflection but we cannot simply avoid it in our actual dealings with art.

From this vantage point I would now like to return to the problem of post-modernity as formulated above. Most critics are agreed in describing this situation as a Babel of quotation and a confusion of styles. The positions which we can take up towards this state of affairs (either the happy eclecticism of 'anything goes' or the decisionistic assertion of *one* advanced material) are both equally unsatisfactory. In saying this we have not solved the problem of evaluation (and to that extent we must agree with Kilb). What can our analysis of Beuys's work contribute to a solution here? In the first place it should teach theory a certain modesty. With respect both to production and experiential reception theory remains heteronomous. It can help to conceptualize the aesthetic as its exists (and that is not an inconsiderable achievement) but it cannot on its own resources establish criteria. When theory attempts to do so, it constantly runs the risk of disgracing itself in front of the works which it simply obscures because its would-be illumination misses them altogether. We cannot leap ahead theoretically and claim that allegory realizes itself in the distintegration of projected meaning and thus gives rise to symbolic meaning out of itself for example. Even after the event we should not attempt to erect this particular structure as a criterion of contemporary art. Beuys is a unique case. Nevertheless, we should be permitted to compare and contrast the paintings of *Die Neuen Wilden* with his works. For this reveals the problems in such an unproblematic return to panel painting, to joyful colourism and secure line. In comparison with the broken unsure line of Beuys's drawings, in which technical facility gives way

to a more tentative jotting, much contemporary painting makes a rather external effect. The success such painting achieves is not unlike that of Makart. These remarks are simply intended to show that evaluation is possible even without a firm theoretical framework which decrees what the most advanced level of artistic material is. Only when theory becomes modest enough to admit its heteronomy will it be able to practice that 'immersion in the matter at hand' which Adorno claimed for himself but certainly did not always succeed in realizing.

In his famous essay of 1919, 'La Crise de l'Esprit', Valéry describes the epoch before the First World War as an Alexandrine chaos of styles, allusions and borrowings:

Dans tel livre de cette époque – et non des plus médiocres – on trouve, sans aucun effort: – une influence des ballets russes, – un peu du style sombre de Pascal, beaucoup d'impressions du type Goncourt, – quelque chose de Nietzsche, – quelque chose de Rimbaud, – certains effets dus à la fréquentation des peintres, et parfois le ton des publications scientifiques, – le tout parfumé d'un je ne sais quoi de britannique difficile à doser![18]

This description astonishes us. For at least in the field of the visual and the plastic arts the decade immediately preceding the First World War appears to us as the heroic epoch of modernist art. Fauvism, cubism, the Blue Rider – these decisive innovations in twentieth-century painting all arose in this period. But nothing of all this appears before the theorist's gaze, which seems dazzled by a mirror that has shattered into a thousand splinters. If such important contemporary phenomena could escape a thinker of such sensitivity and perspicacity as Valéry, then we cannot reject out of hand the possibility that something similar could happen to us. Perhaps we cannot see the epochal art of our own time, dazzled by the colourful ambitious canvasses of the New Fauves.

Even Berman's fear that the universal aestheticization of everyday life could finally lead to a situation in which there would no longer be anything outside art and the latter would therefore disappear can be allayed by considering the case of Beuys. Certainly Beuys did abandon himself to the media. Even those at the greatest remove from the world of avant-garde art still recognized the man with the felt hat and had an instant judgement to pass on him if required. Yet his works remained esoteric, inaccessible even to those who attempted to follow the self-commentaries of the artist. If popularity and esotericism can be so intimately connected with one

another in this way, we may well suppose that art will remain capable of effecting a distancing movement in which it opposes itself to the everyday world as its other. The manner in which Beuys both adopts and revokes the avant-garde project of transcending art, operating from an increasingly indistinct borderline between art and non-art, shows how the practice of the artist already finds itself in advance of the legitimate fears of the theoretician. While we anxiously try and formulate the question, the answer has long since been found but we simply do not see it. It required the death of Joseph Beuys before we could finally see it so clearly.

Notes

Chapter 1 Literary Institution and Modernization

1 For a critique of the concept of modernization, compare H.-U. Wehler, *Modernisierungstheorie und Geschichte* (Göttingen, 1975), pp. 18–30. The concept of modernization includes many different phenomena which are linked only in an additive manner; in the following I will use it in the sense of Weber's theorem of rationalization. If we want to avoid that modernization appears as a self-controlled process, we have to make out the specific social agents of rationalization in the historical process. Finally, we should be careful not to identify as traditional residues those moments opposed to 'modernization'; in view of the contradictoriness of historical processes, we must always ask whether these contradictions are not the very results of modernization itself.

2 W. Schluchter, *Rationalismus und Weltbeherrschung. Studien zu Max Weber* (Suhrkamp, Frankfurt, 1980), p. 10.

3 J. Habermas, 'Die Moderne – ein unvollendetes Projekt', *Die Zeit*, no. 39, 19 Sept. 1980, p. 48; English translation: *New German Critique*, 22 (Winter 1981), pp. 3–14.

4 M. Weber, 'Vorbemerkung zu den gesammelten Aufsätzen zur Religionssoziologie', in *Soziologie, universalgeschichtliche Analysen, Politik* (Kröner, Stuttgart, 1973), pp. 341–2.

5 M. Weber, *Wirtschaft und Gesellschaft*, ed. J. Winckelmann (Mohr, Tübingen, 1972), pp. 365–7. Concerning the different versions of this paragraph, cf. Schluchter, *Rationalismus und Weltbeherrschung*, pp. 208–14.

6 Weber, 'Vorbemerkung', p. 463.

7 Weber, *Wirtschaft und Gesellschaft*, p. 367.

8 Concerning the notion of literary institution, compare P. Bürger, *Theory of the Avant-garde* (University of Minnesota Press, Minneapolis, 1984), (translation of *Theorie der Avantgarde* (Suhrkamp, Frankfurt, 1974) and P. Bürger, The institution of "art" as a category in the sociology of literature', *Cultural Critique*, no. 2 (Winter 1985–6), pp. 5–33.

9 I adopt in the following the results of P. Bürger, 'Zum Funktionswandel der dramatischen Literatur in der Epoche des entstehenden Absolutismus', in *Französische Literatur in Einzeldarstellungen*, vol. 1, ed. P. Brockmeier and H. H. Wetzel (Metzler, Stuttgart, 1981).

10 N. Elias, *Über den Prozess der Zivilisation* (Suhrkamp, Frankfurt, 1976), pp. 369ff.

11 J. Schulte-Sasse, 'Drama', in *Deutsche Aufklärung bis zur Französischen Revolution 1680–1789*, ed. R. Grimminger (Hanser, Munich, 1980), pp. 426–7.

12 We must, of course, specify and shade the traditional view of the ascent of the bourgeoisie during the eighteenth century, taking into account the findings of the new French social history: the importance of the aristocracy for the development of the productive forces and the existence of a 'Bourgeoisie d'Ancien Régime', reluctant to invest. Cf. a summary in G. Ziebura, *Frankreich 1789–1870* (Campus, Frankfurt/New York, 1979), pp. 25–35.

13 Concerning the crisis of the literary institution of the Enlightenment cf. Ch. Bürger, P. Bürger and J. Schulte-Sasse (eds) *Aufklärung und literarische Öffentlichkeit* (Suhrkamp, Frankfurt, 1980).

14 D'Alembert, 'Réflexions sur l'usage et sur l'abus de la philosophie dans les matières de goût', in *Œuvres complètes*, vol. 4 (Slatkine, Geneva, 1967), p. 333.

15 D. Diderot, *Œuvres esthétiques*, ed. P. Vernière (Garnier, Paris, 1959), p. 261.

16 Cf. I. Fetscher, *Rousseaus politische Philosophie* (Suhrkamp, Frankfurt, 1975).

17 Cf. Ch. Bürger, 'Philosophische Ästhetik und Populärästhetik. Vorläufige Überlegungen zu den Ungleichzeitigkeiten im Prozess der Institutionalisierung der Kunstautonomie', in *Zum Funktionswandel der Literatur*, ed. P. Bürger (Suhrkamp, Frankfurt, 1983), pp. 107–26.

18 V. Cousin, *Cours de philosophie* (Hachette, Paris, 1836), p. 223.

19 K. Heitmann, *Der Immoralismusprozess gegen die französische Literatur im 19. Jahrhundert* (Gehlen, Bad Homburg/Berlin/Zurich, 1970), p. 209.

20 Cf. Ch. Bürger, *Der Ursprung der bürgerlichen Institution Kunst* (Suhrkamp, Frankfurt, 1977), ch. 5.

21 Weber, 'Vorbemerkung', p. 462.

22 Th. W. Adorno, *Ästhetische Theorie* (Suhrkamp, Frankfurt, 1970), p. 88.

23 H. Marcuse, 'Über den affirmativen Charakter der Kultur', in *Kultur und Gesellschaft*, vol. 1 (Suhrkamp, Frankfurt, 1965), pp. 56–101.

Chapter 2 Walter Benjamin's 'Redemptive Critique'

1 Wherever possible references are to the available volumes of the projected complete edition of Benjamin's works: Walter Benjamin, *Gesammelte Schriften*, vol. III, ed. H. Tiedemann-Bartels; vol. IV, ed. T. Rexroth (Frankfurt, 1972). Otherwise references are to the selected writings contained in Walter Benjamin, *Illuminationen. Ausgewählte Schriften I* (Frankfurt, 1961), and *Angelus Novus. Ausgewählte Schriften II* (Frankfurt, 1966).

2 Jürgen Habermas, 'Bewusstmachende und rettende Kritik – die Aktualität Walter Benjamins', in *Zur Aktualität Walter Benjamins*, ed. S. Unseld (Suhrkamp Taschenbuch 150, Frankfurt, 1972). The page references are to this edition of the essay. The notes to Habermas's essay contain references to the most important relevant literature on Benjamin. There is an English version of

the essay in Jürgen Habermas, *Philosophical – Political Profiles*, tr. F. G. Lawrence (Polity, Cambridge, 1983), pp. 129–63 (references to this edition follow those to the German edition).

3 Habermas, 'Bewusstmachende und rettende Kritik', pp. 182/133–4.

4 Ibid., p. 182/134. In so far as avant-garde works of art actually oppose the autonomous status of art, we can say with Habermas that 'they escape the direct grasp of ideology critique' (ibid., p. 183/134). But in so far as the intention to break through the autonomy of art towards a real life praxis is realized within social conditions which always tend to re-establish this autonomy 'automatically' (however much the artist tries to rebel against this), then avant-garde art also develops an affirmative moment which can be apprehended by ideology critique.

5 Ibid., p. 184/135.

6 T. W. Adorno, letter to Benjamin of 18 March 1936, in *Über Walter Benjamin*, ed. R. Tiedemann (Bibl. Suhrkamp 260, Frankfurt, 1970), p. 120.

7 Cf. Benjamin, *Illuminationen*, pp. 171, 183.

8 Habermas, 'Bewusstmachende und rettende Kritik', p. 185/136.

9 Walter Benjamin, 'Geschichtsphilosophische Thesen' (Theses on the philosophy of history), VI, in the collection *Illuminationen*, pp. 268–79. Cited below as 'Theses' with the appropriate Roman numeral. There is an English version of the piece in Walter Benjamin, *Illuminations*, tr. H. Zohn (London, 1970), pp. 255–66.

10 Benjamin, 'Theses', VI. Habermas interprets this danger in too general a fashion when he describes it in terms of 'domination by mythical fate' ('Bewusstmachende und rettende Kritik', p. 188/137).

11 Benjamin, 'Theses', VII.

12 Ibid.

13 This passage shows how little contemporary iconclastic tendencies, or more precisely those aimed directly at culture itself, can really call upon Benjamin for support. However, it is certainly true that it is possible to find certain formulations in Benjamin's work which do seem to justify a radical repudiation of bourgeois culture. I am thinking in this connection of the notions of the 'destructive character' and 'positive barbarism' which have furnished the point of departure for a kind of critical cultural reflection that I consider highly problematic. Cf. above all the essays by Lindner and Wohlfarth in the volume *Links hätte noch alles sich zu enträtseln*, ed. B. Lindner (Frankfurt, 1978). Cf. also n. 49 below.

14 Benjamin, 'Theses', XII.

15 Habermas, 'Bewusstmachende und rettende Kritik', p. 186/161.

16 Ibid., p. 190/139.

17 Benjamin, 'Theses', XI.

18 The fact that in his essay on the work of art Benjamin actually expects progress to result from the further development of the artistic forces of production, as opposed to the position adopted in the 'Theses on the philosophy of history', only serves to reveal the unique character of Benjamin's thought which, as Habermas rightly says, 'should not be confronted with inappropriate demands for consistency' ('Bewusstmachende und rettende Kritik', p. 176/130).

19 Benjamin, 'Theses', XV and XVI.

20 Ibid., XVII.

21 Cf. Karl Marx, 'Zur Judenfrage', in K. Marx/F. Engels, *Studienausgabe*, vol. 1, ed. I. Fetscher (Fischer Bücherei 764, Frankfurt, 1966), pp. 31–60. English translation in Karl Marx, *Early Writings* (Penguin Books, Harmondsworth, 1975), pp. 212–41.

22 'The expression "socially necessary" does not signify a compulsion to false consciousness operating like a natural law but an objective constraint arising from the organisation of society itself' (H. Schnädelbach, 'Was ist Ideologie? Versuch einer Begriffserklärung', *Das Argument*, no. 50 (July 1969), p. 83).

23 K. Marx, 'Zur Kritik der Hegelschen Rechtsphilosophie. Einleitung', in Marx/ Engels, *Studienausgabe*, vol. 1, p. 17. As against Habermas's view, therefore, Benjamin does stand firmly in the tradition of Marxist thought when he says that 'the superstructure is the expression of the base. The economic conditions, under which society exists, find their expression in the superstructure.' (Quoted by Habermas, 'Bewusstmachende und rettende Kritik', p. 210/152.)

24 Benjamin, *Gesammelte Schriften*, vol. III, p. 265.

25 Ibid., p. 264.

26 Ibid., p. 265.

27 The third form of history specified by Nietzsche, monumental history, does not enter into Benjamin's synthesis and is criticized by him in the two major reviews of Kommerell's work as the 'heroic view of history' (ibid., pp. 252ff. and 409ff.).

28 F. Nietzsche, 'Vom Nutzen und Nachteil der Historie für das Leben', in F. Nietzsche, *Studienausgabe*, vol. I, ed. H. H. Holz (Fischer Bücherei 927, Frankfurt, 1968), p. 203.

29 Ibid., pp. 204ff.

30 Benjamin, *Gesammelte Schriften*, vol. III, p. 265.

31 Ibid., p. 287.

32 Benjamin, *Angelus Novus*, p. 360.

33 Benjamin, *Illuminationen*, p. 259.

34 Letter to Horkheimer of 16 April 1938 in Walter Benjamin, *Briefe*, ed. G. Scholem/T. W. Adorno (Frankfurt, 1966), p. 751.

35 W. Benjamin, 'Fragment über Methodenfragen einer marxistischen Literatur-Analyse', *Kursbuch*, no. 20 (March 1970), p. 1.

36 Ibid.

37 Ibid.

38 Benjamin, *Illuminationen*, p. 265.

39 We can see that a whole theory of art lies behind Benjamin's deliberately bare formulation when he expresses his desire to secure redemptive critique through recourse to the 'breaks and jagged edges' of the work. On this view the work of art is not an organic whole but a disintegrating unity of contingency. The concept of the work of art which lies behind Benjamin's reflections is that developed by the artists of the avant-garde and of the surrealist movement in particular. It is contingency rather than the intention of the artist which constitutes the central category now obeyed by the work of art. Accordingly the task of the critic is to discern in the contingent the signature of the historical epoch in which the work arose. A strict theory of art, as Benjamin points out, 'would concern itself with the relationship which serves reciprocally to illuminate the historical process and radical change on the one hand and the contingent, external and indeed strange character of the work of art on the other' (*Gesammelte Schriften*, vol. III, p. 367).

40 Benjamin, *Illuminationen*, p. 261.
41 Benjamin, *Gesammelte Schriften*, vol. III, p. 97.
42 Ibid., p. 287.
43 Ibid., p. 290.
44 Benjamin, 'Theses', XIV.
45 Ibid.
46 Benjamin, *Gesammelte Schriften*, vol. III, p. 255.
47 Ibid., p. 259.
48 Benjamin, 'Theses', XVI.
49 The original version of this essay concluded with some remarks which warned against assessing Benjamin's contribution to critical hermeneutics through the distorting medium of Adorno's understanding of Benjamin's work. I have not repeated these remarks here for the following reasons. The complex relationship between the two theorists was only sketchily suggested in that context. But I think the criticism of Adorno's political standpoint in particular was an abstract one since his resigned view concerning the possibilities of real social change under late capitalism did not prevent him from continuing to exercise an influence in the tradition of enlightened critique. One only has to consider his 'critical models' in *Eingriffe* (edn. Suhrkamp 10, Frankfurt, 1963) or the *Stichworte* (edn. Suhrkamp 347, Frankfurt, 1969), for example. Nor did I entirely avoid the danger of constructing a purely political opposition between Adorno and Benjamin, something which has since become a ritual in settling accounts with Adorno's thought. The reception of Benjamin by the student movement still requires critical clarification. I have already expressed some thoughts in this connection elsewhere: 'Neue Subjektivität in der Literaturwissenschaft?' in *Die geistige Situation der Zeit*, ed. J. Habermas (edn. Suhrkamp 1000, Frankfurt, 1978). Of course, with these remarks I do not mean to deny the fact that literary research has learnt from the work of Benjamin in recent years. In this connection we should mention Klaus Garber's attempt to develop a historical–materialist theory of reception through recourse to Benjamin's approach and to demonstrate the validity of the theory by producing a reception history of baroque poetry written from the perspective of ideology critique (cf. *Martin Opitz Vater der deutschen Dichtung. Eine kritische Studie zur Wissenschaftsgeschichte der Germanistik* (Stuttgart, 1976)).

Chapter 3 The Decline of Modernism

1 A Touraine, *La Société post-industrielle* (Paris, 1969); German translation by Eva Moldenhauer: *Die postindustrielle Gesellschaft* (Frankfurt, 1972). Also J.-F. Lyotard, *The Postmodern Condition* (Minneapolis, 1984).
2 Cf. e.g. P. Gorsen, 'Zur Dialektik des Funktionalismus heute', in *Stichworte zur 'Geistigen Situation der Zeit'* (Frankfurt, 1979), pp. 688ff.
3 Cf. e.g. the critique of Adorno in J. Schulte-Sasse and F. Jameson, *Zur Dichotomisierung von hoher und niederer Literatur* (Frankfurt, 1982), pp. 62ff., 114ff.
4 Th. W. Adorno, *Minima Moralia. Reflexionen aus dem beschädigten Leben* (Frankfurt, 1969), p. 291. The citations have been drawn from the appendix of the German edition, which was not included in the English translation.

5 Ibid., pp. 291ff.
6 That de Chirico in his metaphysical phase must be understood as a modern painter has been convincingly shown by W. Rubin: 'De Chirico et la modernité', in *Giorgio de Chirico* (exposition catalogue) (Centre Georges Pompidou, Paris, 1983), pp. 9–37; German edn (Munich, 1982).
7 Th. W. Adorno, *Musikalische Schriften I–III*, ed. R. Tiedemann (*Gesammelte Schriften*, vol. 16), (Frankfurt, 1978), pp. 391ff.
8 Th. W. Adorno, *Philosophy of Modern Music* (New York, 1973), p. 183.
9 Ibid., pp. 183ff.
10 Th. W. Adorno, *Impromptus* (Frankfurt, 1970), p. 77.
11 Adorno, *Philosophy of Modern Music*, p. 182.
12 Ibid., p. 186.
13 Ibid., p. 184.
14 Cf. P. Bürger, *Zur Kritik der idealistischen Ästhetik* (Frankfurt, 1983), pp. 128–35.
15 But the possibility will also have to be taken into account that the content of such a recourse cannot be understood from the individual work but only from a series of pictures. This is the case, for example, for the works of the Berlin painter Werner Hilsing, whose virtuoso readoption of the material stocks of the past, alienated by miniature format (precisely from the circle of 'classical modernism') accompanies the perpetuation of art after its termination with a merrily ironical commentary.
16 Cf. Th. W. Adorno, *Introduction to the Sociology of Music* (New York, 1976).
17 Th. W. Adorno, *Dissonanzen. Musik in der verwalteten Welt* (Göttingen, 1969), p. 8.
18 Ibid., p. 123.
19 Ibid., p. 150. I cannot in this context go into inaccuracies in Adorno's concept of aesthetic rationality.
20 Ibid., p. 148.
21 Ibid., p. 145.
22 Ibid., p. 146.
23 Ibid.
24 Adorno, *Philosophy of Modern Music*, p. 112.
25 Adorno, *Dissonanzen*, p. 157.
26 Ibid.
27 Th. W. Adorno, *Aesthetic Theory*, tr. Christian Lenhardt (London, 1984), p. 162.
28 Ibid., p. 168.
29 Ibid., p. 98.
30 However, especially in his studies on Mahler and Zemlinsky he tried to remove some of its dogmatic rigidity from the theory of the most advanced material. 'At times the flight of the most progressive in art is the relic of the past which it drags along with it', he says of the 'anachronistic element' in Mahler (*Musikalische Schriften*, p. 339). And in the Zemlinsky essay he finds that from later perspectives aspects 'in what was once left behind' can be found that [prove to be] 'more lasting than in the advanced [art] of the past' (ibid., p. 367). He also recognized in Mahler the quotation of the banal (ibid., p. 328).
31 Adorno, *Aesthetic Theory*, pp. 315ff.
32 Adorno, *Musikalische Schriften*, p. 484.
33 Ibid., p. 492.

34 Ibid., p. 177.
35 Ibid.
36 Ibid., p. 587.
37 Ibid.
38 D. Diderot, *Œuvres esthétiques*, ed. P. Vernière (Garnier, Paris, 1959), p. 261.
39 Adorno, *Dissonanzen*, p. 155.
40 Ibid., p. 156.
41 G. W. F. Hegel, *Encyclopedia* (addition to section 133).
42 Cf. on this and prior topics, my book *Theory of the Avant-garde* (University of Minnesota Press, Minneapolis, 1984).

Chapter 4 The Return of Analogy

1 Michel Foucault, *Les mots et les choses* (Paris, 1966); English translation as *The Order of Things. An Archaeology of the Human Sciences* (Tavistock, 1970) p. xv.
2 Ibid.
3 Ibid., p. xvi.
4 This claim is treated with scepticism by Manfred Frank as well as Jürgen Habermas: 'This enterprise [sc. Foucault's archaeological project] is less the inauguration of a new mode of thought than a backstairs return to something we already knew and hardly wish back upon ourselves.' Manfred Frank's harsh judgement here (*Was ist Neostrukturalismus?* (edn. Suhrkamp 1203, Frankfurt, 1983, p. 202) is explicable principally in the light of the fact that he interprets Foucault's admittedly ambiguous remarks about the return of 'langage en son être' as a revival of the representational model of language. He is thus able to claim that the dream of a subject completely transparent to itself in all its acts still lives on in Foucault himself (cf. ibid., p. 214). Habermas on the other hand seems to share Foucault's critique of subject-centred thought: 'Foucault did indeed provide an illuminating critique of the entanglement of the human sciences in the philosophy of the subject: these sciences try to escape from the aporetic tangles of contradictory self-thematization by a subject seeking to know itself, but in doing so they become all the more deeply ensnared in the self-reification of scientism' (*Der philosophische Diskurs der Moderne* (Frankfurt, 1985), p. 344; cf. also the summary of Foucault's critique of the philosophy of the subject, ibid., p. 308ff; English translation as *The Philosophical Discourse of Modernity* (MIT Press, Cambridge, Mass., 1988), pp. 294 and 261ff. However, Habermas criticizes Foucault's later theory of power for simply reproducing the aporia at the heart of the philosophy of the subject, namely the overlaying of the empirical and transcendental perspectives (*Philosophische Diskurs*, pp. 322ff/*Philosophical Discourse*, pp. 273ff.).
5 Foucault, *Les mots et les choses*, pp. 329ff./*Order of Things*, pp. 318ff.
6 Ibid., p. 332/322.
7 Kant occupies a special position in Foucault's thought. According to Foucault, Kant opened up a new perspective for Western philosophy with his question concerning the limits of reason but one which he himself effectively closed off again on account of his anthropological approach to the problem (cf. 'A preface to transgression', in M. Foucault, *Language, Counter-Memory, Practice* (Blackwell, Oxford, 1977), p. 38.

8 Foucault, 'A preface to transgression', pp. 41–2.
9 This is one of the critical questions which Manfred Frank has addressed to the post-structuralist position; cf. *Was ist Neostrukturalismus?*, pp. 127ff.
10 Foucault, *Les mots et les choses*, p. 309/*Order of Things*, p. 296.
11 Ibid., p. 313/300.
12 Ibid., p. 59/44.
13 Ibid., p. 55/40.
14 Ibid.
15 Foucault rejects the kind of interpretation that investigates textual meaning ('analyse du côté du signifié') as well as formal analysis ('du côté du significant') as both inappropriate to modern literature. The only alternative that remains is a sort of interpretive self-immersion in the self-referential literary text.
16 Foucault, *Les mots et les choses*, p. 59/*Order of Things*, p. 44.
17 M. Foucault, 'What is an author?', in *Language, Counter-Memory, Practice*, p. 120.
18 Foucault, *Order of Things*, p. xi.
19 M. Foucault, *L'ordre du discours* (Gallimard, Paris, 1971), pp. 74–5.

Chapter 5 Some Reflections upon the Historico-sociological Explanation of the Aesthetics of Genius in the Eighteenth Century

1 E. Köhler, 'Über die Möglichkeiten historisch-soziologischer Interpretation . . . ', in his *Esprit und arkadische Freiheit [. . .]*, (Athenäum, Frankfurt, 1972), p. 91.
2 In this connection cf. my essay 'Probleme der Literatursoziologie', in *Naturalismus/Ästhetizismus*, ed. Ch. Bürger, P. Bürger and J. Schulte-Sasse (Hefte krit. Litwiss. 1, edn Suhrkamp 992, Frankfurt, 1979), pp. 47ff.
3 Boileau, 'Art poétique' (1674) in the *Œuvres complètes*, ed. F. Escal (Bibl. de la Pléiade 188, Gallimard, Paris, 1966), p. 157.
4 Ibid., pp. 157ff.
5 Taking Boileau's translation of Pseudo-Longinus as the point of departure, the attempt has been made in the field of Boileau research to limit the significance of the concepts of *raison* and *règle* to Boileau's poetics (cf. Th. A. Litman, *Le Sublime en France (1660–1714)* (Nizet, Paris, 1971)) or to reinterpret Boileau's concept of *raison* in terms of intuition: 'To Boileau and his age, however, Reason was still a partner in the act of revelation, a tool of [insight] Suffused with light, it became an unimpeachable [eye of the mind] which gave access to that order of esthetic truth which the discursive powers were powerless to unveil' (J. Brody, *Boileau and Longinus* (Droz, Geneva, 1958), p. 87). It is obvious that post-romantic ideas are here being projected back into Boileau himself (in this connection cf. also J. Brody, 'Boileau et la critique poétique' in *Critique et création littéraires en France au XVIIIe siècle [. . .]* (Editions du CNRS, Paris, 1977), pp. 231–50). S. Vitanovic goes furthest of all in this direction when he explicitly brings Boileau into proximity with the aesthetics of genius ('Le Problème du génie dans la poétique de Boileau' in ibid., pp. 195–202).
6 Voltaire, the 'Préface' (1729) to *Oedipus* in his *Dissertations sur le théâtre* (Editiones Heidelbergenses 14, (Winter), Heidelberg 1949), p. 6.

7 Voltaire, *Dictionnaire philosophique*, ed. R. Naves (Classiques Garnier, Paris, 1961), p. 182.

8 Ibid., p. 528.

9 The article was ascribed for a long time to Diderot but was in fact composed by Saint-Lambert, the poet of the 'Saisons'. Cf. Paul Vernière's introduction to the article in Diderot, *Œuvres esthétiques* (Classiques Garnier, Paris, 1959), pp. 5ff.

10 Ibid., p. 9.

11 Ibid.

12 Ibid., pp. 11ff.

13 Cf. Boileau, 'Art poétique', IIIe chant: 'Voulez vous sur la scène étaler des ouvrages, / Où tout Paris en foule apporte ses suffrages [. . .]', p. 169.

14 Bouhours, *Entretiens d'Ariste et d'Eugène*, [1671] (Paris, 1708), p. 257; quoted in J. Chouillet, *L'Esthétique des lumières* (PUF, Paris, 1974), p. 31.

15 La Rochefoucauld, 'Réflexions diverses', in his *Maximes [. . .]*, ed. J. Trouchet (Classiques Garnier, Paris, 1967), p. 202.

16 Montesquieu, 'Essai sur le goût', in his *Œuvres complètes*, ed. D. Oster (Seuil, Paris, 1964), p. 845.

17 In this connection cf. H. Dieckmann, 'Zur Theorie der Lyrik im 18. Jahrhundert in Frankreich [. . .], in his *Studien zur europäischen Aufklärung* (Theorie und Geschichte der Literatur und der schönen Künste 22, Fink, Munich, 1974), pp. 339ff.

18 Boileau, 'Art poétique', p. 164.

19 Dieckmann, 'Zur Theorie der Lyrik', p. 342.

20 Ibid., p. 345.

21 Ibid., p. 344.

22 Diderot, *Œuvres esthétiques*, p. 260.

23 Ibid., pp. 260ff.

24 Ibid., p. 261.

25 Ibid.

26 K. Ph. Moritz, 'Die Unschuldswelt' in his *Schriften zur Ästhetik und Poetik*, ed. H. J. Schrimpf (Niemeyer, Tübingen, 1962), pp. 55ff.

27 Diderot, *Œuvres esthètiques*, p. 260.

28 Ibid., p. 262.

29 H. Dieckmann emphasizes how talk about the 'feu céleste' or the 'don divin' of the poet continues in France during the seventeenth century but he also limits the significance of this fact for the development of the aesthetics of genius: 'Genius is for the French critics of the seventeenth century simply a vague, undefined power. They neither analyse the concept nor bring it into relationship with specific qualities of a work of art and with distinct faculties of the artist; so that 'œuvre de génie' becomes merely synonymous with 'excellent work'. Sometimes it is even less: a commonplace, an enfeebled term of classical rhetoric' ('Diderot's conception of genius', in his *Studien zur europäischen Aufklärung*, pp. 11ff.).

30 And there is a further factor involved here: the concept of the divinely inspired creative artist can fulfil very different functions in different periods. It could express the struggle of humanist intellectuals for the emancipation of literature from the supremacy of the church (J. Lefebvre, 'Zur Autonomie der Literatur in der frühen Neuzeit' in *Zum Funktionswandel der Literatur*, ed. Peter Bürger (Hefte für krit. Litwiss. 4, edn Suhrkamp, Frankfurt, 1983), pp. 61–78). In Victor Hugo on the other hand the concept is reconnected with the Christian

faith in order to procure legitimation for the creative artist and his personal engagement in social issues of the day (cf. K. Biermann, 'Zwischen Bürger und "Volk". Zum gesellschaftlichen Rollenverständnis des Schriftstellers nach der Julirevolution von 1830', in ibid., pp. 127–46).

31 A. Opitz, *Schriftsteller und Gesellschaft in der Literaturtheorie der französischen Enzyklopädie* (Europ. Hochschulschriften, Reihe XIII: Frz. Sprache und Lit. 31, Lang, Berne/Frankfurt, 1975), p. 211.

32 In this connection cf. J. Schulte-Sasse, 'Drama', in *Hansers Sozialgeschichte der deutschen Literatur*, vol. III: *Deutsche Aufklärung bis zur Französischen Revolution*, ed. R. Grimminger (dtv 4345, Munich, 1980), pp. 474ff.

33 Opitz, *Schriftsteller und Gesellschaft*, p. 207.

34 Cf. Montesquieu, *De l'Esprit des lois*, vol. XI, p. 3.

35 K. Scherpe, 'Natürlichkeit und Produktivität im Gegensatz zur "bürgerlichen Gesellschaft". Die literarische Opposition des Sturm und Drang [. . .]', in *Westerberliner Projekt: Grundkurs 18. Jahrhundert [. . .]*, ed. G. Mattenklott/ K. Scherpe (Scriptor Tb. Litwiss. 27 Kronberg, 1974), pp. 193 and 191.

36 I. Fetscher defends the thesis that 'Rousseau's critique of the present age as expressed in the first Discourse is much more directed against the emerging bourgeois society than against the feudal society which had been overcome' (*Rousseaus politische Philosophie* (Suhrkamp Taschenbuch Wissenschaft 143, Frankfurt, 1975), p. 15).

37 For the changing historical relationship between rationality and literature as an institution cf. my essay 'Institution Literatur und Modernisierung' in Bürger (ed.), *Zum Funktionswandel der Literatur* (translated in this volume pp. 3–18).

38 As is well known, W. Sombart attempted to explain the emergence of capitalism by means of the phenomenon of luxury consumption (*Luxus und Kapitalismus* (Duncker & Humblot, Berlin/Munich, 1922).

Chapter 6 Morality and Society in Diderot and de Sade

1 For the basic concepts of critical hermeneutics cf. 'Vorüberlegungen zu einer kritischen Literaturwissenschaft', in P. Bürger, *Theory of the Avant-Garde* (University of Minnesota Press, Minneapolis, 1984), pp. 3–14.

2 Cf. the famous observations by Marx: 'But the difficulty is not in grasping the idea that Greek art and epos are bound up with certain forms of social development. It rather lies in understanding why they still constitute with us a source of aesthetic enjoyment and in certain respects prevail as the standard and model beyond attainment' (K. Marx, 'Einleitung' to the 'Kritik der Politischen Ökonomie', in K. Marx/F. Engels, *Über Kunst und Literatur*, ed. M. Kliem (Berlin, 1967), vol. I, p. 125).

3 Cf., for example, M. Horkheimer, 'Montaigne und die Funktion der Skepsis', reprinted in his *Anfänge der bürgerlichen Geschichtsphilosophie* (Fischer Bücherei 6014, Frankfurt, 1971), pp. 96–144.

4 Cf. for example, the debate between Arnold Gehlen (*Moral und Hypermoral* (Frankfurt, 1969)) and Jürgen Habermas ('Arnold Gehlen. Nachgeahmte Substantialität', in *Philosophisch–politische Profile* (Bibl. Suhrkamp 265, Frankfurt, 1971), pp. 200–21). There is an English translation in J. Habermas, *Philosophical–Political Profiles* (Heinemann, London, 1983), pp. 111–28.

5 M. Weber, 'Die protestantische Ethik und der Geist des Kapitalismus', in *Die protestantische Ethik I*, ed. J. Winckelmann (Siebenstern Taschenbuch 53/4, Munich/Hamburg, 1969), pp. 180 and 184. L. Kofler offers a materialist interpretation of Weber's analysis in *Zur Geschichte der bürgerlichen Gesellschaft* (Soz. Texte 38, Neuwied/Berlin, 1966), ch. B, pp. 13 and 14.

6 *Studien über Autorität und Familie*, ed. Max Horkheimer (Paris, 1936).

7 M. Horkheimer, 'Autorität und Familie', reprinted in his *Traditionelle und kritische Theorie. Vier Aufsätze* (Fischer Bücherei 6015, Frankfurt, 1970), particularly pp. 197ff. None the less one has to criticize the lack of historical concreteness in Horkheimer's work and an occasional tendency to forced 'actualization'.

8 Cf. for example H. Marcuse, *Versuch über die Befreiung* (edn. Suhrkamp 329, Frankfurt, 1969). This is not one of Marcuse's strongest works. For the foundations of Marcuse's psychoanalytic theory of culture cf. his book *Triebstruktur und Gesellschaft* (Bibl. Suhrkamp 158, Frankfurt, 1965).

9 R. Koselleck, *Kritik und Krise. Ein Beitrag zur Pathogenese der bürgerlichen Welt* (Freiburg/Munich, 1969), p. 84.

10 Ibid., pp. 81ff.

11 Ibid., pp. 124 and 110.

12 Adorno defends this position in his collection of aphorisms, *Minima Moralia* (Bibl. Suhrkamp 236, Frankfurt, 1969). (English translation, *Minima Moralia* (NLB, London, 1974)).

13 H. Marcuse, 'Studie über Autorität und Familie', in his *Ideen zu einer kritischen Theorie der Gesellschaft* (edn. Suhrkamp 300, Frankfurt, 1969), p. 55.

14 T. W. Adorno, *Negative Dialektik* (Querido, Frankfurt, 1970), p. 276.

15 Diderot, 'Le Neveu de Rameau. satire seconde', in *Œuvres romanesques*, ed. H. Bénac (Classiques Garnier, Paris, 1962), p. 396.

16 D. Mornet, 'La véritable Signification du "Neveu de Rameau" ', *La Revue des Deux Mondes*, 15 Aug. 1927, pp. 887–908.

17 The consequences of neglecting the literary dimension of the text for an adequate understanding of the moral problematic it raises can be seen in L. G. Crocker's work, *Two Diderot Studies. Ethics and Esthetics* (The Johns Hopkins Studies in Romance Literatures and Languages 27, Baltimore, 1952). Crocker concludes that the logical outcome of Diderot's dialogue is a 'philosophy of immoralism – the logical end of Diderot's deterministic materialism' (ibid., p. 31).

18 R. Laufer, 'Le Neveu de Rameau', in his *Style rococo, style des lumières* (Paris, 1963), p. 115.

19 Here I would mention the group of researchers associated with M. Launay who have attempted a 'critique convergente' the purpose of which is 'to seek in the form itself for the indications which should guide the interpretation of the content' (M. Duchet/M. Launay, *Entretiens sur 'Le Neveu de Rameau'* (Paris, 1967), p. 12.

20 R. Desné, 'Le Neveu de Rameau dans l'ombre et la lumière du XVIIIe siècle', *Studies on Voltaire*, 25 (1963), pp. 493–507 and his introduction to Diderot, *Le Neveu de Rameau*, ed. R. Desné (Les Classiques du Peuple, Paris, 1972), pp. 37–86.

21 The review can be found in J. J. Engel, *Über Handlung, Gespräch und Erzählung*, ed. E. T. Voss (Sammlung Metzler, Stuttgart, 1964), p. 132.

22 'In all of this there was much that men think and set their behaviour by but is

seldom expressed. And this is precisely the most striking difference between my man and most of the other men we see about us. He confessed the vices he had, which others also have. But he was no hypocrite. He was neither more nor less contemptible than they. He was simply more honest and more consistent, and sometimes more profound in his depravity' (Diderot, 'Le Neveu de Rameau', pp. 476ff.).

23 Ibid., p. 404.

24 'And why, if I can win happiness through vices which are inborn, which I have acquired without labour and which I can keep without effort; which correspond to the customs of my country and please the taste of my protectors and are closer to their special little needs than all those uncomfortable virtues that would only oppress them from morn till night; why should I be so singular as to torment myself like a soul in hell in order to castrate myself and turn myself into something other than I am' (ibid., p. 433).

25 'I do not despise the pleasures of the senses . . . but I must own that my joy is infinitely greater when I have given succour to one who is wretched' (ibid., p. 431).

26 Ibid., p. 428.

27 'I want my son to be happy or, what amounts to the same thing, to be honoured, wealthy and powerful' (ibid., p. 476).

28 Ibid.

29 'There are people like me who do not hold wealth to be the most precious good in the world. Extremely strange people. One is not born with this outlook. One acquires it for oneself; it does not lie in [man's] nature' (ibid., p. 478).

30 'He would strangle his father and sleep with his mother' (ibid., p. 479).

31 Ibid., p. 473.

32 Ibid.

33 Ibid., pp. 481ff.

34 'What an appalling system of economic life it is! Some men have a superfluity in everything, while others, with an equally importunate stomach and an equally urgent hunger, have nothing to eat at all. The worst thing is the physical straits into which misery brings a man. The wretch does not walk like other men, he leaps, he crawls, he is bent double, he drags himself this way and that' (ibid., p. 486).

35 E. Köhler, 'Est-ce que l'on sait où l'on va? – Zur strukturellen Einheit von Diderots "Jacques le Fataliste et son maître" ', *Romanistisches Jahrbuch*, 16 (1965), p. 130.

36 Cf. Y. Benot, *Diderot. De l'Athéisme à l'anticolonialisme* (Paris, 1970), pp. 153 and 184.

37 Diderot, 'Le Neveu de Rameau', p. 483.

38 Ibid., p. 477.

39 Cf. H. A. Glaser's observation: 'What appeared [sc. in de Sade's work] as an image of revolutionary destruction with respect to the old feudal order, as an anticipation of the unbridled individualism of the bourgeois lust for profit or as an exaggeration of the aristocratic hedonism of the Ancien Régime ruthlessly exploiting its privileges – it is as difficult to separate all this out clearly as it is to separate out the elements of the historical process of the revolution itself' ('Literarischer Anarchismus bei de Sade und Burroughs. Zur Methodologie seiner Erkenntnis', in *Literaturwissenschaft und Sozialwissenschaften* (Stuttgart, 1971), p. 351).

40 In connection with the surrealist interpretation of de Sade the essential texts are identified and briefly discussed in R. Jean, 'Sade et le surréalisme', in *Le Marquis de Sade* (Paris, 1968), pp. 241–8. Those interpretations which reveal the influence of the Frankfurt School are discussed below.

41 R. Laufer, 'Le Vertige du libertin: Sade', in *Manuel d'histoire littéraire de la France*, vol. III, ed. P. Abraham and R. Desné (Paris, 1969), p. 418.

42 L. Ducloux, 'Sade: ambiguités d'une apothéose, *La Nouvelle Critique*, no. 181 (Dec. 1966–January 1967), p. 66.

43 Cf. for example the kind of justification appealed to by the first-person narrator in Prévost's *Manon Lescaut*. On this cf. P. Bürger, *Studien zur französischen Frühaufklärung* (edn. Suhrkamp 525, Frankfurt, 1972), pp. 69–94.

44 D. A. F. de Sade, *Les Infortunes de la vertu*, ed. B. Didier (Livre de Poche 2804, Paris, 1970), p. 90.

45 Ibid., p. 92.

46 'The God in whom you believe is simply a product of ignorance and tyranny. When the stronger first desired to subjugate the weaker, he convinced him that the chains he put upon him were sanctified by a God and the weakling, dulled as he was by misery, believed everything that the stronger wished him to believe' (ibid., p. 119).

47 J. J. Rousseau, *Discours sur l'origine et les fondements de l'inégalité parmi les hommes*, ed. J-L. Lecercle (Les Classiques du Peuple, Paris, 1965), pp. 124ff.

48 Cf. for example *La Contagion sacrée*: 'Le prêtre et le tyran ont la même politique et les mêmes intérêts; il ne faut à l'un et à l'autre que des sujets imbéciles et soumis'; quoted in P. Charbonnel's introduction to D'Holbach, *Textes choisis*, vol. I (Les Classiques du Peuple, Paris, 1957), p. 75.

49 J. Ehrard, *L'Idée de la nature en France à l'aube des lumières* (Coll. 'Science' 23, Paris, 1970), p. 417.

50 Ibid.

51 De Sade, *Les Infortunes*, p. 214.

52 'The poor come to replace the weak, as I told you before. To give support to the poor would be to destroy the prevailing order, would be to violate the order of nature . . . would encourage an equality most dangerous to society and promote lethargy and indolence' (ibid., p. 215).

53 'The domination of the strong over the weak has always been one of the laws of nature which was quite indifferent to whether the chains which bound the weak were imposed by the richest or the strongest, or whether these chains destroyed the weakest or the poorest' (ibid., p. 207).

54 On this cf. J. Ehrard's remark about the way in which nature was regarded in the eighteenth century: 'le plus sûr moyen de *naturaliser la morale* était de *moraliser la nature*' (*L'Idée de la nature*, p. 418).

55 Thus de Sade can let his characters develop 'a morality of the strong' which recalls Nietzsche: 'L'ingratitude, au lieu d'être un vice, est donc la vertu des âmes fières aussi certainement que la bienfaisance n'est que celle des âmes faibles' (*Les Infortunes*, p. 208).

56 De Sade, *Justine ou les malheurs de la vertu* (Coll. 10/18, 444/5, Paris, 1971), p. 55. 'It is necessary that the unfortunate should suffer. His humiliation, his pains form part of the laws of nature, and his existence is as useful for the plan of the world as that of the wealth that oppresses him; this is the truth that must stifle every stirring of conscience in the soul of the tyrant or the wrongdoer. He need not subject himself to any limitation but rather can abandon himself blindly

to the idea of any crime that occurs to him: it is simply the voice of nature which suggests these ideas and this is the only way she can make us into agents of her laws.'

57 This aspect has most clearly been explored by P. Klossowski who provides an excellent sketch of 'les rapports de Sade avec la raison' in the 'Avertissement' to the second edition of his book *Sade mon prochain* (Paris, 1967). When Klossowski notes that 'Sade poursuit la désintégration de l'homme à partir d'une liquidation des normes de la raison' (ibid., p. 12), he explicitly emphasizes the philosophical provocation or, to put it in another way, the anti-Enlightenment moment in his work. The problem with Klossowski's penetrating analyses lies in the fact that he either brings the dialectic to a standstill in the justification of God on the Pascalian model where the weakness of human reason is the guarantee of God's existence (as in the texts printed in the first edition of *Sade mon prochain*), or he drains the dialectic of its force (as in the 'Avertisssement' and 'Le philosophe scélérat' which was only added to the Sade book later). Distancing himself from Klossowski, M. Blanchot sees de Sade's originality not in an attack upon the sovereignty of man but in 'la prétention extrêmement ferme de fonder la souveraineté de l'homme sur un pouvoir transcendant de négation' ('La Raison de Sade', in his *Lautréamont et Sade* (Coll. 10/18, 356/7, Paris, 1967), p. 52).

58 M. Horkheimer and T. W. Adorno, *Dialektik der Aufklärung* (Amsterdam, 1947), p. 104 (cf. the English translation, *Dialectic of Enlightenment* (New York, 1972), p. 85). (References to this edition follow those to the German edition.)

59 Ibid., pp. 141/117–18.

60 Ibid., p. 107/87.

61 Ibid., p. 113/92.

62 Ibid., p. 113/93.

63 H-G. Gadamer, *Wahrheit und Methode* (Mohr, Tübingen, 1965), p. 255.

64 Ibid., p. 258, n. 2.

65 P. Gorsen, *Das Prinzip Obszön* (Hamburg, 1969), p. 15. I do not think however that de Sade's republicanism is as unproblematic as it appears in Gorsen.

66 Ibid., p. 15.

Chapter 7 Naturalism, Aestheticism and the Problem of Subjectivity

1 H. Bahr, 'Die Krisis des Naturalismus', in his *Zur Überwindung des Naturalismus. Theoretische Schriften 1887–1904*, ed. G. Wunberg (Sprache und Literatur 46, Stuttgart, 1968), p. 49.

2 'Le grand malheur de M. Zola, c'est de manquer d'éducation littéraire et de la culture philosophique.' 'Il y a des détails insignifiants, il y a des détails bas, il y a surtout des détails inutiles' (F. Brunetière, *Le Roman naturaliste* (Paris, 1883), pp. 112 and 119).

3 Ch. Morice, *La Littérature de tout à l'heure* (Paris, 1889), p. 25.

4 M. Proust, *A la recherche du temps perdu*, ed. P. Clarac/A. Ferré (Bibl. de la Pléiade, vol. III, Paris, 1954), p. 882.

5 Cf. Morice, *La Littérature*, p. 165: 'en art, il n'y a pas de vérité externe'.

6 Proust, *A la recherche*, vol. III, p. 885

7 Morice, *La Littérature*, p. 166.

8 Cf. for example G. Lanson, *Histoire de la littérature française*, p. 1060. An observation by Renan shows that the idea of such an intellectual experiment was extremely widespread at the end of the nineteenth century: 'Le premier devoir de l'homme sincère est de ne pas influer sur ses propres opinions, de laisser la réalité se refléter en lui comme en la chambre noire du photographe, et d'assister en spectateur aux batailles intérieures que se livrent les idées au fond de sa conscience' ('Examen de conscience philosophique 1888', in his *Feuilles détachées* (Paris, 1892), p. 401).

9 Cf. A Guedj, 'Préface' to E. Zola, *Le Roman expérimental* (Garnier-Flammarion 248, Paris, 1971), p. 38.

10 Ibid., p. 35.

11 Ibid., p. 55.

12 Cf. the 'Lettre à la jeunesse', in ibid., pp. 101ff.

13 Ibid., p. 105.

14 Ibid., p. 106.

15 Ibid., p. 131. Aestheticism will see an essential purpose of literature precisely in the stimulation of nervous excitement repudiated by Zola here. So, for example, the young Hofmannsthal praises a work by Hermann Bahr for 'this virtuosity in the stimulation of the nerves, this quivering disposition of supreme sensation' (H. v. Hofmannsthal, *Prosa*, vol. I, ed. H. Steiner (Frankfurt, 1950), p. 18).

16 Zola, *Roman expérimental*, p. 106.

17 Cf. ibid., pp. 79ff.

18 'Je n'accepte pas les paroles suivantes de Claude Bernard: "Pour les arts et les lettres, la personnalité domine tout".' (Ibid., pp. 93ff.)

19 Zola, *Roman expérimental*, p. 92.

20 Ibid., pp. 221ff.

21 Ibid.

22 Cf. ibid., pp. 220ff.

23 Ibid., p. 343.

24 Cf. H. U. Gumbrecht, for example, who repeats the standard charge of dogmatism when he suggests that 'the traditional disparagement of Zola in the marxist tradition represents the continuing attempt to discover new reasons to support the negative assessment originally given by Engels' ('Zola im historischen Kontext', preprint (Bochum, 1976), p. 3).

25 For the problematic question of Lukács attempt to connect a suprahistorical normative aesthetic with a materialist interpretation of history cf. H. Sanders, *Institution Literatur und Roman. Zur Rekonstruction der Literatursotiologie* (edn. Suhrkamp 668, Frankfurt, 1981).

26 G. Lukács, 'Erzählen oder Beschreiben? Zur Diskussion über Naturalismus und Formalismus' (1936) in *Seminar: Literatur- und Kunstsoziologie*, ed. P. Bürger (Suhrkamp Taschenbuch Wissenschaft 245, Frankfurt, 1978).

27 Cf. the remark by J. Dubois: 'plus peut-être que par leurs héros, les Rougon-Macquart vivent en nous par les lieux de travail, d'habitation et de plaisir qu'ils mettent en scène' (the introduction to E. Zola, *L'Assommoir* (Garnier-Flammarion 198, Paris, 1969), p. 11).

28 H.-J. Neuschäfer has rightly pointed out that in the introductory chapter of *Germinal* Etienne Lantier is employed as a mediating figure 'through whose eyes the reader becomes acquainted with the new milieu' (*Populärromane im 19. Jahrhundert von Dumas bis Zola* (UTB 524, Munich, 1976), p. 170).

29 E. Zola, 'Ébauche de "Au Bonheur des dames"', in his *Œuvres complètes*, vol. XV, ed. M. Le Blond (Paris, 1928), pp. 467ff.

30 V. Klotz points out that Zola reproduces the warehouse through the eyes of the figures in the novel: 'We are not presented with a picture of the thing as it is once and for all but only the momentary impression which it makes upon a sensitive self.' (*Die erzählte Stadt . . .* (Munich, 1969), p. 197). This subjectivization of description finds its limit however in the fact that almost all of Zola's descriptions reflect only *one* kind of perception, irrespective of which character is involved.

31 E. Zola, *L'Œuvre* (Garnier-Flammarion 278, Paris, 1974), p. 102.

32 This would be the natural starting-point for an analysis which sees naturalism as providing the appropriate form of literary institutionalization for a bourgeois–egalitarian society, as opposed to the aestheticism of a Hofmannsthal, for example, with its yearning for traditional hierarchies (cf. the contribution by Lothar Paul in *Naturalismus/Ästhetizismus*, ed. P. Bürger, C. Bürger and J. Schulte-Sasse (Suhrkamp Verlag, Frankfurt, 1979)).

33 It is well known that Zola's novels were subject to repeated attack from that traditional type of criticism among the educated classes which appealed to the criterion of *bienséance* based upon a hierarchical conception of elevated and ignoble subjects and the language associated with each. One example of this: 'On imaginerait difficilement une telle préoccupation de l'odieux dans le choix du sujet, de l'ignoble et du repoussant dans la peinture des caractères, du matérialisme et de la brutalité dans le style' (Brunetière, *Le Roman naturaliste*, p. 13).

34 Zola, *Œuvres complètes*, vol. XI, p. 477.

35 Zola, *Roman expérimental*, p. 243.

36 Naturalism shares this repudiation of the symbolic representation of the social totality with aestheticism. This clearly brings about changes in the epic material which apply equally to both of these mutually antagonistic movements. An explanatory approach concerned with society as a whole is probably the best way to address these changes (cf. the section on the 'Problems of the sociology of literature' below). Here I would merely refer in passing to the extremely modernist aspects of Zola's programme (one might think of Proust's analysis of passion or the repudiation of established meaning in the surrealist idea of 'hasard objectif').

37 For the opposition between the organic and the avant-garde (assembled) model of the work of art, cf. the author's *Theory of the Avant-Garde* (University of Minnesota Press, Minneapolis, 1984), ch. 4.

38 Social historians have repeatedly confirmed the realistic content of Zola's descriptions. Cf. M. Bouvier-Ajam, 'Zola et les magasins de nouveauté (*Au Bonheur des dames*)' and J. Bouvier, '*L'Argent*: Roman et réalité', both in the Zola issue of the journal *Europe*, no. 468–469 (April–May 1968), pp. 47–54 and 54–64.

39 This kind of psychologization brings Zola very close to the genre of popular biography which has been subjected to critical ideological analysis by L. Löwenthal (*Literatur und Gesellschaft. Das Buch in der Massenkultur* (Soz. Texte 27, Neuwied/Berlin, 1972), particularly pp. 203ff.

40 'Mais Saccard ne s'échauffait que par l'outrance de ses conceptions. . . . Et ce que les Croisades avaient tenté, ce que Napoléon n'avait dû accomplir, c'était

cette penseé gigantesque de la conquête de l'orient qui enflammait Saccard, mais une conquête raisonneé, réalisée par la double force de la science et de l'argent' (E. Zola, *L'Argent* (Garnier-Flammarion 271, Paris, 1974), pp. 116ff). Cf. also the following remarks by Zola from his 'Dossier préparatoire' concerning the psychology of his hero: 'Certainement, il veut avoir de l'argent, pour l'assouvissement de besoins. . . . Mais il y a aussi la joie pure de se battre, la conquête pour la conquête, la joie en elle-même du joueur, soit qu'il gagne soit qu'il perde' (ibid., p. 463).

41 Lukács, 'Erzählen oder Beschreiben?', p. 88.

42 Neuschäfer judges this issue rather differently when he writes that Zola invests 'the somewhat dry economic side of the argument with the necessary human interest for the first time' (*Populärromane*, p. 194).

43 Zola, *Œuvres complètes*, vol. XI, pp. 480ff.

44 Ibid., vol. XV, pp. 484, 486.

45 'Le dénoûment est simple, vrai et attendrissant. C'est celui de *L'Ami Fritz*: Denis déclare à Mouret "qu'elle l'aime" de même que Suzel se jette au cou de Kobus spontanément. . . . Le livre se termine par la récompense accordée à la vertue et par le traditionnel mariage final des vaudevilles de Scribe' (ibid., vol. XV, p. 483).

46 Ibid., pp. 484, 485.

47 Ibid., vol. XVIII, p. 427.

48 Ibid., p. 429.

49 Ibid., vol. XIII, p. 458.

50 'Après avoir renoncé au personnage central, pourquoi ne pas renoncer complètement au personnage doué d'une individualité propre? Puisque son sujet, par sa nature même et par son étendue *rejetait par principe toute psychologie*, pourquoi, élevant cette fois ses habitudes littéraires à un degré extrême de poésie et d'abstraction, n'aurait-il pas donné à son livre un seul, unique et énorme personnage, la foule, la grande foule, qui gronde si superbement dans les meilleurs chapitres de "Germinal"' (quoted by A. Dezalay, *Lectures de Zola* (Paris, 1973), pp. 52ff; my italics).

51 M. Barrès, *Le Culte du moi* (Livre de Poche 1964, Paris, 1966), p. 17.

52 Ibid., p. 19.

53 Ibid., pp. 17, 20.

54 By referring to contemporary reviews and previously unpublished letters by admirers, E. Carassus has been able to show that Barrès played the role of spiritual leader for a number of young people at the time (*Barrès et sa fortune littéraire* (Bordeaux, 1970), pp. 35–42). This was also true outside France. Thus H. v. Hofmannsthal, for example, pointed out with reference to this novel: 'It is the very system of modern life, the ethic of modern nervous sensibility. It teaches us how to live' (*Prosa*, vol. I, p. 44).

55 Maurras for example talks about 'toutes ces strophes en pointe qui . . . nous éclairaient aussi sur nous-même et sur le monde' (quoted by Massis in the 'Préface' to Barrès, *Le Culte* p. 11).

56 Ibid., p. 368.

57 Ibid., p. 389.

58 Cf. ibid., pp. 388, 397, 409.

59 Ibid., p. 447.

60 Ibid., p. 451.

61 Ibid., p. 457.

62 'Je fus écœuré de cette surcharge d'émotions sans unité dont je défaille' (ibid., p. 387), 'ma dispersion d'âme' (ibid., p. 389).

63 It is probably D'Annunzio who offers the most blatant example of this connection between the cult of beauty and the glorification of violence. On this question cf. A. Recknagel, 'Die restaurative Rebellion gegen den Autonomiestatus der Kunst bei D'Annunzio', in *Bildung und Ausbildung* (Vorlagen des Mannheimer Romanistentags 1977), ed. R. Kloepfer et al. (Munich, 1978).

64 Cf. the author's 'Ästhetisierende Wirklichkeitsdarstellung bei Proust, Valéry und Sartre', in P. Bürger, *Aktualität und Geschichtlichkeit* (edn. Suhrkamp 879, Frankfurt, 1977), pp. 160–94.

65 Barrès, *Le Culte*, pp. 477ff.

66 A detailed examination of the possibility of exploiting this approach for a theory of the novel can be found in H. Sanders, 'Institution Kunst und Roman' (cf. note 25).

67 On this cf. part II of the reader mentioned in n. 26, *Seminar: Literatur-und Kunstsoziologie*.

68 Cf. G. Goebel's suggestive reference to 'the cyclical return of previously played-out forms' in the moments of crisis within the history of the bourgeois concept of literature ('Literaturgeschichte als Geschichte des Literaturbegriffs an französischen Beispielen des 20. Jahrhunderts', in Kloepfer et al. (eds), *Bildung und Ausbildung*).

69 J.-M. Mayeur, *Les Débuts de la IIIe République 1871–1898* (Nouvelle Histoire de la France contemporaine 10, Paris, 1973), p. 49.

70 Ibid., p. 53.

71 On the boulangiste movement cf. ibid., pp. 165ff, particularly p. 179.

72 Quoted in J. Huret, *Enquête sur l'évolution littéraire* (Paris, 1894), p. 18.

73 Ibid.

74 'La République libérale et parlementaire, en ces années de difficultés économiques et sociales, déçoit les masses' (Mayeur, *Les Débuts de la IIIe République*, p. 162). Unfortunately there has not yet been any investigation into the social position of the writers of those documents examined by E. Carassus, which revealed Barrès's role as a kind of spiritual leader among the young at the end of the nineteenth century (*Barrès et sa fortune littéraire*, pp. 35–42).

75 As an example of such a group-sociological analysis cf. Th. Neumann, *Der Künstler in der bürgerlichen Gesellschaft. Entwurf einer Kunstsoziologie am Beispiel der Künstlerästhetik Friedrich Schillers* (Soz. Gegenwartsfragen, NF 27, Stuttgart, 1968). Among other things Neumann explores the instability of these artistic groupings and alliances.

76 The 'Manifeste des cinq' is printed in M. Le Blond, *La Publication de 'La Terre'* (Paris, 1937), pp. 63–6.

77 Huret, *Enquête*, p. xxi.

78 Ibid., p. 263.

79 Ibid., p. 288.

80 Ibid., pp. 17ff.

Chapter 8 Dissolution of the Subject and the Hardened Self

1 An account of the various versions of the novel can be found in B. Morrow/B. Lafourcade (eds), *A Bibliography of the Writings of Wyndham Lewis* (Black Sparrow Press, Santa Barbara, 1978), pp. 28ff.

2 Hugh Kenner above all has sought to encourage greater recognition of Lewis's work. See his study, *Wyndham Lewis. The Maker of Modern Literature* (New

Direction Books, Norfolk, 1954).

3 In a letter of 23 Nov. 1953 to the literary theorist Hugh Kenner, Lewis describes the project underlying his novel in the following terms: 'In writing *Tarr* I wanted at the same time for it to be a novel, and to do a piece of writing worthy of the hand of the abstractist innovator (which was an impossible combination). Anyhow it was my object to eliminate anything less essential than a noun or a verb. Prepositions, pronouns, articles – the small fry – as far as might be, I would abolish.' (Wyndham Lewis, *The Letters*, ed. W. K. Rose (Methuen, London, 1963), pp. 552ff.

4 Standing at the window Bertha awaits the arrival of the sinister Kreisler; 'Behind the curtains Bertha stood with the emotions of an ambushed sharp-shooter; she felt on her face the blankness of the house wall, all her body was as unresponsive as a brick. . . . Then it appeared to her that it was *he*, the enemy, getting in: she wished to stop him there, before he came any farther: he was a bandit, a house-breaker, after all a dangerous violent person.' (*Tarr*, 2nd edn (Penguin Books, Harmondsworth, 1982), p. 184. All subsequent references refer to this edition.)

5 In this connection see the interpretation of Frederic Jameson who combines structuralist and psychoanalytical methods of analysis with a materialist approach concerned with uncovering the historical conditions of a given literary form. Despite the convincing character of Jameson's methodological approach, which replaces the question about the mimetic nature of the work with the question concerning the historical conditions of the form and identifies the system of competing European nation states as the 'condition' of the form of 'national allegory' (which is how he understands *Tarr*), it nevertheless seems to me that the structuralist–psychoanalytical oppositional model which Jameson employs as a framework for interpreting the figures of the novel actually eliminates certain essential contradictions within the figures themselves, contradictions which precisely constitute the cognitive significance of the novel. (F. Jameson, *Fables of Aggression. Wyndham Lewis, the Modernist as Fascist* (Univ. of California Press, Berkeley, 1979), pp. 87–104.

6 Lewis, *Tarr*, p. 20.

7 Ibid., pp. 47ff.

8 Ibid., pp. 128ff.

9 Ibid., p. 48.

10 Ibid., pp. 211ff.

11 Ibid., p. 21; cf. p. 213.

12 Ibid., p. 312.

13 Ibid., p. 309.

14 Ibid., p. 240.

15 Ibid., p. 205

16 Ibid., p. 206.

17 Ibid., p. 314.

18 Ibid., p. 88.

19 Ibid., p. 89.

20 Ibid., p. 193.

21 Ibid., p. 190.

22 Ibid., p. 201ff.

23 Ibid., pp. 201.

24 Ibid., p. 194.

25 Ibid., pp. 77ff.
26 Ibid., p. 125.
27 Ibid., pp. 26ff.

Chapter 9 On the Actuality of Art

1 Peter Weiss, *Die Ästhetik des Widerstands* (3 vols, Suhrkamp, Frankfurt-am-Main, 1976–81), vol. II, p. 23.
2 Ibid., p. 21.
3 Ibid., p. 23.
4 Ibid., p. 33.
5 Ibid., p. 17.
6 Contemporary aesthetic thought is still torn between the extremes of a traditional concept of the work on the one hand and the avant-garde claim to incorporate art into actual life praxis on the other. Cf. my study *Zur Kritik der idealistischen Ästhetik* (Suhrkamp Taschenbuch Wissenschaft 419, Frankfurt, 1983).
7 Weiss, *Die Ästhetik des Widerstands*, vol. II, p. 16.
8 Ibid., p. 30.
9 Ibid., pp. 21ff.
10 In this connection see my excursus on Weiss's *Die Ästhetik des Widerstands* in Peter Bürger, *Aktualität und Geschichtlichkeit. Studien zum gesellschaftlichen Funktionswandel der Literatur* (edn. Suhrkamp 879, Frankfurt, 1977), pp. 18–21.
11 F. Schiller, *On the Aesthetic Education of Man: In a series of letters*, ed. and tr. Elizabeth Wilkinson and L. A. Willoughby (Clarendon Press, Oxford, 1982), pp. 201, 203.
12 For Weiss's plan for a new 'Divine Comedy' see *Notizbücher, 1960–1971*, pp. 211ff and *passim*.
13 Cf. Peter Weiss, 'Gespräch über Dante', in his *Rapporte* (edn. Suhrkamp 276, Frankfurt, 1968), p. 146.
14 Ibid., p. 147.
15 Ibid., p. 145.

Chapter 10 Everydayness, Allegory and the Avant-garde

1 This is also true for Jean Baudrillard's claim that the opposition between essence and appearance has disappeared in favour of the universalization of the 'simulacrum' (*L'Échange symbolique et la mort* (Paris, 1976)). Cf. ch. 2: 'L'Ordre des Simulacres'. Baudrillard's thought itself presupposes precisely that level which is not appearance and whose abolition he asserts.
2 Cf. H. Böhringer, 'Postmodernität [. . .]', in his *Begriffsfelder. Von der Philosophie zur Kunst* (Berlin, 1985), pp. 55–61, esp. p. 60.
3 The remarks in parentheses refer to A. Kilb, *Die Allegorische Phantasie* [. . .], F. Fehér, *Der Pyrrhussieg der Kunst im Kampf um ihre Befreiung* [. . .], R. A. Berman, *Konsumgesellschaft. Das Erbe der Avantgarde und die falsche Aufhe-*

bung der asthetischen Autonomie, in: *Postmoderne: Alltag, Allegorie und Avantgarde*, eds. C. and P. Bürger (Suhrkamp Taschenbuch Wissenschaft 648, Frankfurt 1987). An English version of Berman's essay is available in his book *Modern Culture and Critical Theory* (University of Wisconsin Press, Madison, 1989), pp. 42–53.

4 Cf. Jürgen Habermas, 'Die Moderne – ein unvollendetes Projekt', in his *Kleine Politischen Schriften I–IV* (Frankfurt, 1981), p. 450.

5 Cf. Ferenc Fehér, 'What is beyond art. On the theories of postmodernity', *Thesis Eleven*, no. 5/6 (1982), pp. 5–19. In this connection we should also mention Rüdiger Bubner who in an essay entitled 'Moderne Ersatzfunktionen des Ästhetischen' attacks among other things the avant-garde notion that creativity is a capacity innate in all human beings, who in most cases are merely prevented from developing it by the force of circumstances (cf. the beginning of André Breton's *Premier Manifeste du surréalisme*). Bubner writes: 'Celebrated artists, whose outstanding achievements are rewarded with prizes, assure us that we are all born artists, even if we do not all meet with similar success.' The allusion to Joseph Beuys is obvious. (In *Merkur*, no. 444 (Feb. 1986), pp. 91–107, here p. 95.)

6 U. K. Preuss recognizes the distinction between legality and morality as a fundamental and irreversible one as far as the modern constitutional state is concerned. But he too feels forced to consider the necessity for a 'reintegration of politics and morality' in view of the quite new world-historical situation which has made the idea of war unthinkable (*Politische Verantwortung und Bürgerloyalität [. . .]* (Frankfurt, 1984), p. 38 and p. 211. Cf. also pp. 22ff.)

7 J. Beuys, *Dank an Wilhelm Lehmbruck*, printed in *taz*, 27 Jan. 1986, p. 2.

8 Ibid.

9 J. Beuys, *Zeichnungen [. . .]*, exhibition in the National Gallery of Berlin (Munich, 1979), p. 31.

10 Ibid.

11 Ibid., p. 35.

12 Quoted in *Der Hang zum Gesamtkunstwerk [. . .]*, exhibition in the Kunsthaus of Zurich (Aarau/Frankfurt, 1983), p. 424.

13 Caroline Tisdall, *Joseph Beuys* (The Solomon R. Guggenheim Foundation, New York, 1979), p. 120.

14 Ibid., p. 72.

15 Ibid., p. 162.

16 Ibid., p. 102

17 Ibid., p. 105.

18 Paul Valéry, *Œuvres* vol. 1, ed. J. Hytier (Bibl. de la Pléiade, Paris, 1957), p. 992.

Index